Praise for Drawing with Children

"Mona Brookes has gained international recognition for the remarkable work she has done in teaching art to both children and adults."
—*New Horizons for Learning*

"Self-expression and creativity are no longer only for children. Corporations are now recognizing the value of accessing visual skills for adults as well. Mona Brookes offers all of us—children and adults, beginners and advanced artists—an invitation to explore our creative selves."
—Nancy Margulies, corporate creativity consultant and author of *Mapping Inner Space* and *Magic Seven*

"The method emphasizes step-by-step guidance for drawing in a learning environment that is noncompetitive and nonjudgmental, where when pencil meets paper there is no right or wrong."
—*The Washington Post*

"Mona Brookes, creator of a revolutionary drawing method, has developed techniques for utilizing right-brain functioning in children to create surprising artistic results."
—*The Smithsonian Associate*

"Monart shows that anyone is capable of drawing."
—Kennedy Center Events for Teachers

"The Monart Method works! This expanded edition contains valuable applications in 'drawing across the curriculum.' It's a MUST for parents and teachers."
—Dr. Lucia Capacchione, art therapist and author of *The Creative Journal for Children* and *The Creative Journal for Teens*

"I have used *Drawing with Children* as the required text for my Art in the Elementary School course for six years. The book in conjunction with a one-day seminar by a licensed Monart teacher is an unqualified success."
—John Solem, Professor Emeritus, Art Department, California Lutheran University, Thousand Oaks, California

"Mona's method helps teach children with learning disabilities and is particularly useful in helping educators cross language barriers."
—*The Whole Life Times*

"Teachers using the Monart method have dramatically changed their view of themselves and their students regarding not only the ability to learn how to draw but to learn. Mona has found and perfected a unique method of bringing out ability in people that they didn't believe they had. What better goal for education."
—Ralph J. Kester, Ed.D., Dean of Continuing Studies,
Seattle Pacific University

"I use *Drawing with Children* both professionally and personally. Mona's ideas work for me whether I'm working with individuals or groups and with people of all ages and abilities. Plus, now I can draw respectable hippos!"
—Anna Kealoha, homeschool teacher and homemaker,
author of *Trust the Children, Songs of the Earth,
Pleasure Point,* and *Preachers of Passion*

"The BAD NEWS is you probably will not have the pleasure and excitement of taking a class in drawing from Mona Brookes. The GOOD NEWS is you do not need to as long as you have her book!"
—Larry Mitchell, Fine Arts Consultant,
Sonoma County Office of Education

"I have witnessed firsthand the admiration, respect, and adulation that the public feels for Mona Brookes and her methodology of teaching drawing. To those unable to take classes, everything is here in her book if you really want to learn."
—Robert Evans, Director of Administration and
Special Exhibits, Capital Children's Museum

"A superb job of simplifying the drawing process, taking away the mystery and the terror. In all the years of giving and organizing teacher workshops, I never read more positive evaluations from teachers."
—Jean Katz, Director Special Arts Programming,
L.A. County Superintendent of Schools

"I knew the instant I met Mona Brookes she was someone who was going to have a profound effect on the life of my daughter and her thoughts would one day be an established part of school curricula everywhere."
—Joanne Nelsen, parent, *Huntington Beach News*

Drawing with Children

Also by Mona Brookes

DRAWING FOR OLDER CHILDREN AND TEENS

Mona Brookes

A Jeremy P. Tarcher/Putnam Book
published by
G. P. Putnam's Sons
New York

Drawing with Children

A Creative Method for Adult Beginners, Too

The following works of art are reprinted with the
permission of the Los Angeles County Museum of Art:
"Woman," 1952. Willem de Kooning, United States (b. Holland),
1904–. Purchased with funds provided by the estate of David E.
Bright, Paul Rosenberg & Co., and Lita A. Hazen. M.75.5.
"Le Vestiaire, L'Opera, Paris." Kees van Dongen, Holland, 1877–1968.
The Mr. and Mrs. William Preston Harrison Collection. 26.7.15.
"Decorative Composition," 1914. Maurice Prendergast, United States,
1859–1924. Mr. and Mrs. William Preston Harrison Collection. 31.12.1.
"The Accordion Player," 1940. Rico Lebrun, United States (b. Italy),
1900–1964. Gift of Miss Bella Mabury. M.45.1.11.

Jeremy P. Tarcher/Penguin
a member of
Penguin Group (USA) Inc.
375 Hudson Street
New York, NY 10014
www.penguin.com

Most Tarcher/Penguin Books are available at special quantity discounts for bulk purchase
for sales promotions, premiums, fund-raising, and educational needs. Special
books or book excerpts also can be created to fit specific needs. For details, write
Putnam Group (USA) Inc. Special Markets, 375 Hudson Street, New York, NY 10014.

Library of Congress Cataloging-in-Publication Data
Brookes, Mona, date.
Drawing with children : a creative method for adult beginners, too
/ Mona Brookes.
p. cm.
Includes bibliographical references and index.
ISBN 0-87477-827-1
1. Drawing—Technique. I. Title.
NC730.B658 1996
741.2—dc20 95-49072 CIP
HC: 0-87477-832-8
Pb: 0-87477-827-1

Design by Marysarah Quinn
Cover design by Susan Shankin
Cover illustration © by Alicia Nelson—age 5

Printed in the United States of America

70 69 68 67 66 65 64 63 62 61

This book is printed on acid-free paper. ∞

*W*ith gratitude to my friend and thinkmate, Elliott Day, for the hours he talked with me about safe environments, and a drawing process that would help all ages achieve success.

*I*n memory of Gertrude Dietz, for her original vision. She gave me complete freedom, trust, and her school full of cherished Tocaloma tots. She saw drawing as a teachable subject that her young preschoolers could master and that I could teach.

Contents

Acknowledgments

Thanks to so many:

To my son, Mark Hall, for the endless ways he kept me and the Monart Schools going while I wrote the original book.

To California Arts Council member Noah Purifoy, for his motivation and support.

To Governor Jerry Brown, for forming an arts council that would honor the arts in education and encourage me to change the way drawing was taught.

To Howard Gardner, for doing the research that would give me a scientific understanding of why the methods I had devised were so far-reaching in their scope and results.

To Dee Dickenson for New Horizons for Learning, Marilyn Ferguson for the *Brain Mind Bulletin,* Ray Gottlieb for the Eye Gym and the connection to vision therapy, Alice Fine for the application of Monart to language acquisition, Lucia Capacchione for Playworks and the opportunity to teach the three Rs through Monart, Marianne Karou for Movement Expression and exposure to kinesthetic learning, Geraldine Schwartz and Dez Bergman for the Vancouver Learning Centre and the Visionaires, Ann Lewin for the D.C. Children's Museum and her focus on ways of learning, Barbara Cull for ERAS and the exposure to working with the so-called learning handicapped, Opal Wong and the hundreds of elementary-school teachers like her for their feedback from the classroom, and Ina Balin and the endless number of Monart parents who taught me the importance of art to a family.

To Jeremy Tarcher and his staff for their encouragement and patience.

To my aunt, Beverly Bender, for spending so much time with me when I was a little girl and showing me how to draw.

To my mother, Mary Boles, for always inspiring me toward a questioning mind.

And with much love, to my family of licensed Monart Drawing School owners and their students, who provided many of the illustrations for this book.

For a current listing of licensed Monart Schools, check the web at www.monart.com.

A Note to Parents and Educators

Ten years ago, when I wrote this note in the first edition of *Drawing with Children,* I could speculate hypothetically on the use of Monart with a variety of different kinds of learners. Today, I speak out as a practitioner with ten years of experience, with important data for the reader on the profound impact of this method on children's learning.

We live at a time of such rapidly accelerating change that few thoughtful people are willing to predict what the world of work will be like for children now in school. For the graduating classes in the year 2000 and further into the third millennium, the human competencies required may well be beyond our current ability to imagine. As parents, mentors, and educators of twenty-first-century citizens, we urgently need to look at our curricula with a view to culling those key competencies that will provide the platform for learning and continuously relearning in their future. For this, we must consider the whole array of human skills required to create the powerful learners and thinkers these children will need to be.

No parent or teacher can afford to complacently believe that what has been sufficient until now will serve in such a future. When we examine what we have been delivering to our young and vulnerable consumers in the form of useful future competencies, we find that we have focused on teaching verbally based, orally delivered curricula. We teach with a listen-to-me approach that serves only those who respond successfully to that mode of learning.

We have undervalued those whose natural visual competencies allowed them to use these skills as artists, artisans, architects, and engineers in spite of a lack of attention and training in these modalities. We have poorly served those with average skills by failing to teach them how to capitalize on their strengths. Sadly, when a child's ability to develop the requisite auditory processing competencies is compromised through a learning disability, we leave unused, undeveloped, and undervalued the potential to learn using visual skills and other modes of learning.

In the note written for the first edition of this book, I described how drawing, like speaking, was a natural form of human communication. As evidenced in caves and tombs thousands of years old, our ancestors related their history, called on their gods for intervention, and testified to their kings' importance, wealth, and victories through their drawings. In our time, this form of human expression is considered child's play. Its place in the curriculum recedes as the grade level increases, to the extent that no place of honor is given on high school diplomas for excellence in art. In this small volume, Mona Brookes provides the tool to change this reality.

Visual learning can be used both to directly access all subjects and to support other modes of learning. Via the modeling, or watch-me, strategy, through visual display with pencil or computer, students can learn all the basic subjects in the curriculum *if* they have the "drawing alphabet," the basics for seeing with educated eyes.

Key thinking skills in visual perception, visual-spatial organization, and visual attention to detail are taught directly by the Monart system. These skills are also measured and counted in performance tests using standardized intelligence measures. How these norms would improve if we actually started teaching these skills to all children!

Drawing also has the important advantage of being considered fun and play. Because it has not been an academic subject, measured and judged as have reading and math, it is free of most of the baggage related to fear of failure and anxiety around academic success. People are willing to do it for the very pleasure of it, and if encouraged to learn how to do it in the climate of safety provided by Monart, they would build

the competencies described above without even knowing they were doing this.

Indeed, this is exactly how we use it at the Vancouver Learning Centre, where Monart is prescribed for learning disabled children whose visual competencies have been compromised. Once they build these skills to the required thresholds, we can much more easily teach them to read, write, and spell. Thus, it becomes part of the basic skill platform used to develop the academic subjects. At our Learning Centre, Monart drawings are displayed in colorful array everywhere children look. Their artwork earns these students a place of pride in our community. No wonder they are so willing and eager to do it!

We also use the Monart method with children whose visual competencies are intact, but whose auditory processing competencies are compromised. Here, we use it as reward and relief from the stress of continuously focusing on their weak areas. These children *love to do it* and sometimes unusual talent emerges, having been hidden under the heavy burden of low esteem in general and low value for what they can do well. These children learn rapidly and often blossom as human beings. This provides new energy and confidence for learning in other areas. It also directs them to consider career options where these skills are important, such as work as visual artists, artisans, architects, and in the use of electronic media for building and design.

We are a two-handed, two-footed, bilateral, bicameral, multifaceted species. In the future, visual skills of every kind, from drawing to visioning, will need to be primed, to stand equal with all our other skills. It makes no more sense to ignore its development than it would to tie one hand, or one foot. We need the full flow of all our human skills to deal with a future so challenging and so complex that we can hardly imagine it.

Mona Brookes's wonderfully simple and engaging system provides a tool for all teachers and parents to provide the gift of visual competence to their children. It offers special educators the tool both to bring impaired skills to new thresholds of competence and to reward visual learners with an activity of choice that builds self-esteem and produces new confidence.

Insights of genius tend to be simple and elegant in expression. Once understood, we almost cannot imagine why we didn't think of it before. In the last ten years of use at the Van-

couver Learning Centre, we have observed the power of Monart to transform the lives of hundreds of learners. As parent, teacher, and psychologist, I recommend it to you without hesitation.

Geraldine Schwartz, Ph.D.
Founder and President
Vancouver Learning Centre

Preface: The Monart Method

When I was asked to revise *Drawing with Children* for a tenth anniversary edition, I was immediately aware of how much I have learned about education and art over the last ten years.

The book was originally written for parents to enjoy drawing with their children and included a few notes to teachers. Since then, the Monart method has grown to a fully developed art curriculum for preschoolers all the way to what I call "terrified" adult beginners. *Drawing with Children* and my second book, *Drawing for Older Children and Teens,* are both being used by thousands of schoolteachers around the world. My little Monart School has grown to an international network of artists who are licensed by me to teach private Monart classes and conduct after school enrichment programs in the public schools. These owners of Monart Schools train public school teachers to use drawing as a way to develop basic educational skills.

This new edition is thus a guide for classroom teachers as well as parents. I am so happy to add this important new information for schoolteachers, to present new illustrations depicting the kind of results that are possible, and to share with you how the Monart method can enhance the creative and intellectual capacity of both children and adults.

At a time when more and more of our youth are being designated as having learning problems, I am thrilled to report that Monart is a program that is helping them. It turns out that visual emphasis was one of the missing links in our teaching environment. It has now been established that if you draw

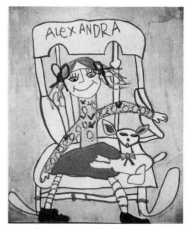

Tocaloma preschooler— age 4
From a study of her doll in a child's rocking chair.

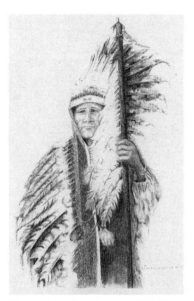

Susannah Kaye—"terrified" adult beginner
After 8 months of lessons. Inspired by Howard Terpning.

what you are learning about, you will learn it much faster and retain the information much longer. Everyone loves to draw if they are given a nonthreatening environment with enough structure for success and enough freedom for creativity. That is what Monart provides. The particular sequence of lessons in this book builds a safe environment as it teaches students to use an alphabet of shape to analyze and break down what they see. Development of perceptual and analytical skills increases critical thinking and problem solving. Easy and quick artistic success also builds self-esteem, and this confidence is transferable to other educational areas.

Monart-trained teachers use drawing to teach literature-based reading, writing and composition, math and geometry, science, social studies and multicultural studies, geography and mapmaking, and primary and secondary language acquisition. Students automatically learn the course curriculum in a motivated state because they are having fun drawing. The good news is that schools are reporting up to a 20 percent increase in reading, writing, math, and language skills for students who are exposed to the Monart program.

When I first designed the Monart method, I couldn't find any structured drawing programs for young children. Gertrude Dietz, the director of a preschool where I had been hired to teach, wanted me to teach realistic drawing skills to about one hundred four- and five-year-old children, in groups of about fifteen to twenty. Their regular teachers did crafts projects and provided them with free time to do symbolic stick-figure-style drawings, but Gertrude believed that if children were given structured lessons they could learn to draw in realistic styles as well. She felt young children could learn to draw, just as they could be taught to play the piano or to read. Gertrude was so convinced that such art instruction would work and that I was the person to undertake it that I didn't question her belief.

I originally planned to research the subject and put some ideas together based on what others were doing. I had no idea I would come up empty-handed. Traditional drawing curricula were for children over twelve or thirteen years old, and were basically geared for those who already drew pretty well. The few books on realistic drawing were geared for older teens or adults. Their content was limited to traditional Euro-

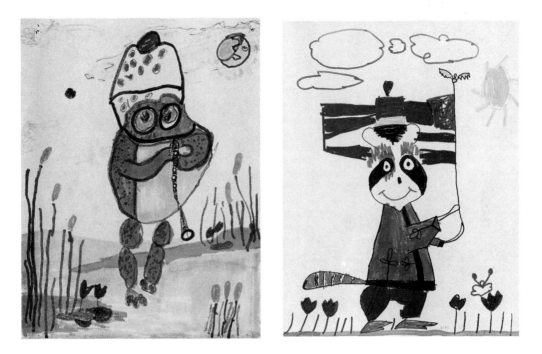



(Left) **Tocaloma preschooler—age 5**
From a storybook.

(Right) **Tocaloma preschooler—age 5**
From a storybook.



pean fine art styles and mainly focused on drawing the human face or the nude model.

Thank goodness Gertrude and I were ignorant of the prevailing philosophy that said you shouldn't give young children any guided instruction in the field of drawing. We assumed it was acceptable to give basic instruction in drawing, since this was true for music, dance, and all the other artistic subjects. Gertrude gave me complete freedom to explore any avenue that worked. I was as astounded by the results as were my students and their parents.

With my next door neighbor and buddy, Elliott Day, I spent endless hours making up lessons and trying different approaches. Elliott's contribution was essential. He helped me develop a set of simple general principles. As a composer and musician he had a way of breaking things down into their basic components. By showing me how he broke down a musical composition, he taught me to analyze how I went about "seeing" and then drawing. Elliott felt the confused nondrawer just didn't know what the basic components of vision were. He felt that the shapes of objects came in endless varieties and that the basic shapes, such as circles, triangles, and

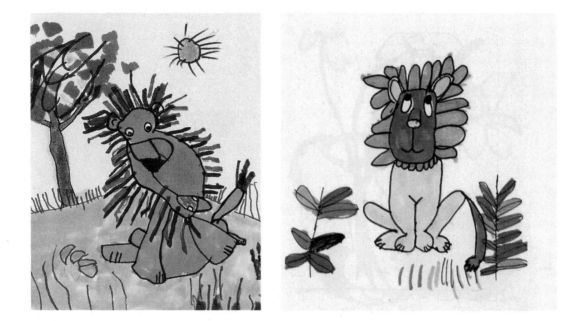

Creative differences and self-expression
From a figurine of a lion.

(Left) **Tocaloma preschooler—age 4**

(Right) **Tocaloma preschooler—age 4**

squares, didn't describe the material world enough to allow for success in drawing. He wanted to know the fewest number of lines that were involved in creating any possible shape. He pointed out that there was a system of basic elements for every other subject he could think of. For example, all Western forms of music derived from twelve basic tones, Indian music twenty-two; every dance had its basic movements or steps; every language had an alphabet. He felt the main reason people couldn't draw was that they were overwhelmed with complex visual data and had no system with which to analyze it. This led us to devising an "alphabet of shape" that consisted of five basic elements of shape. Any object that a student wanted to draw could simply be analyzed in terms of how these five elements of shape were combined. The success of the method was that you could use demonstration to train students to see each general shape, but the students were then free to interpret the detail in any way they wished. As a result, every child could achieve realistic representation of the subjects to be drawn, and yet every drawing was creatively different.

The environment became as important as the technical information being provided. Our students thrived in a noncompetitive, nonjudgmental classroom where there was no

critique of their work, no right or wrong way. The words "mistake," "good," "bad," "better," and "best" were eliminated. We didn't allow comparisons of either each other's work or their realistic drawings with the stick-figure pictures they did on their own free time. Students were encouraged to walk around and look at each other's work for the purpose of learning, but followed the strict "complete silence" rule. They learned to appreciate differences instead of comparing, and became very confident, independent, and creative in their work.

When Gertrude asked me to paint her favorite storybook characters on the school yard fence, the children joined in, picking their favorites as well. They drew toy trucks, dolls, and still life arrangements with equal ease. They followed the general guided demonstration, but their drawings all looked different as they made up their own compositions and created their own additional details and background information.

Drawing with Children gives beginners of any age the basic information they need to analyze and reproduce what they see. It also encourages self-expression in an environment that is conducive to exploration. Beginner adults send me letters delightfully proclaiming mastery of a skill they always believed was beyond their reach. For many, drawing fills a cre-

Gertrude Dietz—director of Tocaloma Preschool
Happy to see her favorite storybook characters painted on the school yard fence.

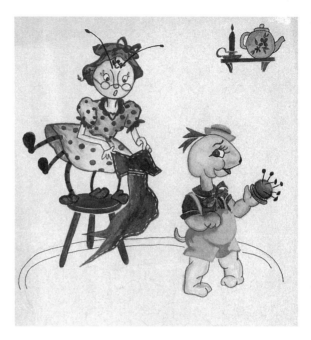

**Mona Brookes—the author—
age 6**
From a book of rhymes.

ative void that they experienced in their lives. It affords them a way both to express themselves and to relax.

Once you or your child or students have mastered the lessons in this book, you can turn to my second book, *Drawing for Older Children and Teens*. It covers the more sophisticated subjects of perspective, shading, and life drawing in a simple and practical way and explains the different styles of drawing, giving hints on how to plan compositions and develop projects. Parents and teachers of children who are eight and up say that it leads them to the realistic kinds of drawings they want to accomplish. Children over ten or so can use the book by themselves. High school art teachers report that it helps students who think they can't draw become confident enough to go on to more advanced work.

I am convinced that drawing realistically is a natural ability that we all possess. Once given the general information needed to master this skill, one can then develop one's own creative way to interpret what one sees. With very little effort you can use the methods in this book to teach yourself, your children, or your students how to draw. A few suggestions on how to use the book will be presented before you begin.

I wish Gertrude were still with us and that I could share these developments with her. She told me once that after she

was gone I was to keep looking in the sky for her. She was sure that if such things were possible she would be a sea gull and would come down and let me know it was her. So far I haven't had her land on me, but I feel her sitting over my shoulder at the computer as I write this tenth anniversary edition of the book she inspired.

Working with the many children, artists, educators, and students in developing the Monart method has enriched my life beyond anything I could ever have planned. I have seen how much growth is possible when our vision is strong enough. We are all capable of so much more than we realize. I thank Gertrude for that vision and Elliott for helping me develop logical thinking, patience, and positive expectations. Give yourself these gifts as you work with this book. Since drawing is one of the most relaxing and enjoyable ways to communicate and express yourself, I invite you to experience its magic. I am honored to be your guide.

Mona Brookes—the author— age 11
Inspired by a fairy tale.

How to Use This Book

You do not have to be working with children in order to use this book. It was also designed as a self-teaching method for teenagers and adults. Of course, any child who can understand the text and instructions could do the same. Simply turn to the child within yourself when you read instructions on how to teach, treat, or talk to a child, and you will be your own best teacher. If you are going to be working with other adults or the elderly, you can appeal to the child in them and use the instructions in the same manner. The instructions are phrased in such a way that you can read them to yourself as your own teacher, or you can read them out loud and guide the child or other adult whom you are teaching.

Take a quiet hour by yourself and first scan the entire book without doing any drawing. Put the book aside to let it settle a bit, and then start back at the beginning, by yourself. Read the Preliminaries section through Lesson 1 in depth, following any instructions that are given. You may need several days to assimilate all this information, experience your prelesson drawing, and follow the instructions regarding purchasing of supplies and setting up the environment. It is very important to the success of this undertaking that you do this preplanning. If you are working alone, complete the lessons in the same sequence as they are presented in the book. If you are going to be teaching children, don't introduce them to the lessons until you have dealt with the majority of your own drawing blocks and confusions. It is rare for this to take more than a couple of weeks if you open yourself up to change.

When you are completely ready to guide a child, return to Lesson 1 and repeat it together. As you progress through the

book, scan each lesson by yourself, prior to teaching another person, taking as many sessions as you need to digest the material before moving on to the next lesson.

There are a couple of things you will need to understand in order to make the most efficient use of the lessons. If you take care of these now, you will be ready to start.

Duplication of Drawing Samples

With apologies for the possible inconvenience, I recommend that you make photocopies of several of the exercises and drawing samples presented in the following pages. Otherwise, it becomes very awkward to try and study a sample in the book and at the same time turn pages and follow the instructions in the text. This can be especially disruptive to a child who is already dealing with motor coordination problems. If for any reason you can't get to a copy machine, trace as many of the exercises as you can for easier handling. It would be better for a child to work from a copy of an exercise that is a bit different from the one in the book than to prop the book up or work with a piece of paper folded into the book.

Following is a list of the copies you will need.

1. Starting Level 1, exercise (page 44, Fig. P.5)

2. Starting Level 2, exercise (page 44, Fig. P.6)

3. Starting Level 3, exercise (page 45, Fig. P.7)

4. The Five Basic Elements Chart (page 60, Fig. 1.2)

5. Mirror Imaging, exercise (page 69, Fig. 1.6)

6. Wow! I Can Draw, exercise (page 76, Fig. 1.11)

7. Overlapping, exercise (page 86, Fig. 2.5)

8. Leo the Lion, lesson sample (page 94, Fig. 2.11)

9. Leo the Lion, simplified (page 94, Fig. 2.12)

10. Bird Montage, lesson sample (page 100, Fig. 2.15)

11. Individual Birds, simplified (page 101, Fig. 2.16)

12. Carousel Horse, lesson sample (page 107, Fig. 2.18)

Drawing Instruction Format

The step-by-step instructions offered for drawing the lesson samples follow the same pattern in all the lessons. When drawing examples are shown in the side margin, notice how some of the drawing is in dotted-line form and some in solid. You will not be drawing in dotted lines. Such lines are present only to help you visually keep track of the instructions. The dotted lines will become solid ones. You will draw in regular solid lines, with the exception of a few instances where you will be taught to use "guideline" dots.

As you experience each lesson, you may want to take time to digest it before rushing on to the next one. If you do this, you'll get a nice surprise—you and your students or children will begin to think of projects to draw that are similar to the lesson you just finished. It will reinforce the learning if you do a few similar projects of your own before taking on the additional information involved in the next lesson.

Any further instructions will be incorporated in the individual lessons themselves. Have a wonderful time exploring your world of perception and sharing it with others.

Free Use Permission Information

If you are employed as a public or private academic school teacher or an institutional worker, you have permission from the publisher to photocopy materials for use in the classroom to accompany your verbal lessons.

If you are using the book to teach a college-level course, you have permission from the publisher to photocopy no more than ten to fifteen pages for handouts to your students. Beyond that amount you need to write the publisher for permission or consider assigning the book as a textbook for the class.

If you wish to teach private art classes or after-school enrichment programs, or work for community art centers or recreation programs, it would not be legally appropriate to present yourself as a Monart teacher, solicit art students based on the curriculum in this book, or imply that you are teaching Monart by using the materials, five elements of shape, or lesson plans from this book.

The trademark Monart is a registered service mark and cannot be used by anyone who is not contracted and licensed by the Monart International Institute. The only classes that are entitled to represent Monart display a license signed by the author and are administered by owners who were personally trained by Mona Brookes. The only people qualified to conduct in-service training sessions in the use of her methods are members of her personal staff. For further information, contact Mona Brookes directly at 10736 Jefferson Blvd. #509, Culver City, CA 90230.

Preliminaries

Before You Draw

In order to develop yourself as an artist and be able to teach others, you need to consider your feelings about your own drawing and your opinions about drawing in general. The adults who take my training say that their drawing ability is strongly improved by this preliminary work on their opinions; they are surprised to find it as beneficial as the drawing experiences themselves. This section will help you explore your feelings, provide you with a preinstruction drawing experience, and assist in the unfolding of your full potential.

How You Feel about Your Own Drawing Ability

If you feel confident about your drawing but want a vehicle to teach others, approach this method with a fresh and open outlook. If you don't feel confident about your own drawing or your ability to work with children, let me assure you that this can change. The drawings by beginner adults that you see in the color section exemplify the kind of work that was achieved by worried and unconfident beginners. None of these students knew whether they could draw and were surprised at their results. If you want to improve your own drawing and don't intend to teach anyone else, simply become your own teacher.

How often have you heard someone conclusively state, "I can't draw"? It is accepted that only a few are blessed with the gift of drawing and that no excuse is necessary for not being able to draw. You can even hear successful painters, designers,

and artistically inclined people make this statement, but with additional embarrassment and frustration. This attitude can change, whether you want to teach yourself or others. One gentleman, shaking and sweating at the beginning of a one-day workshop, admitted to the group he was shocked to display such real fear over the idea of possibly being unable to draw. He said he was sorry he had come; he was sure he'd fail. By the end of the day, he was beaming with pride at his accomplishments and said that if he could draw, anyone could. He couldn't believe I had witnessed this same phenomenon many times.

WHERE YOU STAND NOW

Read the list of five statements and pick the one that best fits the way you feel about your drawing. Make the choice according to the way you feel now, rather than past opinions.

1. I am very confident and satisfied with my current drawing ability.

2. I can draw, but I would like to draw better.

3. It has been so long since I've drawn, I don't know if I can draw anymore.

4. I can't draw, but I think I could learn.

5. I can't draw, and I don't think I could learn.

WHAT YOU THINK ABOUT DRAWING

Let's see how you feel about drawing in general. Read these eight statements and notice how many you tend to agree with.

1. The ability to draw is inherited.

2. There is a right and a wrong way to draw.

3. Drawing is simply for pleasure and has no practical use.

4. Art lessons should be given only to those children who show talent and may become artists when they grow up.

5. Structured drawing lessons are inappropriate for children; they should develop their ability through free expression and exploration only.

6. People who can't draw realistically, with accurate shading and correct proportion, aren't real artists.

7. Real artists draw from their imagination and don't need to copy things.

8. Real artists are pleased with most of what they produce.

Most of us feel that certain of these statements are true. I now believe that none of them are true. As we consider these falsehoods, we begin to relate emotionally to our frustrating childhood drawing experiences. Reevaluating those memories with updated information will help us make the shift toward success. As we proceed we'll be discussing these ideas in more detail.

LET'S DRAW

You can make the most progress in your drawing by establishing how the eight issues you just considered affect your current drawing ability. Take the next few minutes and see how you draw today. You want to evaluate how you feel about your drawing the way it is, so there is nothing to gain by trying to attain any particular effect. Just do as well as you can without worrying about it.

- Find a quiet space where no one will interrupt you for at least 30 minutes.

- Unplug the phone.

- Find a flat surface to draw on, and make yourself comfortable.

- Use plain paper and a black felt-tip marker or ballpoint pen with a regular to fine point. If all you have is a pencil, don't use the eraser.

- Have paper for note-taking next to the drawing paper.

Draw a Scene with . . .

a house

a person

a tree

some bushes and flowers

at least five other things of your choice

A Few Tips

- Relax and enjoy the process.

- Don't start over or erase if you don't like something. Make some kind of adjustment and continue until you finish drawing all the subjects.

- Don't allow yourself to be interrupted.

- As you notice your thoughts and emotional reactions, stop and write them down on the note paper. For the sake of the exercise, try not to analyze them yet. Simply note your feelings and jot down a few words to remind yourself of them.

When You Have Finished

- Get up and take a stretch, but don't allow yourself to talk to others or be distracted from the process.

- Come back, prop the drawing up, and take a long, hard look at it.

- Add any additional comments to your notes.

How You Felt

Now you can analyze your feelings and comments. Take a few minutes to let the memories that go with the feelings surface. Here are some things to consider as you learn what it all means for you.

How did you do, compared with how you thought you would do?

While you were drawing, did your thoughts reflect any of the opinions or experiences you had as a child? What can you remember about those early drawing experiences?

Were any of your thoughts related to the eight statements about drawing that you considered prior to the drawing experience? If so, how did you come to have those opinions?

If you found yourself being overly critical about your performance, don't worry; you're not alone. I find that even people who do quite well will malign themselves. Once I heard a ten-year-old quietly tell another student, "I don't even believe the awful stuff I say about my drawings anymore, I must be fishing for compliments," and they both burst into knowing laughter. If you experienced any self-doubts while you were drawing, it would be normal for you to feel reluctant to let others see your drawings, to feel that you would not be able to improve easily, or to feel uncomfortable with the idea of teaching someone else. None of that is necessary. If you can hang in there for just a few days of discomfort and are willing to change your opinions and expectations, you can quickly see amazing growth.

Changing Your Attitudes and Abilities

Exposing yourself to new information about the drawing process will make a more dramatic change in your current ability to draw than will any other factor. Changing your expectations about what is acceptable and possible can be the key to unlocking the door. So let's take the eight statements you considered about the subject of drawing and see if we can shed some new light on them.

NEW UNDERSTANDINGS

1. *The ability to draw is inherited.* This is one of the main reasons people believe they can't draw. If you don't have an artist in your immediate family, as many of us don't, you might have decided it was impossible for you to draw after a few minor attempts. Once you've bought the idea that drawing is an inherited talent, you are probably too quick to give up when you don't achieve immediate success or your beginning attempts feel uncomfortable. Can you imagine how many people would learn to roller-skate if they took this same approach?

Drawing is a teachable subject and artistic talent can be developed. When I first faced packed schoolrooms of thirty-five restless and doubting preteens, I wasn't quite sure they would

have the success that the original preschoolers had had. I think I was as shocked as anyone else when, time after time, all the children achieved a variety of imaginative and successful results. I now realize that such success can be expected when you create a safe environment and give students the information they need.

As for "hereditary artists," some of the most resistant students come from a family with a designated artist as one of its members. Many artists bring their children to Monart with the hopes that someone outside of the family will encourage them to try. These children often had refused to draw at all for fear of being compared with the artist in their family. My own son, for instance, never participated in art in school, convincing all the teachers he just wasn't interested in the subject. Since he was an excellent musician, no one felt it was necessary for him to draw. When he was a teenager, he came into my studio a few times and announced his inability. We were all amazed when at nineteen he finally decided the safe environment was so accessible that he would take the training. His drawings were very sensitive and imaginative and showed great promise. He became the Monart staff's favorite substitute teacher and later taught some classes of his own.

2. *There is a right and a wrong way to draw.* You will find very little agreement, even among art critics, on what is good or bad art. In art courses, one professor will grade a drawing with an A, while another will reject it. Since it really boils down to personal opinion, you might as well listen to your own inner critic and draw for yourself instead of others. Unless you want to sell your art, it is not important to consider what others may or may not like.

3. *Drawing is simply for pleasure and has no practical use.* Operating on this premise, public schools in the United States cut art budgets first, whenever money is tight. In the early 1980s some art classes were still available, but these usually came in the form of sporadic "crafts time" for the very young or elective art classes for upper grade levels. As the economic crunch hit, in the late '80s, the arts completely disappeared in many school districts. Interestingly, my Monart teacher training programs began to increase at the same time. The teachers' and parent teacher associations began to hire us to come to

their districts and teach them our method, paying for their training out of their own personal budgets. They instinctively knew that the arts helped children succeed in other school subjects. School districts began doing studies to show that control groups of students given the Monart training were scoring better in reading, writing, and math at the end of the year. As Howard Gardner and other education specialists began to talk about multiple intelligence theory, parents and teachers got the statistics they needed to prove their intuition had been right. Such studies convinced administrators that arts programs like Monart were a necessity, not a luxury. In the '90s as budgets are being cut even more, school districts are using regular curriculum funding to underwrite integrated programs combining drawing with basic academic subjects. One of the major reasons I was so thrilled to write the revised edition of this book was to talk about these new developments in the added chapters.

Adults who learn to draw also tell many stories about how their lives have changed and other skills have improved in the process. Business corporations are giving the Monart drawing courses to middle managers to help them with their problem-solving abilities and critical-thinking skills. It's interesting to note that when people accomplish something they never thought they could do, it changes their belief system. They realize they can approach other unknown areas and subjects with a more open attitude to learning.

4. *Art lessons should be given only to children who show talent and may become artists when they grow up.* Now that I know that all children can draw if given the proper exposure, I find this statement ridiculous and confusing. I regret that it intimates that you need to "grow up" to be an artist and only adds to the confusion. Who says you have to be a certain age to be an artist? Unfortunately, children's artwork is looked down on; its intrinsic worth is not recognized, nor is it displayed or hung with due respect. Children could be enjoying their own artwork in the books they read, the items they use, and on the walls of their homes. I was delighted when, as the public began to see serious art exhibits of Monart students' work, they often asked how to contact the parents to find out if they could buy the children's artwork for their homes. When

Monart students receive encouragement from relatives and friends to become artists when they "grow up," many respond, "I'm an artist *now*!"

5. *Structured drawing lessons are inappropriate for children. They should develop their ability through free expression and exploration only.* We don't expect children to play the piano, study dance, or learn a sport without showing them the basic components of these subjects. Why do we expect them to understand the complexities of drawing on their own? Imagine expecting children to write creative stories without teaching them the alphabet and the structure of language. Learning the language of drawing and painting is likewise essential for anyone wanting to pursue those arts creatively.

Adults who think they can't draw are taught by methods that include demonstration, visual exercise techniques such as mirror imaging, copying other line drawings upside down, and drawing the edges of negative space. Children need to learn the drawing process also, but with similar exercises that are geared to their age level. Children's creativity is not stifled if they're provided with a very general structure and are allowed to interpret the information any way they wish.

Some of my original Monart students are now nineteen to twenty years old. I still have contact with some of them. The ones who continued in classes through their teens became extraordinarily skilled and independent in their work.

They received recognition as artistically gifted students, and some are now art majors in college. Others are beginning to apply for internships and will eventually open Monart schools of their own. Many of the students who dropped out before the critical age of eight or nine did not continue with art or become independently creative. But this happens in music, math, dance, and most other subjects. If they were to expose themselves to art instruction again, these same students would blossom very quickly. A nineteen-year-old girl recently walked into my Santa Barbara school in wide-eyed shock. She just happened to be passing by the studio and saw the artwork in the windows. She was so excited that she interrupted the class and began telling me how she remembered drawing with me when she was in nursery school. The next week she joined the adult class and treated the other students by bringing in the portfolio her mother had saved of her preschool drawings.

Within weeks she was turning out very lovely, creative, and independent work. Because she had already learned the basics as a child, she went right on to skilled drawing.

6. *People who can't draw realistically, with accurate shading and correct proportion, aren't real artists.* Just mentioning Picasso's name seems to remind everyone of the inaccuracy of this statement. Many people don't even know that he was an accomplished realist in his early years. They are not aware that an artist can be equally proficient in many styles but simply prefer one over the other. It is my hope that we will drop our need for comparative judgment and learn that any approach to art is valid. However, if people are dissatisfied with their ability to draw realistically, they should understand that drawing is a teachable subject. With practice and study, they can achieve success.

7. *Real artists draw from their imaginations and don't need to copy things.* When it comes to drawing the endless number of creatures or subjects in nature, or the thousands of man-made objects in the environment, artists who work in realism often have extensive files of reference materials and pictures to remind themselves of the shape and structure of what they wish to draw. Sometimes they observe the object itself; but even then, they take photographs of it so they can continue working on the drawing later. They make sketches from other drawings and photographs, rearrange things, add ideas from their imagination, and create what is considered an original piece of artwork. Any realistic artists who imply they work solely from their imagination are not telling you the whole story. In this book I have simply given children and adult beginners the same options as professional artists.

We need to stop mystifying the drawing process and explain to students how artists actually achieve the results they do. For instance, Picasso and Michelangelo both copied other artists' work for at least two years as part of their initial art training. When Picasso began to express himself in what were considered "unique" styles he was actually copying many of his images from African masks. Painters such as Degas and Toulouse-Lautrec worked from photographs of their subjects, and many famous painters have used each other's paintings for inspiration.

Imagination always plays a part in the process. It is not a separate function existing independently from visual data. Integration of observation and imagination is what is needed. Again, I see both as necessary, rather than one taking precedence over the other.

8. *Real artists are pleased with most of what they produce.* Like the rest of us, professional artists are often dissatisfied with their work. Knowing this, we ought to give ourselves and the children we work with the freedom to be dissatisfied and to learn from experience. About ten years ago I developed a set of questions that help in this regard. I ask these questions in every group I lead, from large auditoriums full of educators to small groups of kindergarten kids. Literally thousands of people have answered them with the exact same responses and get the point at the end of the session. The questions are as follows:

1. "If an artist does five drawings, how many do you think they will like enough to frame and want to show people?" All groups easily and consistently answer, "One, or maybe two."

2. "Out of the five drawings, how many do you think they will dislike enough that they will not want others to see them and will want to start over or discard them entirely?" Consistent answer again, "One or two."

3. "What do you think they will do with the one or two left over?" Small children will answer, "Give it to Grandma," or "Save it in my drawer." Adults seldom make any response but once in a while say, "Save them."

4. "Why don't you give yourself the same privilege that you would give an artist?" No one ever says a word. They sit there looking at me in confusion.

5. "Why do you think you have to like everything you do?" The total silence continues. Even the four-year-olds realize the ridiculous expectations they place on themselves.

6. "If you do five drawings with me today, how many of them can you expect to like real well?" They smile and answer, "One, maybe two." Then when I ask, "Can you expect to dislike something about one or two of them?" they have

this relieved look on their faces and respond, "Yes." When I ask, "What will you do when you dislike something?" it is very easy for them to simply realize they can make changes or start over without risking their self-esteem or feeling like a failure. It is equally a relief to them when I remind them that artists seldom finish a piece of artwork in one sitting and that they too can continue working on something at a later date.

If you don't come to grips with unrealistic expectations, you may find yourself giving up before you've begun. When an adult beginner doesn't like his or her first couple of drawings, he tends to throw them away and conclude he has no ability. When a child tells an adult she doesn't like something about her drawing, it is quite common for the adult to begin praising the drawing and trying to talk the child into liking it. Adults act as if it would be a terrible experience for a child to dislike something about his or her work. If you do this, you rob a child of the ability to solve problems and develop creative thinking skills. It also creates tremendous stress to have to live up to false expectations. When I first saw teachers doing this to students, I remembered how angry this made me as a child. I remembered thinking, "What's the big deal? Why would it be so awful to just dislike a drawing?" When I was learning to play the flute no one was surprised when I hit wrong notes or tried to tell me how wonderful it sounded. Such false expectations and need for praise are probably two of the biggest reasons people aren't free to learn how to draw. Our society is totally unrealistic about what to expect of beginning drawers. We have created an unwillingness to take risks and to enjoy the process of learning. One of the most powerful things you can do to change this pattern is to present the above six questions to your students and discuss their responses honestly and openly with them.

Giving the Artist in You Permission to Unfold

With this new information and the realization that you have more in common with "real" artists than you thought, here are some suggestions on how to let the artist in you come out.

- Listen for your "silent critic" and retrain it. When you find yourself getting negative ideas about your abilities, don't judge yourself, just notice it and insert the new information you have just learned about your real potential.

- Know that you can be your own teacher or learn along with your students.

- Remember there is no wrong way to draw. If it is the way you want it, it is perfect. If it isn't, you can change it or start over, without feeling it's a failure.

- You don't need to feel guilty about using other visual data; professional artists don't draw entirely from their imaginations either.

- Don't prevent yourself from copying or getting ideas from things you see; you'll interpret them differently anyway, the way other artists do.

- Be patient with yourself, and have fun while you learn. Remember that all artists experience a certain dissatisfaction with much of what they produce. Don't throw away a drawing you think isn't perfect; you may learn from it later—or someone else may love it just the way it is.

This book will help you change your misconceptions. With the exception of one student, the adult drawings throughout the book were created by people who were afraid they could never draw the way they wanted to. The children's art was not created by gifted children. These drawings were done by regular kids who were given the kind of safe environment we have been discussing, as well as the information on how to see and explore, which you will receive in the chapters that follow.

The typical symbolic stick figure drawings that you see on page 20 are the type of drawings that children all over the

world do naturally, and children should be given time to develop this activity by themselves. Such drawing is important for self-expression and language development and should not be compared to realistic drawing. As children think about a car and draw two circles for the wheels and a straight line between them for the car, they are creating the symbol for a car. Realism is not important, since children are simply communicating ideas to themselves. As they express these ideas, they have a running dialogue going on in their mind. For example, as they draw the symbol for the car and a stick figure of themselves, they are saying such things as, "This is me getting in the car with Daddy to go to the store." Linking words to objects and ideas to sentence structure is occurring in their inner vision as they draw. They are unconcerned about what the marks on the paper look like. I suggest that you be as unconcerned. You can let them talk about their pictures, but it is inappropriate to focus on realistic interpretation of the images. This experience is about communication of ideas, not artistic achievement. Drawing is a nonverbal language; it implements the acquisition of any primary spoken language that is being developed.

The realistic drawings that also appear on page 20 can be achieved by all children as well, if given the guidance and basic information contained in these lessons. It can be introduced to four- or five-year-olds and not conflict with a child's ability to continue symbolic expression and primary language development. They can draw symbolically whenever they have free time and realistically during planned and guided drawing sessions. At around eight or nine, children will naturally give up symbolic styles of drawing and want to draw realistically. Only a rare few are able to do so by themselves, however, because symbolic drawing does not naturally evolve into realistic drawing. Realistic drawing is a completely different subject. Except for the rare few, children need instruction in the basics in order to achieve realism to their satisfaction. There isn't any reason children can't enjoy both styles of drawing through their early childhood development. The only time I have seen a child have difficulty is when an adult shows partiality for one style over the other or compares them for some reason.

Rather than being limited to stick-figure drawing, children who also draw realistically are building visual perception, concentration, and problem-solving abilities along with language

development. When they give up symbolic drawing they can easily make the transition into the creatively sophisticated styles of drawing done by older teens and adult artists they wish to emulate. If children can learn to draw in this way, so can you. I encourage you to put your doubts aside and watch the transformation take place.

Brian Solari—age 4
Right: Symbolic self-portrait he did on his own.

Far Right: Realistic guided lesson on same day. His skill in realism increased each year, and he also continued the important symbolic experiences until age nine.

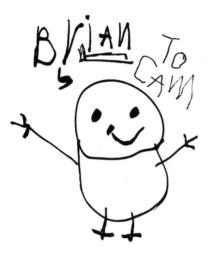

Molly Adams—age 9
Symbolic drawing she did on her own.

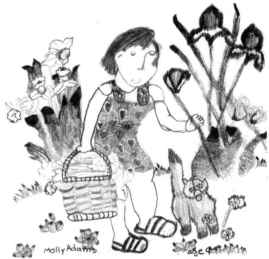

After six months of instruction, Molly was able to expand her rendering ability and also draw with realistic interpretations and complex detail.

Alexandra Salkeld—age 7
Alexandra looked into the mirror and created this self-portrait on her own.

On the same day, Alexandra received the instruction in Lesson 5 on how to draw faces and saw herself with retrained eyes. She easily accomplishing this drawing.

Donna Albertson—age 7
Donna looked in the mirror as she drew herself. Without instruction in visual observation, she could only use stick-figure symbols that were familiar to her.

Immediately afterward, she was given the information you will find in Lesson 5 and redrew herself with newfound realism.

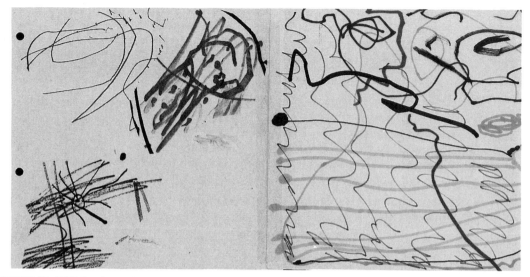

TYPICAL TWO- AND THREE-YEAR-OLD SYMBOLIC DRAWINGS AND SCRIBBLINGS

Ben Pfister—age 3

Eric Russell—age 2

TYPICAL TWO- AND THREE-YEAR-OLD REALISTIC DRAWINGS AFTER INSTRUCTIONS

Not all two- or three-year-olds are ready to draw realistically, but as soon as their motor coordination allows them to duplicate the five elements of contour shape, they can understand how to render what they see.

Josh Ifergan—age 3

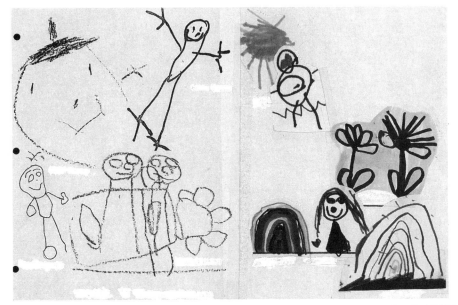

TYPICAL FOUR-YEAR-OLD STICK-FIGURE AND SYMBOLIC DRAWINGS

Sable Snyder—age 4

TYPICAL FOUR-YEAR-OLD REALISTIC DRAWINGS AFTER INSTRUCTION

Most four-year-olds are ready for instruction. They understand the process but may have to wait a little for their motor coordination to develop. By four and a half it is rare that they are not ready. Of course, it is important not to rush them. You may begin the visual perception games until they can duplicate the five basic elements of shape.

Tocaloma preschooler—age 4

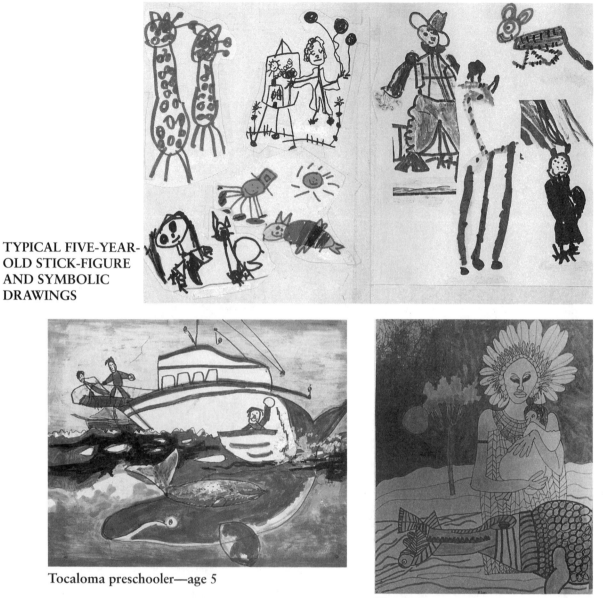

TYPICAL FIVE-YEAR-OLD STICK-FIGURE AND SYMBOLIC DRAWINGS

Tocaloma preschooler—age 5

Kim Balin—age 5

TYPICAL FIVE-YEAR-OLD REALISTIC DRAWINGS AFTER INSTRUCTION

All five-year-olds are ready to add the joy of representational drawing to their lives. They will continue to draw stick figures and wonderful symbolic images by themselves until eight or nine years of age. Symbolic drawing is a natural process, but does not lead to drawing realistically. Teaching the basics of realistic drawing does not interfere with free symbolic expression. The two are different subjects, and you can encourage them both.

Setting the Stage

Part of being able to create is having an enjoyable space in which to work with the kind of supplies that will facilitate success. In setting the stage we will create a comfortable space and a conducive mood, go shopping for supplies, and get inspired to begin a collection of drawing projects.

Preparing Your Work Space

It is highly recommended that all the people who are going to be drawing together take part in the planning. Encourage a process by which you openly communicate ideas concerning the arrangement of the space and the type of mood you will need for concentration and creativity.

ARRANGING THE SPACE TOGETHER

Whether you are a schoolteacher creating a classroom setting or a parent setting up a space at home, the same factors need to be considered. You will be creating a different arrangement depending on the number of people who will be drawing.

• *Demonstration area.* In the classroom you will need to have a large area on the wall. The ideal surface is a corkboard on which you can pin large pieces of butcher paper for demonstration and have plenty of room left over for graphic ideas and sample drawings. If all you have is a chalkboard, use masking tape to hang up large pieces of butcher paper. Chalk

does not adapt well to the process of drawing, so you will need to demonstrate in marker or other media on paper. Overhead projectors are okay for simple abstract line drawings, but when you want to demonstrate color, realism, or shading they are inadequate. At home you simply want a space next to the child that allows her to see your demonstration of ideas. In either setting, have a tall table or rolling cart available to set up a still life or objects to be drawn.

• *Seating and drawing surface.* The tables in a classroom need to be arranged in a way that will allow all the students to face the demonstration area. When choosing a space at home you'll need a flat table surface. Have small children in chairs or booster seats that allow them to sit comfortably without being up on their knees or reaching up to the surface. Make a mat out of white tag board or heavy paper that will keep marker inks from bleeding through onto the table and will serve as a place to test colors.

• *Neatness.* You will be learning how to see the shapes of things and looking at a lot of visual data. Visual clutter can make it impossible for most people to focus. It is important to remove all items that do not relate to the drawing process. Have the children in a classroom remove all textbooks and other papers from their desks and clean away all the pinned-up work and bulletin-board items that surround your demonstration area. If you are working at home at the kitchen table, take time to clean everything off first. Trying to draw in the midst of newspapers, toasters, and dishes will cause too many distractions.

• *Lighting.* Bring in as much light as possible. If you are using lamps at home, make sure they are in a direction that does not cause the hand or the body to cast a shadow on the paper.

• *Access to materials.* Have a system that eliminates as much as possible the need to get up and down. Searching for supplies causes a break in concentration that isn't conducive to success. At home it is best if you can create a permanent space, where the supplies are always out. This will encourage consistent involvement and independent work.

- *Traffic flow.* In the classroom you want to create the ability to move around without disturbing others. The secret is to keep the silence rule enforced even when students get up to get supplies or look at another's work. At home the challenge is to keep others from moving through your space or distracting you. Make it a rule that no one come into the area or interrupt you when you and your child are drawing.

CREATING THE MOOD TOGETHER

I can't stress enough how important it is to talk with your students first about the kind of mood you are going to create and why. Here are the main points that will help you create an enjoyable environment that also encourages success.

- *Concentration.* Explaining the virtue of silence is not enough. Unless students are motivated to want silence for themselves you will be in an endless battle of wills. Most people have never experienced the pleasure that total silence can be, are uncomfortable with it, and don't even know they would like it. From the minute we awake until the end of day most of us are besieged with noise, blaring music, or a continually running TV. Classrooms have an undertone of whispers, and the moment the teacher is preoccupied the whispers escalate into loud talking. I have as much trouble motivating adults to be comfortable with silence as I do a group of children. Artists know the benefits of silent concentration. I knew that unless I could help students experience this peaceful concentration, they would never have the kind of success they wanted. After trying a variety of approaches, I finally found a system that works. If you can be comfortable with silence yourself, I guarantee the following system will work.

1. *Tell your students or your children the following.* "If you are talking you go 'blind.' Your mind is busy talking and can't see well enough to tell your hand what to do. I know you want to have success with your drawing and you don't realize how badly it can be affected by talking or becoming distracted by others who are talking. I also know it is a very hard habit to break and so I will help you. Unless I am giving instructions, I will not talk myself or encourage you to talk with me about things other than your drawing."

In a classroom you can take it one step further. "I will protect you from others' talking and move people who are having trouble talking to each other. There is no reason to be embarrassed or feel you have done anything wrong if I move you. We all have trouble learning to enjoy silence. I will give you a warning first, and if you still have trouble I will move you away from your talking buddy. I will just take your drawings and move you there, so let's not make a big deal out of it, and we can go on with the lesson without any problems."

2. *Don't make any idle threats.* Be aggressive and diligent about enforcing the silence. It is usually necessary to follow this system very rigidly for a couple of weeks. Once people experience the relief of complete silence and concentration, they love it. Children look forward to this quiet time and won't allow a newcomer to interrupt it. They will expect you to demand this silence for them. You can expect up to an hour or an hour and a half of this kind of total silence from students of any age before they will need a break. The results will show up dramatically in their artwork. They will appreciate focused concentration the way all artists do, and see the differences it makes in their progress.

- *Learning to see.* Build an appreciation for the time you will be taking to learn to see. Explain that the eyes need to train the mind how to look, so that the mind can tell the hand what to do.

- *Planning.* Create an awareness of how much time and frustration can be avoided by being patient, warming up, and planning first.

- *Speed.* Explain that drawing is a subject that doesn't work well if one is too quick to draw before looking, and that you are both going to learn to study things and take your time.

- *Perfection.* Explain how there is no wrong way to draw. Make it clear that you will be learning ways to change things that you feel dissatisfied with and that no one is expected to like everything she draws. Explain that it is natural to be a bit uncomfortable and dissatisfied during any learning process.

- *Feelings.* Encourage the student's freedom to express positive or negative feelings and to ask for help and suggestions. Make assurances that as you learn together you will help each other with your problems and frustrations, and that there is always the option to take a rest and finish later.

shopping for supplies

Imagine if you had never bowled before and were dropped off at a deserted bowling alley to play. The essence of bowling may completely escape you if you couldn't watch others use the equipment, find out what the rules of the game are, and practice using the ball. The same is true of the drawing process. No matter what age a student is, he needs to explore the materials and find out how they can be used before beginning to draw.

WHAT TO BUY

For the beginner, it is very important to use supplies that assist motor coordination. When you draw in a representational style and are trying to depict the shapes and sizes of things realistically, you need to control the configurations of your marks and lines. Felt-tip markers are excellent for this; they provide the flowing control of line in many different thicknesses, and they allow for color effects similar to the beauty of watercolor. The inability to erase forces the beginner to look at the subject carefully and plan first before drawing—which is appropriate, since looking more accurately is the main challenge. Crayons do not lend themselves to representational drawing because the line is not sharp and smooth and is difficult to control.

Watercolors and brushes are the most difficult drawing media to control, and so for children under eight they are more appropriate for free and loose painting projects. After some drawing confidence is attained, you can do more detailed watercolors with children over eight or nine. Drawing pencils, with all their wonderful shading abilities, can be used after the student learns to see and there is no more danger of becoming dependent on the eraser.

Before I recommend pen and paper supplies for beginners, I want to bring up one point about felt-tip markers. Solvent-based inks give off a strong odor and can cause headaches or other reactions. You have the option of using odorless, water-base inks, but the drawing may fade away very quickly. If you choose to use the indelible inks, which do provide more variety of color and shading and are more permanent, be sure the room is well ventilated.

BEGINNING SHOPPING LIST

Fine- and broad-tipped colored markers. Fine-tipped markers are for drawing, so buy an assortment of the darker colors. Broad-tipped markers are mainly for coloring in, so lean toward lighter shades that blend well together. Buy an assortment of all the colors in the rainbow, with extra shades of blues, greens, and browns for making foliage and skies and water more varied.

This is one time when buying the expensive brands will save you money. The problems with the cheaper markers are that points break easily or become mushy, poorly designed caps can cause pens to dry out sooner, and colors are diluted with water so that the ink streaks and clumps up on the paper. Cheap markers are also very unsophisticated in color range and can severely limit the beauty of a drawing. If you must buy the cheaper pens, supplement your supply with a few of the expensive ones, especially in lighter blues and greens for sky and foliage.

Test the pens in the store to make sure they are not old stock and close to drying up. Make a good one-inch square of color, since a dried-up pen will work for a few strokes even after it is dead. What you are looking for is a smooth wetness. If the pen streaks or makes a squeaky noise, it is probably close to drying out.

Black drawing marker. Since most brands of black ink fade, smear, and turn greenish when touched by nearby colored inks, it is important to find a particular brand that will retain its quality. Be sure to test your choices first by running yellow or light-colored inks next to the black.

Scratch paper. A ream of photocopying paper is about the cheapest available and lets you feel free to do a lot of testing and planning.

Drawing paper. Most art stores carry a medium-priced paper in sketch-pad format. Get the thickest brand available that has a matte finish. Slick or shiny paper will cause a lot of smearing problems.

Where to Shop

Shopping for supplies is part of the creative process. Inadequate supplies can limit your ability to produce the effects you want. Try to develop a relationship with a particular sales clerk who will help you with your needs. Check out the various types of stores that carry drawing or graphics supplies. Prices may vary considerably, so it is worth the extra time to find a reasonably priced store.

Art stores. Traditional art stores carry the better-designed solvent-base and water-base ink markers and a wide variety of drawing papers and graphics supplies in large quantities. But prices range dramatically, so shop around.

Office supply chains, such as Staples and Office Depot. These stores are among the few places where you can find a large assortment of colored construction paper, which is a nice paper for chalk pastels. They carry a wide variety of drawing supplies and papers at much lower prices than art stores.

Large chain paint stores. In most cases, prices here are much lower than in even the chain-type art stores. But take the time to compare the brands, since some stores carry only the cheaper pens.

Large drugstores, photocopy chains, and markets. Watch out for narrow selection and limitation to cheaper brands. These are, however, among the best places to find black pens and photocopy paper.

Department stores. Art departments in department stores are on their way out. They tend to carry the better-quality pens you are looking for, but the prices can be much higher than at art stores. Since turnover here can be slower, watch out for old stock.

Ideas for Inspiration: Knowing what's Possible

Most young children in America have observed only the symbolic and stick-figure-type drawings that they and their friends create. They have never had the opportunity to see more fully developed drawings by children their own age. Organizations from other countries may sponsor collections of fine artworks by children, but in the format of contests, prizes, and a competitive atmosphere, and the results are usually not displayed in this country where children get a chance to see them. Some countries' entries include fully developed representational drawings by children as young as six or seven. These are the same types of drawings that Monart students are producing at an even earlier age of four or five. Fifteen years ago the sponsors of such contests reported to me that American children were poorly represented, due to the lack of any structured

Nicholas Christ—age 4

Tocaloma preschooler—age 5

FIG. P.1 *With guidance, very young children can achieve fully developed drawings.*

guidance in the field of drawing. I am happy to report that immediately after that, a Monart student placed second in one of these worldwide contests, and every year I hear parents and students talking about how they entered such contests and received recognition and awards.

Since the publication of the first edition of this book, thousands of elementary-school teachers have been using the method and seeing their students achieve very skilled results. If children aren't exposed to this kind of realistic drawing, they don't know it is possible and as a result don't even try to achieve it. The drawings by the four- and five-year-old students (in Fig. P.1) exemplify this more fully developed representational work.

A first "assignment" in preparing children or yourself for the drawing experience is to spend time simply perusing the student exhibitions in this book for inspiration and exposure to what is possible. Even children who are actively drawing and confident about their ability need new ideas and encouragement.

Kimberly Ikeda—age 11

Patrick Dillon—age 12

FIG. P.2 *This type of fully developed work can be achieved by all children, not just the gifted.*

Remember, the type of work in the student exhibit of eleven- to twelve-year-olds in Fig. P.2 does not come from "special" or "gifted" children. The drawings throughout the book are by "regular" kids from all walks of life who have been given guidance on how to draw. You can assure your children and yourself that you can all attain this level of drawing skill.

SHARING YOUR FEELINGS

If you still aren't feeling comfortable about your own drawing ability, try admitting this to your students or children and soliciting their support in a team effort. The fact that you let children know that you will have to learn together is never a hindrance. Teachers tell me that their students are even more productive and cooperative when they feel it is a matter of helping each other.

COLLECTING THINGS TO DRAW

Purchase several file folders in which to start collecting your potential future projects. Large X-ray envelopes are great for holding oversized samples of graphic ideas. The only place I know to get them is from the medical supply houses that service hospital and X-ray labs. Call one in your area and speak to the person who is in charge of ordering the clerical supplies. He or she can tell you where to buy them.

Label your files with the major topics that interest you: birds, animals, flowers, sea life, people, transportation vehicles, buildings, landscape scenes, designs, and so on. Look through illustrated books, greeting cards, magazines, or photographs and select images that appeal to you. Don't worry right now about whether a project might be "too hard," since you are going to be much more capable than you think. Save anything that has something in it you would like to be able to draw, even if it is only part of the entire image. Ask friends to save illustrative materials for you.

Begin examining three-dimensional objects around your living space and be aware of things you might want to draw in later projects. Include everything from kitchen articles, knick-knacks, flower arrangements, toys, sports equipment, and

stuffed animals to such larger items as potted palms, bicycles, furniture, cars, and sculpture.

As you get more into the drawing lessons, you will be given specific advice on how to collect and plan projects. There is also an entire chapter in my second book, *Drawing for Older Children and Teens*, on how to plan projects. But there is no need to wait. Start gathering these materials now, and you will be more than inspired for your future drawing adventures.

Creating a Supportive Climate

Now that you have set up your work area, considered what is possible to achieve, and begun collecting inspirational projects, give some thought to how you might make your drawing climate conducive to concentration and free from emotional stress. Confidence and drawing ability are very much affected by the way an artist emotionally reacts to ongoing experiences. The feelings involved may not even be related to the drawing itself, but they can dramatically affect the ability to perform. Drawing and concentration are inseparable. When concentration is broken by talking and distractions, there is a very obvious rise in children's dissatisfaction with their work.

Unless you are aware of these issues, children can get confused, thinking that they don't have the ability to draw, and they may give up. Setting up a climate that will support children throughout their experience is as important as the particular drawing method you choose.

Communication Can Aid the Process

While you are getting your students started on their drawing, limit your verbal communication to basic and simple instruc-

tions. Having to process words distracts the part of our mental concentration needed for drawing.

TALK ADULT

Children notice when you use a different tone of voice with them than you do with your adult friends, and they act accordingly. Talk to them normally, using mature language, and they'll act responsibly and perform with confidence. Use a singsong voice pattern with baby talk and they'll be sure to act immature and become insecure about their performance.

Perhaps they interpret baby talk as a sign that you don't believe they are capable of much and that you don't expect them to understand much of what is going on. As you talk to them in a normal tone of voice and ask them to respond in kind, you will see tension release from their body and their ability rise to a more mature level.

Tape yourself talking with your children or students and listen to yourself later. Your awareness of baby talk is usually all it takes to begin to break the habit. A teacher friend of mine who was unaware of this tendency in herself and who couldn't make adjustments when she was told about it ceased baby-talking instantly once she actually saw and heard herself on videotape with the children.

When you treat children as equals, you'll be rewarded by their wanting to talk to you about what is important to them and trusting that you will respect their thoughts and opinions. The two-way communication will result in more creativity and learning for both you and them.

TALK NONJUDGMENTALLY

Your use of language is as important to the process as any technical information you impart. If we truly want children to believe there is no right or wrong way to draw, then we have to back up our assertions with nonjudgmental language.

If you don't give some thought to the words that you choose, they can end up blocking you from the creativity you wish to experience. Certain phrases lock in judgmental ideas about the artistic process. These phrases concern performance, competition, comparisons, and risk of failure. Take note of the

following words and begin to listen to how you use them when you communicate:

Words That Inspire Competition

Good

Bad

Better

Best

Words That Instill Frustration or Fear of Failure

Right

Wrong

Cheat

Mistake

Easy

Hard

I suggest that you quickly replace these words with ones that are more neutral. As long as you use the above words, children really won't trust your insistence that they can do no wrong, and they will continue to be competitive and insecure about their artwork. When you use the word "mistake," for instance, you immediately imply that mistakes exist and that your students are subject to making one at any moment.

Even though it requires attention to break these habits, it is well worth the effort. Tend to this language change before drawing begins, and decide on the words you are going to use instead. Here are some suggestions that will make the transition a little easier:

Talk about how two drawings are "different" from each other, rather than describing either one in terms of good, bad, or better. Point out how you can personally "like" one drawing better than another, without that actually making it a better drawing. Talk about learning to appreciate differences.

When you hear children talking about making a mistake, take the time to address that comment. Mention that a visit to art galleries or museums makes you realize there is no right or wrong way to create art; famous artists have very different ways of interpreting the same thing. Remind them that if there is no right and wrong, there can be no mistake. Help them remember that it is a question of deciding whether or not they choose to change something that they don't like.

When you encounter resistance because children think something is too *hard,* find a way to help them get past the block. Explain that as they begin to see that everything is composed of the five elements of shape, they will discover that *nothing* is *harder* to draw than something else, it will just take *more* or *less* time depending on the complexity and detail of the subject. When you realize you can take all the time you want to finish a project, you no longer have to avoid things you want to draw but fear are too difficult.

TALK SPECIFICS

An adult student came into one of my classes after taking a college drawing course in perspective and coming to the conclusion that she was totally "inadequate." She claimed she just "couldn't get it." It turned out her college teacher would discuss how to draw a box from various angles in an intellectually abstract and verbal mode, with only a completed drawing for an example; there was neither a demonstration nor an actual box to serve as a model. As the instructor's hand flowed back and forth across the example, he would explain how to "come down here *like this,* then go back in there *like that,* and so on."

I call this method of teaching the this-and-that syndrome. Most of us can't relate at all to this method because it is too vague. We need a combination of specific words that relate to the parts being discussed, an object to look at, and a step-by-step demonstration to understand the process. For example:

Notice the front of this box, just the part facing you. Notice that the rectangle it makes is made up of four straight lines coming to angle points at the corner. Watch how I duplicate that shape in my demonstration. Now draw that rectangular shape first. Next, notice how the side of the box has straight

lines that recede away from you and make the box appear smaller at the back than the front.

Notice how the top of this vase has a hole in it that is like a squashed circle. I'm going to draw the top of my vase about this big in my demonstration. Decide how big you want your vase to be and where you want it on your paper. Now draw a squashed circle, similar to the one you see on the vase, wherever you want the opening of your vase to be. Now notice how the sides of the vase are made up of curved lines. First it curves in, then it curves out. Do one side of the vase first. Now use the same kind of curves to make the other side match.

For beginners and small children, it is critical to have the object in view, as well as a sample line drawing of the main parts of the object. For a large class to be able to see the sample drawing, it needs to be at least 16×24. As you demonstrate, you need to mention the part you are drawing and the specific types of lines you are using to construct each part of the object.

We are often blocked from understanding a new subject simply because of the technical language used to explain it. Drawing can be intimidating for this reason. Here is a sentence I found in a drawing book designed for elementary-school-aged children: "We call vertical lines perpendicular when they make right angles with horizontals." I question the average adult's ability to understand this sentence, let alone a young child's. Use words that describe as simply as possible what you see. Here is an example of how to convert and use visual words:

Horizontal line: a line lying down.

Vertical line: a line standing up.

Diminishing perspective: things appearing smaller as they get farther away.

Profile: side view.

Contour line: line following the edge.

Always describe what you are about to draw by using simple, visually descriptive words. Since children eventually need to recognize technical vocabulary, you can always include it, but put the emphasis on the visually descriptive words.

Troubleshooting

No amount of persuasion can make a person draw who does not want to. Sometimes, however, you can get so worried about keeping a child or student involved that you are not sensitive enough to a problem and let it go too far. Following are some potential problems you want to be alert to:

Visual difficulties or eye strain. Watch for tension around the eyes, frowning of the forehead, putting the face very near the paper, becoming unusually sleepy or nervous, drawing upside down or backward, or drawing pieces of the object and not being able to connect the pieces. When these clues appear, take a break and do the palming exercise that you will learn in Lesson 1. Any of these situations can occur on an "off day," so don't be alarmed. If a child consistently displays this kind of difficulty, it may be wise to consult an eye-care specialist.

It is not uncommon for four- or five-year-olds to draw backward for a short time. In a nonstressful way, point it out, show them the difference on a separate paper, and then let it go for the time being. Each time you observe it, point it out again. It will usually correct itself within a few weeks if you just continue to remind the child, without demanding change. Read my recommendations in the section titled Reaching Special Education and At Risk Students if the problem continues past the age of five or six or causes learning problems in reading or writing.

Tension. Tension often occurs in the shoulders or jaw, manifested by shoulders raised in a rigid position or jaws clenched tightly. A gentle hand on the back of the neck or shoulder will help ease the tension and open the way for a few questions or support from you. Just a "How are you doing?" can begin to release inner tension. Tension is often unrelated to the drawing process. It may be the result of something that happened earlier or something else the child is anxious about. Ask a few questions and allow the child to release his feelings.

Frustration. Frustrations are usually directly related to the process of drawing. Children will manifest their frustration in body squirming, nervous talking, playing with the equipment in a dazed state, banging their feet against the table or a neighbor, scribbling across the drawing, fidgeting with the paper as if they were going to crumple or tear it, and general loudness and disruptive behavior. The situation calls for a halt to the

drawing process, a discussion about the child's drawing in relationship to the behavior, and friendly support. Suggestions and help in solving the drawing problem usually eliminate any further need to address behavior problems. Remember to remind children that all artists are often dissatisfied with their work. This is the most powerful tool you have to combat frustration.

Distraction. It is very common for children of all ages to become distracted. Demanding constant or total attention will only make you irritable and result in exhaustion for you both. Just try to reclaim the child's attention and go on. Distraction as the norm needs your intervention, however. I find it best to pick a time when you are not drawing to talk to children who are consistently distracted. Of course your drawing environment may be the culprit. At home, make sure that television, music with words, or other family members are not distracting. In a classroom, make sure to keep any outside noise or activities at a minimum.

Fatigue. If a person is genuinely tired, it really doesn't matter what the reason is. Simply stop and put the drawing away to finish later. However, if a pattern develops in which a particular child is no longer tired once the drawing is put away, there may be another reason. Fatigue is often present when we are avoiding feelings or are frustrated. In this case the child needs some help to confront the feelings or frustration and go on.

The following general strategies will help set a good positive tone. Copy them down on a separate piece of paper and review them each time you begin a drawing session. Don't forget that if you are drawing alone, you need to treat *yourself* this way.

Emphasize the fun involved in the process.

Let go of preconceived results and let yourself explore.

Acknowledge that there is nothing wrong with tense feelings, but be willing to let go of them and relax.

Allow others to draw their way, don't try to manipulate them.

Be supportive and understanding.

Be ready for the totally unexpected. It is not uncommon for a child who is drawing just fine from your point of view to suddenly burst into uncontrollable sobbing. In older students the reaction is more subtle, but the experience is essentially the same. A child can also be very upset and not show any outward sign of it. Never assume that inner experience matches outer behavior. We have been so conditioned in this society that even four- or five-year-olds act docile instead of letting us know they are having a problem.

I strongly recommend that if things get to a crying stage, don't make a big deal about it or try to talk a child out of it. In fact, it helps if you make it clear that it's okay to cry for a minute and get out the feelings. Encourage the child to stop crying as soon as possible and to let you know what's wrong so you can help. Keep the same tone of voice, give some loving support, and go on with other things at the same time. If you are overly concerned and sympathetic, the child can get the message that something awful happened and that crying is bad. Be matter-of-fact about the whole thing. As the crying winds down, ask the child to take a few big breaths first and try to express what's wrong. Statements about not having to like every drawing and seeing how we can change it are invaluable. But don't assume the crying is even related to the drawing, unless the child says it is.

What is really needed in any situation that begins to be tense or uncomfortable is concern about what is going on and a joint effort toward a solution. Thinking of solutions together is one of the joys of the process. Sooner than you would imagine, drawing problems become interesting challenges instead of uncontrollable calamities.

Choosing Your Starting Level

Before you or your child use the lessons in this book, you will need to establish the level at which you will begin the lessons. Because of motor coordination and attention span differences, it is necessary to teach the lessons at different levels, established by simply ascertaining how complex a visual pattern the student is able to see and duplicate in an exercise provided for you. If the choice doesn't turn out to work well, you can always lower or raise the level as needed.

The exercises are based on the ability to recognize and draw the five elements of shape presented in Lesson 1: the dot, the circle, the straight line, the curved line, and the angle line. Children as young as one year old can recognize and play games with the elements of shape, but they are usually not ready to use them in the drawing process until late three or early four years old. You can begin trying the exercises around this age, but if a child has trouble duplicating the images, go back to recognition work and the random warm-ups. Do this recognition work for a couple of months and then return to the exercises and try again.

After you do the exercises and choose your starting level, we will discuss developmental guidelines for children. First I will give you some tips on how to do the recognition work with newborns through four-year-olds. This visual perception training for babies makes a big difference in their readiness for

drawing as well as reading and other subjects. Then I will explain the stages of development that you can expect with children from around four years old to twelve. These guidelines represent general age levels and how children's interest, attention span, and motor coordination tend to respond to the drawing lessons. Teenagers have the same motor coordination and performance potential as adults, but they need extra encouragement due to emotional and social pressures.

Starting-Level Exercises

Start students of all ages at the beginning of the Level 1 exercise. Copy the image you see directly under the example with a regular-tipped black marker. Offer a little guidance in the form of verbal support and suggestions to get your students going, but once the procedure is sufficiently understood, let them go on their own.

It is not necessary to reproduce the image exactly, since that is not our goal in the drawing process. You merely want to duplicate the same general structure with the same basic components. For example, it is not important to have the same exact size or confidence of line. But do attempt to duplicate the type and number of lines represented, as well as the relationship of how one line is attached to another (see Fig. P.3). Similarly, in the more complex examples as shown in Fig. P.4 it would not be important to have the same exact number of lines in an area, but to accomplish filling the area with lines in the same manner as represented in the example.

Approach each level progressively. As the child takes one image at a time, she will suddenly hit a place where she begins to have more difficulty. If a particular image causes much of a holdup, tell the child to skip it and go on; she can come back to it later. Even when an image starts having inaccuracies or missing parts, continue to go on to the next image, until more than half of a particular image is inaccurate or missing. Note that there has been a lack of completeness, but keep going on to the next image, doing one at a time, until the child is unable to complete two or three of them consecutively. Then stop and determine the starting level at which she completed the majority of the images. This will be the level to use in starting the lessons.

Name: Heather (age 4) Date: 9-30

FIG. P.3 *It isn't important to be exact; you are just looking for the same combination of elements. You don't need to say anything about the confidence of line, either; it gradually improves with maturing.*

Heather Alef—age 4

Name: Melanie Schoenberg AGE: 8 Date: 4/10/86

FIG. P.4 *It isn't important to fill an area with the exact same number of elements but to create the same type of texture in an area. The sample is to the left, and Melanie's duplication is to the right.*

Melanie Schoenberg—age 8

Above all, approach the exercise without tension or fear of failure. Explain to those children under eight that they probably won't be able to finish all the images and are not expected to, so they will not feel unsuccessful when they need to stop. Make it clear that this is not some kind of test or contest, that it is just an indicator of which lesson to pick in the book. Also

make it clear that they won't miss any lesson. The higher-level lessons can be done later, when their confidence and skill has grown, and the lower-level lessons can be done whenever they want. Have fun and treat these exercises as visual games.

Level 1. The images in Fig. P.5 can be drawn by children as young as three and a half or four. If youngsters can duplicate the majority of these images, they are ready to begin drawing. The few three-year-olds who are ready may be able to duplicate shapes, but they have a much shorter attention span and will need lots of breaks during the lessons.

If a young child cannot duplicate enough of the images to start the lessons, give him a lot of support, read Lesson 1 as suggested, begin doing some of the visual warm-ups to help him get ready, and try the exercise again in a couple of weeks. It usually takes a few weeks of waiting until he'll be ready. Don't rush things. It's like walking. It will happen at the right time, and there is no reason to hurry it.

Level 2. These images in Fig. P.6 can be duplicated by children anywhere from just before age six up to seven or eight. Don't be concerned if a child as old as seven or eight has difficulty reproducing the images in this group. Start her out with Level 1 lessons, and she will probably jump very rapidly to Level 2 as she gets acclimated. As the child passes into the Level 2 exercise, offer some renewed encouragement and guidance to help her orient herself to the more complex ideas. Emphasize that these images are not really harder but just have a lot more lines and need more time and attention to complete. Encourage her to take one line at a time and build off it, choosing the simple ones to start with.

Level 3. The images in Fig. P.7 can be rendered by children from eight or nine years old up through adults. If people over nine years old have trouble with the exercises, it doesn't mean they are slow. They may have had no prior exposure to this type of visual perception work and simply be visually disoriented. It usually only takes a couple of weeks for them to catch up to their age level. Start at Level 2 and give them a lot of recognition work, and they should easily go right on to Level 3. As an adult, you may want to do the Level 3 drawing lessons on your own, but also do the appropriate lessons for any children you are working with.

When you begin the lessons, don't be surprised if the performance level quickly changes and you can incorporate the

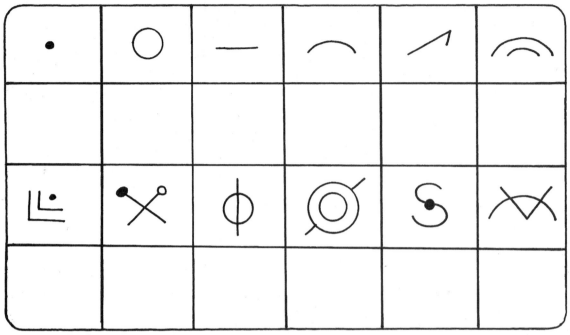

FIG. P.5 *Level 1 exercise.*

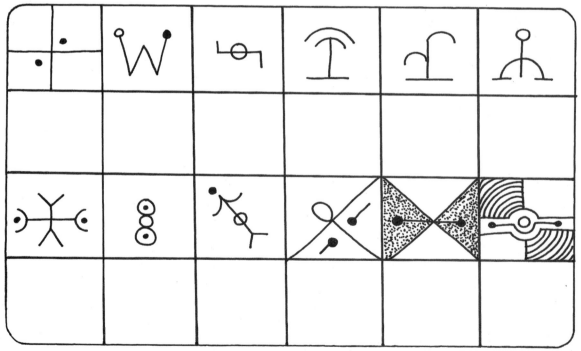

FIG. P.6 *Level 2 exercise.*

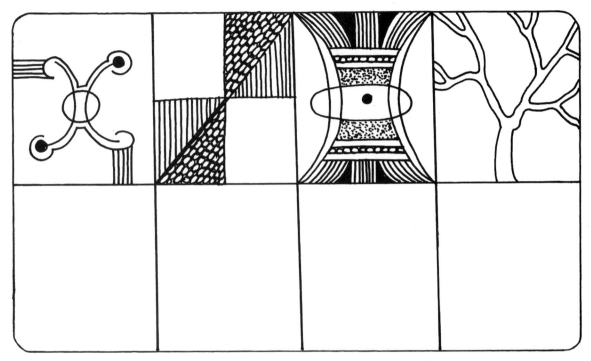

FIG. P.7 *Level 3 exercise.*

more advanced suggestions. It is also possible for a person to regress and have difficulty for a brief period before regaining confidence and continued growth. Don't be concerned; it's a normal phenomenon. Be flexible and open to changes in either direction. Of course you should add to the suggestions in the book whenever you have an inspiration of your own. You and the children are the best judges of how to interpret and embellish the ideas and lessons in a comfortable format for yourselves.

General Guidelines for Different Age Groups

It is very important for you to understand the differences between the two major types of drawing that I discussed briefly on page 15 in the Before You Draw section. Symbolic drawing and representational drawing are engaged in for totally different reasons, with completely different results and benefits. Unless you recognize these differences you may be tempted to

compare the results and interrupt the normal early childhood developmental stages that are necessary to all children. The information in this book pertains only to the development of realistic drawing skills. This process can begin as early as four years old and as late as old age. Symbolic drawing, on the other hand, is a natural experience that all children engage in from around two years old until about nine or ten, when they stop as naturally as they started. I have watched thousands of children enjoy the benefits of both these types of drawing at the same time. However, when an adult does not understand the differences, I have seen him confuse children and cause disruption in their development. Here, again, is an explanation of the differences between symbolic and realistic drawing, and how you can include both in a child's experience.

Symbolic Drawing

Some call this "stick-figure drawing" or "abstract" drawing. It is a natural phenomenon that children engage in all over the world. Symbols are used to represent objects or feelings, and it is not appropriate to interfere with the child's freedom to use any type of line or color to express himself. Since most children stop this type of drawing by eight or nine years old, it is not related to being able eventually to create realistic drawings. If it were related, we would not have ended up with only one percent of the population being able to draw realistically on their own. Symbolic drawing is about communication, expressing the self, and language development. If it is unfavorably compared with realistic drawing, it can cause the child to prematurely stop this important activity. When children draw symbolically they are having internal conversations with themselves about what they are drawing and thus forming communication and language patterns. This activity helps them communicate and deal with words and symbols. Children must be allowed to draw this way on their own, with no commentary or interpretation of the images they create. Monart students who have been given years of representational drawing lessons have no confusion over the two kinds of drawing. They engage in symbolic drawing whenever they are given free time, and give it up at the same age as their peers. They don't feel they are reverting to less mature drawing unless an adult implies they are.

Representational Drawing

Only the rare child learns how to draw representationally or realistically on his own. It is just like learning to play piano, learning ballet, or learning to write stories. Children need information about the subject and guided instruction in how to master the basics before they can become creatively independent. Unless they are given this information and guidance, before they stop symbolic drawing they will assume they weren't born with the ability to draw realistically. The closer they get to preteen years, the more they will resist the activity and not want to try at all. If they are given guidance in realistic drawing from the time they are very young, they will quickly graduate to sophisticated and skilled drawings right after giving up their symbolic drawing styles. Most will continue to draw on and off for the rest of their lives and apply their skills to other artistic endeavors.

As you study the following guidelines for different age levels, keep in mind that I am only talking about *representational drawing* skills. I am not contradicting the developmental stages described by such art educators as Victor Lowenfeld. These educators describe the developmental stages of *symbolic drawing* skills. There is no controversy between us, since we are discussing two entirely different subjects. It is important to remember that children can do both symbolic and realistic drawings without either activity interrupting the benefits of the other.

Although age doesn't determine your starting level, certain general developmental guidelines for each age group will help you keep the lessons challenging without tedium or frustration. If you are working with children at home, do these exercises and determine starting levels individually. When you begin the lessons, you will need to group children into the appropriate starting levels and work with them at different times. Not only can older children be hard on their younger siblings, they can also be frustrated and underchallenged if grouped together with younger children. If you are working with groups of children in a school setting, pick the average starting level for the group. Most who fall a little behind will quickly catch up or will hang in there. As you get into the lessons you can always give extra challenges to the ones who are more advanced.

The newborn to three-year-old. As soon as babies can see and hear they begin to put information together. As they hear such words as "mama," "daddy," and "milk" they visually and kinesthetically connect the word to the object. Object recognition leads to verbally saying the word in connection to the object. It is my opinion that infants who are given visual information are the children who end up being visually gifted. Once I realized that genes were not the reason children couldn't draw, I began to see that visual training and recognition was the key. It can start on day one. As you talk to babies you can show them things and talk about visual information the same way you get them to recognize material objects. For example, you can run their finger along straight edges and talk about straight lines, put their hand through a circle and talk about circles, point out how objects get duller in color as they get farther away, note the way light makes shadows on the underside of objects. Infants can recognize the five elements of shape long before they are ready to pick up a drawing tool. Babies can grow up appreciating the visual world as a natural phenomenon and have what I call a *drawing readiness*. This drawing readiness can make an enormous difference in their overall visual perception and ability to handle any visual subject.

By the time the infant is a toddler, her motor coordination is rarely sophisticated enough for representational drawing, so encourage scribbling and playing with drawing equipment. But don't forget she is *fully capable of visually understanding and recognizing the elements of shape.* It is not too early to go ahead and complete the lessons in the book yourself and let the baby watch you, sharing all the information with the child in your daily routine. You can demonstrate the five elements of shape by showing a toddler where they appear in objects. You can let him help you choose things to draw and show him the way you draw them.

The three-year-old. Begin discussing visual concepts with a three-year-old. You can make a game out of recognizing, touching, and naming the five elements of shape that compose a particular object. You can usually have the child duplicate these five elements in a crude way on paper, along with encouraging and supporting exploration and scribbling. Some three-year-olds may have the motor coordination to combine the five elements into simple drawings of objects, but they should not be pushed to do so when their attention span or in-

terest is not up to it. A few three-year-olds may be ready to begin the lessons with Level 1 instructions, but they should be watched for tiredness and allowed to occasionally stretch and rest.

The four-year-old. Most four-year-olds are ready to begin the lessons with Level 1 instructions. Be on the lookout for tiredness and allow for necessary breaks. Four-year-olds need constant repetition of new information, so don't be alarmed if they completely forget everything from one week to the next. If the four-year-old is not quite ready yet, give her a couple of months and try again, continuing to do the visual recognition work that is suggested for the younger child.

The five-year-old. Five-year-olds may belong either with the four-year-olds or six- to eight-year-olds in terms of performance level. Remember, this has nothing to do with intelligence or eventual performance but may be directly related to interest and ability to focus. It is very important that they participate according to interest and performance level rather than particular chronological age. They are apt to leap in ability overnight once they understand the basic concepts.

The six- to eight-year-old. The child in this age range can hold information longer but still needs constant reminding to stay visually focused. Most are ready to start at Level 2 instructions. They may shift between two levels on any particular day, depending on energy level and ability to focus. A few seven- and eight-year-olds may be ready to take on the challenges of the Level 3 instructions, so give it a try every once in a while to keep the way open and flexible.

The eight- to thirteen-year-old. At this age the self-conscious child begins to compare her artwork with that of the adult illustrations gracing her toys, books, and clothing. Even children who have been having success with their drawings can suddenly become dissatisfied, regress to less capable levels, and want to quit. This directly coincides with the fact that they are letting go of their stick-figure drawing styles and are more interested in realism. Some children suddenly want to achieve what would be labeled photorealism and desire perfection. Don't be concerned about starting level in this case. Encourage the child to start at any appropriate level and explain how it is very common for children to experience an overconcern for perfection around this age. Assure them that children's artwork has a different look to it than adults' and

that they wouldn't want to rush the process. In most cases, progress is very rapid after you simply bring the fears and dissatisfactions out in the open.

These starting levels are devised only to give you a general guideline to the lesson plans. There is nothing that says you can't try an idea from any level that you wish, change it to suit a particular effect you want to create, or make up similar ones that work for you. Be patient with what unfolds, don't put any emphasis on comparison of levels, and keep encouraging yourself and your children to simply enjoy the learning process you are experiencing together. Don't let a few discouraging results stop you from shifting your start level, regrouping, and trying again. I have watched many students continue in the face of doubts and can assure you that they were more than grateful for the encouragement to keep at it.

Dotti Stitz-Russell and her daughter, Michelle, are a dramatic case in point. Michelle started lessons at age four and happily produced wonderful drawings, like the still life in Fig. P.8, week after week. Around age eight she began to compare herself with a friend who had been in the same classes. Michelle said she thought her friend drew much better than she did and that she couldn't draw anymore. She felt very insecure. We all encouraged Michelle to continue and explained how her doubts were very common at her age. We assured her that her fears were unfounded, but she faltered and had difficulty. For two or three months she continued in spite of the insecurity and discomfort. Then she began to turn the corner. She became more secure and independent than she had ever been, producing marvelously sophisticated drawings that she loved. A year later, at age nine, she was disappointed but proud when the publishers of the first book felt a still life drawing of hers was too adult looking to be accepted for the cover of a book on children's drawing. Michelle proudly began teaching other children at her school how to "see" using the alphabet of shapes, and how to use the elements of shape to draw. At the rewriting of this book, Michelle is now nineteen and is considered artistically gifted. She has entered college and will pursue art as her career. The exotic portrait in Fig. P.9 is an example of her recent work.

Dotti has just as remarkable a success story as her daughter. In the beginning, she sat on the couch of the studio and watched her daughter's lessons. She was one of the first adults

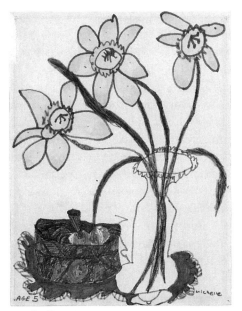

Michelle Stitz—age 5
FIG. P.8 *Michelle had motor coordination and attention problems. Her teachers noticed a strong improvement with the art lessons.*

Michelle Stitz—age 19
FIG. P.9 *Now a serious art major in college, she remembers how insecure she felt at first.*

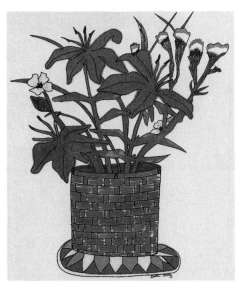

Dotti Stitz-Russell—adult beginner
FIG. P.10 *After watching her daughter, Michelle, take lessons for two years, Dotti opted to try. She was a total nondrawer.*

Dotti Stitz-Russell—art teacher
FIG. P.11 *Twelve years later Dotti owns a Monart School and teaches hundreds to draw, along with getting a degree in early childhood development and running a nursery school.*

who decided to try the method herself. She was not sure if she could draw at all and spent several weeks denigrating her work and worrying about her results. The still life in Fig. P.10 was one of her first attempts. Then she began to see encouraging changes. Two years of involvement later, she sheepishly asked me if I thought she could ever be a Monart teacher, quickly adding that I could laugh it off if I thought it was too ridiculous to consider. It is one of my greatest satisfactions that Dotti not only ended up being an excellent art teacher but went on to own a Monart School of her own, returned to school and received a degree in early childhood education, opened a nursery school in conjunction with her art school, and is affecting the lives of the many children with whom she works. The wonderful still life in Fig. P.11 is a recent piece that Dotti did from kiwi fruit.

When you begin to have doubts, about your own artwork or that of your child or student, remember that there are many stories like Dotti's and Michelle's. Stick with it, and you will be more than pleased. When children appear doubtful or feel insecure, be there for them with the needed encouragement. It is that easy to stop our competitive and stifling behavior patterns and encourage the dormant talents that are innate in us all.

Lessons

Learning the Basics

The steps in this lesson will help develop your drawing ability and enrich your visual perception of the world. Former workshop participants write most often about how radically they felt a shift in the perception of their environment, how much more aware they became of their detailed surroundings and the vastness and beauty of nature. In this lesson you will also learn some relaxation techniques to heighten your awareness, you will do some preliminary scribbling to get used to the equipment, familiarize yourself with the five basic elements of shape and see them in your environment, and learn how to invent warm-up exercises. As you see how everything you want to draw is continually made up of the same five elements, it will change your ability to observe visual data and demystify the drawing process. Then, poof! Before you know it, you and the children will be drawing recognizable objects as you put those elements together in specific combinations.

Conducive Relaxation

Before you even put pen to paper, it is important to release the tensions of the day and relax mind, body, and eyes. This will aid you and the children in reaching a state conducive to concentration and visual focus. In order to gain the cooperation of your children, explain that it is common for physical and emotional tensions to be held in the neck and jaw, the eyes, the

shoulders, and the lower back, and that the suggested exercises are designed to relax these areas. The five to ten minutes it takes is more than worth the effort and directly shows in children's ability to focus and achieve satisfaction with their drawing session. One day, after about twenty minutes of failing to get across a particular point, I decided I must have planned a confusing or disorganized lesson. Then I decided to stop and do some of the following relaxation exercises, just in case. When I continued with the same instructions, it was as if there had never been a problem. Try these exercises by yourself first, before discussing them and doing them with your children.

MIND AND BODY RELAXATION

1. Sit at the drawing table, flat in the seat, with uncrossed legs. If a child is small, be sure you have a booster seat or something to prop him up to a height where his elbows rest comfortably on the tabletop. Pull up from the crown of your head to straighten the *spine,* and relax your whole *back* and *shoulders.*

2. Relax the tension in your *face,* especially the *jaw.* Let your jaw drop open and hang slackly. Then check out your *neck* and wiggle the tension out of it by rotating your head from side to side and up and down.

3. Take a big breath and let your *shoulders* drop as you exhale. Keep pulling up from the head with a straight spine as you drop your shoulders, and don't let yourself slouch. Do this at least two or three times.

4. Relax the *throat* and *chest* area by taking completely silent, long deep breaths. Breathe through the nose and out the mouth. Repeat this two or three times.

5. Make sure your *legs* are uncrossed. Plant your feet firmly on the floor, reshuffling your bottom in the chair to help your *lower back* area hold your weight in a balanced and relaxed position.

6. Check out your *whole body* and see if you are holding tension anywhere else. Release it. Check one more time. Release it all.

EYE RELAXATION

The following exercise, which is called palming, was devised by William Bates, author of *Better Eyesight Without Glasses,* and can be used before any physical or mental activity in which you want to perform more adequately. It seems to relax all the sensory nerves, including sight, and rids you of mental and physical strain. The eyes can see better for longer periods of time and can maintain a more relaxed state. Look at the photograph of a child palming in Fig. 1.1 and then follow these steps:

1. Take off any glasses or obstructions around the eyes.

2. Check out your body posture and relax as described above, with a straight spine and neck. If you need to bend forward, do so with the whole upper torso, rather than the neck. Dropping your head forward at the neck tends to rigidify your body.

3. Rest your elbows on the desk or tabletop surface in front of you. If this is not possible, rest your elbows near the waist area.

4. Rub your hands together until they are warm.

5. Close your eyes. Cup the palms of your hands and place one over each eye, heel of palm on cheekbone, fingers crossed over the forehead. Make sure that you are not pressing on the eyeballs directly.

6. Think of the area behind your eyeballs. Imagine a black dot on the backside of each one. Relax those dots . . . more . . . and more. Take a few completely silent breaths. Go back to the spots behind your eyeballs. Relax them more . . . more . . . and even more.

7. Open your eyes slowly and try to maintain this relaxed state the entire time you draw. You can repeat this exercise for a minute or two at any time during the drawing session, if you become frustrated or tired.

FIG. 1.1 *Palming is a way to relax the eyes, and help them see better for longer periods of time.*

Experimenting with Your Supplies

Becoming familiar with your tools and equipment is essential. An enjoyable way to do this is to randomly play with the basics of drawn lines and marks. In other words, make the first drawing experiences scribbling and doodling. But remember: A child who works diligently on a scribble can be shocked and hurt if it is treated with disrespect by older children or thrown out before its time. In fact, when I pretend I'm going to throw the scribbles away in the adult workshops, I consistently see adult faces dissolve into childlike replicas of pouting or angry expressions. As you do the following exercise with children, try to appreciate the beauty of scribbling and the deep involvement the child feels as she experiences the flow of the lines and the color patterns. The following suggestions will also help.

1. Remember to use a heavy cardboard mat under the drawing to protect the tabletop from the bleeding of the marker ink. Have at least 20 sheets of 8½" × 11" scratch paper at hand.

2. Place all your markers near the drawing, so that you can test them for their different characteristics and abilities to blend with each other.

3. Choose any marker. Put the cap on its end or lay it down on the table, so that your other hand is free to hold the paper. This may seem picky, but insecure drawers often don't take charge of their paper; they tend to slump in their seat and hold their head in their hand, not noticing how the paper is slipping around and causing inaccuracies and more insecurity. It becomes a self-fulfilling prophesy for them to look at the shaky drawing and see proof that, just as they've known all along, they "can't draw."

4. Make an agreement with yourself not to create any specific shapes on the paper but to randomly make scribbling lines flow around the surface.

5. Use each one of the different types of markers you purchased and notice the way each performs. Notice the thickness and quality of lines that result from the different ways

you use the points. Let the marker sit still and see how much it soaks into the paper.

6. Try overlaying colors onto each other and investigate which types you can blend and mix and which types smear and streak.

7. Notice that it is easier to make a mark down than up, since the pen point tends to stick into the paper when you push it upward.

8. Take charge of your paper and explore how you can turn it at different angles to control the direction and quality of the lines.

9. Use as much paper as you need to fully explore all these suggestions.

When you are done, take a look at all the patterns and colors, and make a note of which effects you like. Place these drawings under your mat and check to see that you have re-capped all the markers adequately. You're now ready for the basics.

Recognizing the Five Elements of Contour Shape

We will now examine how to isolate and observe the five basic elements of shape. The contour edges of the objects you wish to draw and the spaces between them are represented by continual patterns of these same five elements. The elements give you the information you need to re-create any shape, whether simple or complex, on a piece of paper. After you become confident with drawing contour edges, you will learn how to fill in with volume and shading. Students report that seeing the edges of everything in terms of these five elements of shape is the main thing that got them to relax and feel confident.

Now that you have your body relaxed, your senses activated, and you are familiar with the tools of the trade, you are ready to tell your mind what to look for with your eyes. If you were unable to obtain a photocopy of the five basic elements

THE 5 BASIC ELEMENTS OF SHAPE

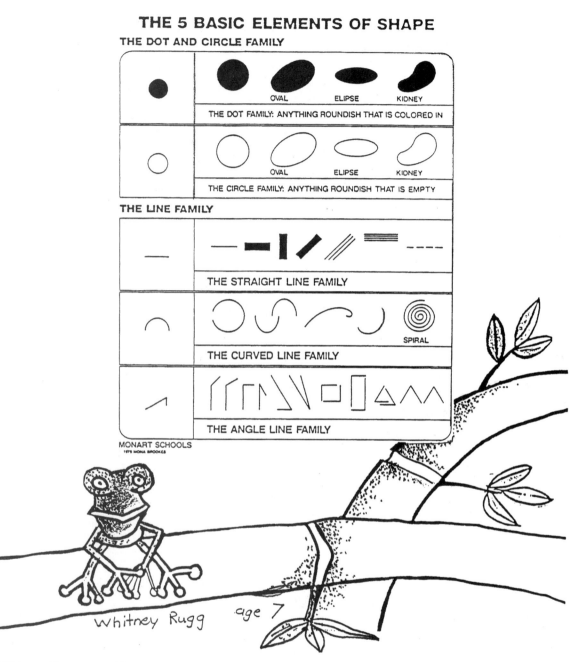

THE DOT AND CIRCLE FAMILY

OVAL ELIPSE KIDNEY

THE DOT FAMILY: ANYTHING ROUNDISH THAT IS COLORED IN

OVAL ELIPSE KIDNEY

THE CIRCLE FAMILY: ANYTHING ROUNDISH THAT IS EMPTY

THE LINE FAMILY

THE STRAIGHT LINE FAMILY

SPIRAL

THE CURVED LINE FAMILY

THE ANGLE LINE FAMILY

MONART SCHOOLS
1979 MONA BROOKES

whitney Rugg age 7

Whitney Rugg—age 7
FIG. 1.2 *The contour edges of the objects you wish to draw and the spaces between them are represented by continual patterns of these same five elements.*

chart in Fig. 1.2, I recommend that you fashion a handmade version to put up in your drawing space.

As you familiarize yourself with these elements, use all your senses to explore and recognize them in your environment. Research in movement therapy reveals that information and memories are stored in the body cells, and educators are claiming that learning is accelerated if you can tap into the body experience as well as the intellect. After you talk about a visual element, get up, move around your environment, and begin to explore finding and touching that element in your visual field.

Keep in mind that there is actually more than one "right" answer in the world of vision. The same object looked at from different positions or distances has a different appearance. For example, the hole in a pencil sharpener is a circle to the student who is a foot away and a dot to the student who is twelve feet away. With small children, make sure you are discussing the same object by actually handling it. For example, after discussing and looking at the dots on the chart, you might go to a doorknob and feel it in the palm of your hand, pluck a grape from a bowl of fruit and feel it in your mouth, or throw a ball back and forth. Later on, when you are drawing an object that is giving you difficulty, remember to get close to it and pick it up and feel it in order to better understand its shape.

You can also make up games of moving through space in patterns that represent the elements. Get the children to do such things as pretend they are straight lines while walking in curved patterns on the floor, or make angles out of their arms and legs while hopping in dot patterns around the room.

STUDYING THE ELEMENTS

Most people who try to teach this material make the mistake of talking about "the five basic shapes." This is very confusing! For example, a straight line or a curve line are not shapes. Make sure you realize you are talking about "the five basic *elements*" that can create shape. There is no set number of basic shapes that will make it possible to draw the endless detail in the world.

The next section will give you the description of the five elements and how to recognize them in the environment.

1. THE DOT AND CIRCLE FAMILY

The Dot: Anything roundish and colored in.

The difference between the dot and the circle is that the dot is colored or filled in and the circle is empty. Notice that the dot family includes anything that is round and has no straight or pointed edges. It can be perfectly round or very wobbly as long as it is filled in with texture or color.

Most of us think of a dot as small, and it limits our imagination. Open up your mind to dots of any size, and go point out at least three that you can see. Explore them.

Close your eyes and build your inner vision by seeing images of very small dots all the way up to huge ones, such as a speck of pepper, a tack, a hubcap on a tire, a weather balloon, the planet Earth from outer space.

The Circle: Anything roundish and not colored in.

The circle has the same variety of shape and size as the dot but is empty of texture or color. Notice that the rim does not have to be thin, and the shape can wobble around as long as there are no pointed edges. Go around again and find at least three circles to explore. Be careful that you see the entire circle; don't talk about something that you intellectually know is a circle but is not wholly visible. For example, when there are flowers coming out of a vase, you can't really see the whole circle at the top of the vase, or when you slip a circular ringed bracelet over your wrist you are left with seeing only a curved portion of it. Your drawing ability is blocked when you try to draw from what you think instead of what you see.

Stimulate your inner vision again and try to imagine as many different circle shapes as you can in a variety of sizes, such as a necklace clasp, the rim of a glass, a Hula Hoop, the track around a football field, the white-light ring around the moon.

2. THE LINE FAMILY

The Straight Line: A line with no bend.

Most people think a straight line can only be thin. As you look at the chart together, point out the straight lines that are

fat and see them as straight lines rather than as small rectangles. You can observe a door or the ceiling of a long room as a fat straight line when considered in this way.

When you observe and explore straight lines in the environment, they are usually attached to things and have to be isolated in order to be recognized, such as a line going from the ceiling to the floor in the corner of the room, one side of a picture frame, or one particular branch in a tree. If you are inside a man-made structure, there should be about you an endless variety of straight lines.

When you make up straight-lined images in your inner vision, remember to vary the size and length: a cat's whisker, a ruler, a stairway handrail, a crosswalk line, the silhouette of an eighty-story office building, a six-lane freeway out in the desert.

The Curve Line: A line with any degree of bending.

The minute a straight line begins to bend, it becomes a member of the curved line family. Of course the ways in which a line can bend are infinite as long as it does not close together and make a circle. Since curves have a tendency to be strung together in many different directions, it becomes important to isolate them in order to see them individually. For example, the letter *S* is really two curves joined together.

One of the biggest challenges in drawing is when there is a series of curves all strung together that change direction. You might think it would be easy for beginners to draw subjects like Mickey Mouse or Donald Duck, for example, because of their childlike quality. But if you observe Donald Duck's bill closely, it's a perfect example of curves that weave in and out of each other, and it requires an extra amount of focus to duplicate. Children are really frustrated when they can't get recognizable characters to "look right," so beware of subjects that entail multiple curves in the beginning lessons. As you look for curves in your environment, observe the body parts of human beings around you. It will help you get ready to draw people.

Close your eyes again and conjure up as many images as you can of the different sizes and widths of curves, keeping in mind the need to isolate one at a time, such as an eyebrow, the handle of a cup, a tree limb, the side of a blimp, a rainbow.

THE ANGLE LINE: A LINE THAT BENDS SO MUCH IT COMES TO A POINT.

The angle line can be thought of as two straight lines joining at some point, but since it is most often drawn with the motion of one stroke, it needs to be thought of as one line that bends to the degree of forming a point. An angle can be very thin and narrow or very wide and open. Notice how you can create triangles and rectangles and squares when you join more than one angle line together. You will need to isolate angles from what they are attached to in the environment, the same way you did with straight lines.

As you imagine them in your inner vision, you might refer back and forth to the chart to stimulate the variety of degrees and sizes possible, such as in the corner of a staple, the bend in a spider's leg, a forked twig, the corner of a room, the top corner of a skyscraper, or a laser beam reflecting off something.

PLAYING VISUAL GAMES

An infinite variety of games and exercises can be devised to locate the five basic elements in the environment. You don't have to wait for drawing time to engage in visual games; you can do them whenever you have a few free moments. Following are some suggested games and eye warm-ups to consider along with the ones you invent.

Find One. Call out one of the five elements of shape and have the child find an example of it.

Which One Is It? Point to one of the five elements of shape and have the child define it.

What's It Made Of? Pick an object and together try to define every element that is represented in its makeup.

What Is It? Describe an object verbally, telling how the five elements construct its shape. Have the child guess what the object is. Take turns coming up with the object. Here are some examples:

• A round dot of wood about two feet across, with four straight pieces of wood placed equally around the dot and extended downward about three feet to the floor. Two slats

of straight wood extend upward from the round dot, which has a curved slat of wood across the back. (a chair)

- An open circular tube of plastic about four inches tall, which is sealed closed at one end by a thick dot of plastic. (a glass)

- A 4½-inch round dot-shaped disc with a circular small hole in the middle; with names of musicians and songs on the surface of the dot. (a CD)

Warm-ups

Before you get into drawing representational objects, play with drawing the five elements in both random and structured warm-ups. You can create a balance between structured and free styles of drawing, since there are endless ways to do warm-ups and exercises. The following suggestions will help you create warm-ups and use visual awareness games for the young child. Remember that you want to be able to spontaneously use some kind of similar warm-up before each drawing session.

THE RANDOM WARM-UP

Freehand abstract designs are one of the best ways to become familiar with the elements of shape, since there is no way one can make a so-called mistake. Simply draw the five elements all over the paper with this random-type format.

Look at the chart; on a piece of scratch paper, make at least one of each of the five elements. Here are a couple of things you might watch for as you begin to draw them:

Coloring in the dot. As you draw your first dots, it is a perfect time to teach some basics about coloring in. Use the broad-tipped markers for any shape that is bigger than the head of a tack, since the fine-tips are too streaky and time-consuming. The main point to get across is to *go around the edges first, slowly; then go faster in the middle.* You will save time and prevent streaking if you follow this practice, especially when coloring in large backgrounds.

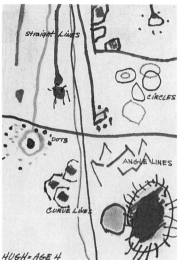

Hugh—age 4

FIG. 1.3 *Random placement of the five elements gives freedom while learning takes place.*

Ryan Port—age 6

FIG. 1.4 DUPLICATION WARM-UP *Devise warm-ups for children to duplicate images. It will help them develop motor coordination and become more visually aware.*

The angle line. If a child is trying to draw an angle and keeps ending up with a rounded bend instead of a point, it's because he doesn't have the fine motor coordination yet to draw the angle with one stroke. In this case you can tell the child to *make a straight line, pick up the marker, put it down on the point, and go in the other direction.*

After you draw one of each of the five elements, place variations of them all over your paper in a similar way to the example in Fig. 1.3, done by a four-year-old child. Try not to make any recognizable objects this time.

THE DUPLICATION WARM-UP

These warm-ups take the same format you used in choosing a starting level. Make yourself a master copy of blank squares, so that you can photocopy a good supply of blanks for the future. Then use your imagination and devise challenging warm-up exercises to fit your children's abilities, using combinations of the five elements in the same manner as shown in Fig. 1.4, done by a four-year-old. Although the child will be copying the image in the blank square next to your sample, remind her that exact duplication is not necessary. As long as the same kind of elements are in the same general pattern, the child will be learning enough structure to duplicate recognizable images. This is the first opportunity you have to make everyone feel okay about the copying that is necessary for learning to draw. It is important to explain that in other areas of study it may not be acceptable to copy, but that in the subject of drawing one must learn how to copy in order to learn how to duplicate shape.

MATCHING WARM-UP

Look at Fig. 1.5 in which the child circled the image in each row that matched that of the sample. Again, make a master of blank squares, with a heavy black line separating the sample from the four choices, and photocopy a good supply. Then make up similar warm-ups to challenge your children's level of performance.

This exercise emphasizes a completely different learning process, in which there is differentiating between visual images

in order to pick the ones that are the same. This is another way to help children be more visually alert to combinations of elements. Elementary-school teachers report that this warm-up also helps children with their math, since it deals with the counting of elements. Even if children don't know language or word concepts for numbers, they are visually comparing and analyzing numbers of digits and components. They seem to grasp a visual way of relating to numbers and sequence.

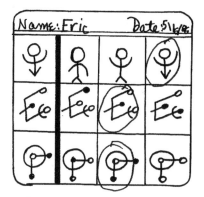

Eric Otani—age 5
FIG. 1.5 MATCHING WARM-UP *Make warm-ups to help children differentiate between visual images.*

MIRROR IMAGING WARM-UP

One of the things that confuses people in the drawing process is drawing the opposite side of an object. This happens in still life with vases or bottles and in figure drawing when you attempt to draw both sides of the body. Being able to duplicate the symmetry in objects accurately is one of the skills that those who draw are particular about. Drawing two sides of an object that look the same but are in reverse is a challenge that takes some practice. The following warm-up in Fig. 1.6 was designed to provide such practice. This type of exercise is found in Betty Edwards's *Drawing on the Right Side of the Brain*, along with other very helpful suggestions on how to retrain your seeing.

I find that some people need guided suggestions in order to be able to relate to this exercise. It really helps when you can break the sample down and recognize the five elements as they are represented one after another, from the top down to the bottom. As you do so, note if you should draw the element toward or away from the central dotted line in order to create the reversed direction.

Look at the first sample in Fig 1.6 on this page, which is already completed, and imagine a thinking process that goes something like this: *First, I'll make a straight line down and stop across from the straight line on the other side; next, I'll make an angle corner and then a straight line lying down and going toward the dotted midline; then I'll stop halfway toward the midline and make another angle corner; then I'll make a straight line going down to about the center of the whole image. Next, I'll make a backward C-shaped curve going away from the midline and out as far as the angle corner above it; then I'll make another backward C-shaped curve going away from the midline that is half the size of the one*

above it; and then I'll make a curve line that gradually slopes out and down, away from the midline, and ends up on the tip of the baseline.

With some such thinking process to understand what he's doing, the person who is struggling will suddenly get the idea and be able to solve the puzzle. Whenever you need extra focus, remember to take it slowly and to concentrate.

Now complete the remainder of the samples. Note that some will make faces looking toward each other. Make up your own face in the last sample that is blank, and then reverse it.

When you want to construct mirror image warm-ups for children under eight or nine years old, make them very simple, with only one or two combinations of elements.

THE ABSTRACT DESIGN WARM-UP

This warm-up game is one of the most fun to play. Everyone loves to doodle and make up abstract designs, but now that you have a repertoire of all the elements of shape, you can create with a different kind of confidence. Here are some suggestions on different ways to make up design warm-ups by your chosen starting level. This time, certain suggested techniques will enable you to make a cohesive design that can be colored in, as opposed to the elements floating around on the paper in random fashion. Notice how this is done by giving instructions that require the elements to connect with each other and extend to the borders of the paper. As usual, use your imagination to create some new experiences.

Level 1

Make the instructions very simple at first. Remember, there is nothing wrong with copying, and you might have a child simply copy your demonstrated design at first. It is also a good idea to keep the paper small—8" × 8" or even 6" × 6"—to match the length of attention span for very young beginners. After they get used to the idea, you can make up verbal instructions and let them place the elements that are required into their own individual compositions, while you follow the same instructions. At this stage, wait to draw your version

FIG. 1.6 *Mirror imaging exercise.*

until they have committed themselves, in order to encourage individuality.

If the child does not follow instructions and does something different than you ask, there is no reason to start over or feel anything is wrong. Have the child notice the differences between what she drew and what your instructions were without requiring any change. You can comment on how her design is fine the way it is, but in the future when she is drawing recognizable objects it will make a difference if she continues to choose not to follow instructions. She may, for example, end up with a bunny rabbit that has three eyes instead of two.

Look at the two different Level 1 compositions in Fig. 1.7, created from the following instructions. Then follow the instructions yourself and see what you come up with.

- Turn your paper in any direction you want.

- Choose a fine-tipped colored marker and make three straight lines anywhere you want on the paper, but start the line on the edge of the paper and run it off another edge of the paper when you are done. It doesn't matter if the lines cross over each other; just be sure they start on an edge and stop on an edge.

- Choose a broad-tipped marker and make three dots anywhere you want on the paper. Remember when you color your dot in to go around the edges first, and then you can go fast in the middle.

- Choose another broad-tipped marker and put it on one of your dots; then make a curved line or a sequence of curves go in any direction you want, so long as it goes off the edge of the paper when you are done.

- Choose a fine-tipped marker and make one circle anywhere you want in your drawing so that it touches another mark somewhere.

- Now color in your design however you want. Use flat color, which is one color filling in the space evenly, or use textured color, which is using more than one color or making patterns with colors.

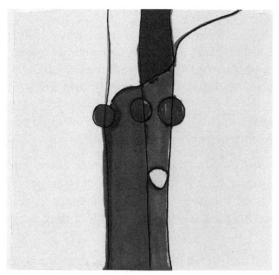

Sabrina Weisman—age 4

Benjamin Marcus—age 4

FIG. 1.7 *Two interpretations of Level 1 design warm-up, the beginnings of providing the general structure that will allow for creative interpretation.*

Christina Chang—age 6

Brian Kang—age 9

FIG. 1.8 *Two interpretations of Level 2 design warm-up. Using more complex forms.*

Level 2

Instructions for this can follow the same format as in Level 1, but with more complex ideas and a bigger piece of paper. The two student examples in Fig. 1.8 resulted from the following instructions; use the same instructions to come up with your own version.

• Turn your paper in any direction.

• Take two fine-tipped colored markers and use them any way you want to draw four straight lines on your paper, starting on the edge of the paper and running them off the edge when they are finished. It doesn't matter if they cross over each other.

• Take a broad-tipped marker and create three dots on your paper, all different varieties and sizes.

• Take a fine-tipped marker and make a circle that touches one of your dots in some way.

• Take another fine-tipped marker and make two angles on your paper anywhere you want, starting on an edge and finishing on an edge the way you did your straight lines.

• Take a broad-tipped marker and make a curved line that starts at one of your dots and goes off the paper. Then start in the same place as you did before and make another curved line that goes off the paper somewhere else.

• Now color in your design any way you wish, but leave at least three of the blank spaces the color of the paper.

As you make up these types of warm-ups, do not feel you must always use every element. For example, make some of the instructions out of curved lines and angles only, or just dots and curves, or just circles and dots. Solicit the child's ideas and have her make up the instructions sometimes. This project can be a short warm-up for 10 or 15 minutes on a small piece of paper, or a comprehensive undertaking of an hour or two on a larger piece of good drawing paper.

Level 3

Use all the same ideas as given in the examples for Levels 1 and 2, but strive for far more complexity. Attempt a more finished look, and use a larger piece of drawing paper with a border. One of the ways you can make it more challenging is to give each other verbal cues only and incorporate multiple concepts in an instruction.

Look at the two examples of the same Level 3 instructions in Fig. 1.9, and then follow the sample instructions yourself to see what happens.

- Using any variety of markers, draw a straight line that travels from one edge of the border to another with three circles of various sizes superimposed along it.

- Incorporate a group of five dots within one of the circles, and then repeat another group of five dots somewhere else in your design.

- Take five colors of fine-tipped markers and use them all to draw two angles anywhere in the design, so long as they start and stop on the edges of the border.

Lilia Fulton—age 11
Junko Nakamura—age 10

FIG. 1.9 *Two interpretations of Level 3 design warm-up, using instructions with multiple concepts and incorporating blending of colors and textures.*

Celene Temkin—age 5
FIG. 1.10 *Doing line designs on top of torn paper collage.*

- Use any broad-tipped colors you want to make straight-lined striped patterns in the negative spaces that are left in the design, but leave at least two of the spaces blank.

- Pick one of the striped areas and make straight lines going in a different direction with the same five markers you used to create the angles.

- Pick a light-colored broad-tipped marker and fill three of the areas in your design in with flat, plain color. Since it is a light color, you can go right over any stripes.

The variations on this kind of warm-up are endless, including making any kind of random design you want out of combining the five elements. Use your imagination to invent something different. For example, you could, as in Fig. 1.10, even take a separate piece of paper that is smaller than your drawing paper and cut it all up with scissors or tear it into shapes. Then you could color the pieces independently, paste them into the design space, and then add lines and element shapes on top of a collage.

These warm-up exercises show you that two people can use the same instructions and end up with a variety of results. Learn to encourage and appreciate the differences between one piece of art and another. The assumption that one must draw something exactly as it appears can be a major block to students feeling they are able to draw at all. The same is true of the exercises and lessons in this book; they are merely a guide to get you started. Once you get the idea of how to structure an exercise or a project, change it around any way that suits you. Then you can sit back and learn to appreciate the different results. Give yourself enough freedom to appreciate the fact that in drawing you may set out for one result and actually end up with an entirely different one. If you are too fixed on one idea, you can completely squelch the playfulness and the spontaneity of your intuitive mind.

Wow! I Can Draw!

It is only one minor step further to drawing recognizable objects. If you take the elements and arrange the instructions into certain patterns, you will find yourself drawing an object with the same ease that you duplicated abstract design shapes in the duplication warm-up shown in Fig. 1.4. In other words, it is no harder to draw a bird than an abstract group of the same elements. It simply takes a different kind of focus to assure that you put all the parts in an order that will represent the bird in a recognizable way. Let's experience how easy it is.

Complete the exercise shown in Fig. 1.11 the same way you did the Level 1, 2, 3 exercises—by simply copying the images next to the sample. As you draw the images, pay attention to which of the five elements you are using. Notice that the process is no different than that used in the level exercises; the images just make recognizable objects instead of abstract configurations.

Now look at the two examples of the bird drawings in Fig. 1.12, which were made from the same set of instructions; then follow the coming instructions yourself and watch your own bird unfold on the paper. When you draw this bird with young children, you will need to demonstrate the shapes on a piece of paper as you talk about them. The dotted line in the example on pages 77–78 is only to indicate the current part you are to

**FIG. 1.11 WOW! I CAN
DRAW EXERCISE** *If you
take the five elements and
arrange them in a particular
order you will find yourself
drawing a recognizable object
instead of an abstract design.*

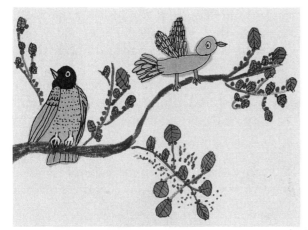

Michelle Walker—age 7

FIG. 1.12 *Two different versions of the same instructions. Follow them and watch your own version unfold.*

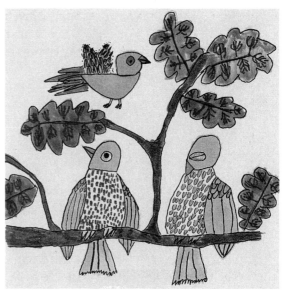

Ali Herred—age 6

draw. You will draw in regular solid lines. As you go to the next instruction, the prior dotted line will convert to a solid one.

Use a black small-tipped marker to draw the entire bird; then you can color it in any way you want when you are finished.

1. *The eye.* Make a *dot* for the center of the eye, anywhere you want on your paper, leaving room for the body, tail, and legs. Draw a *circle* around the eye to make the outside rim.

2. *The beak.* Make a small *angle line* in front of the eye, leaving a space between the eye and the beak, with the point of the angle going toward the eye. Draw a *straight line* for the middle of the beak, going away from the eye, as long as you want your beak to be. (It will look like an arrow.) To make a sharp point on your beak, start at the tip of the beak and draw a *straight line* from the tip across the top. Do the same for the bottom of the beak.

3. *The head.* Draw a *curved line* over the top of the head, until it comes down the back of the head and stops somewhere below the beak. Draw a *curved line* from the bottom of the

beak downward to the same length as the back of the head. Draw a *straight line* across the bottom of the head and across the paper until it is as long as you want your bird's body to be.

4. *The body.* Draw a *curved line* from the bottom of the head to make a chest; curve it under to go across for the stomach, and then curve it up to the straight line you made to the end of the body.

5. *The wing.* Make an *angle line* from the back of the bird to the length you want your wing to be. Make feathers on it in any design you want.

6. *The back, other wing, and tail.* Since everybody's bird is a different size and shape, add any lines you need to close the spaces between the wing and the body to show the back of the bird. Add the other wing if you wish, coming out from behind the bird. Add long *U-shaped curved lines* out of the back of the body for the tail, and decorate the feathers any way you want.

7. *The legs and feet.* Make *single or double straight lines* to create your legs where you want, and add three *single or double curved lines* for the toes.

8. *The branches and berries.* Take a brown broad-tipped marker and make a *straight or curved* branch that comes from the edge of the paper and through the feet of the bird. Yours may have to take a totally different shape than the one in this sample, due to differences in the placement of your bird and its size and shape. Add more branches, wherever you want them to be. Take a fine-tipped dark-colored marker and make leaves by drawing a *straight line* for the middle of the leaf and a *curved line* on either side that goes from tip to tip. Add any design or veins on your leaves that you wish. Then take a broad-tipped colored marker and make *dots* for berries wherever you want them.

9. *Finishing up.* Color your bird as you wish, but use at least three colors for variety. Look outside at a tree and notice how the leaves are never all the same exact color. Pick several colors for your leaves. Add anything else you want to your

drawing. The students who did the bird in Fig. 1.12 also looked at the storybook *Tico and the Golden Wings* by Leo Lionni for additional ideas. If you want to color in the background, be sure to go all around the edges of the objects in the picture and the border with the broad-tipped marker first. Then you can go faster as you color in the spaces, which prevents the ink from drying too fast and causing streaks.

Voilà! A drawing. A drawing that is recognizable. One in a series of many to come. Remember, you will be satisfied with some, and you won't be satisfied with others. All are steps toward the confidence and pleasure that are bound to come along with your explorations.

Drawing from Graphics

Now that you are able to look at a visual image, recognize each component as one of the five elements, and interpret those elements into your own drawing, you can use all types of graphic materials to inspire yourself and your young students.

Representational artists look at existing images in order to draw, use their imaginations to delete, add on, change things, and end up with a completely original work of art. Figure 2.1 features a group of magical cats that were inspired by a greeting card, and Fig. 2.2 presents a beautiful abstract that was inspired by a photograph of a pelican. Continue collecting graphic materials for such inspiration. Get into the habit of carrying a pad, and sketch what you can't take home with you. I'll always remember the afternoon I was frantically looking for a new project at the last minute. I walked into the last store I had time to browse in. There before my eyes was a $300, five-foot batik of African animals. The price and size both made it impossible for me to buy, but it was perfect for a class project. Thanks to the sketch pad, I made two versions of pieces of the batik, with notes on color and designs. The next day I walked into class with my own 18" modified marker-pen version of the batik. I have been using this project for years, and it has inspired many coveted drawings. The elephant by Noel Chen in the color section was one of the first.

Train your eye to spot possible subjects on any item that could be decorated with graphics, such as greeting cards, wrapping paper, billboard signs, paintings, fabrics, toys,

Greeting Card

Jennifer Whitney—age 8

FIG. 2.1 *A magical group of cats that was inspired by a greeting card. Artists look at other images, change things, and end up with a completely original work of art.*

Joel Axelrod—adult

FIG. 2.2 *A beautiful abstract, inspired by a photograph. Artists copy a part of some image they see, play off it, change it, and build it into a statement of their own.*

household goods, pottery, jewelry, and printed materials such as books, coloring books, magazines, and brochures. You will find that you will draw more as you have more models to draw from.

This lesson will furnish you with some drawing tips and then go right into a project geared for your starting level. The drawing tips will give you some suggestions on how to instill a connection with your subject, how to plan compositions with overlapping objects, some ideas on how to change areas of the drawing that you are not satisfied with, and some suggestions on various effects you can achieve with coloring and shading. The lesson guides you through a project with a sequence of steps that can be used in all future drawing sessions. You will pick the project that fits your starting level, but you can always return to the others and do them later.

The progressive lessons were designed to fit the degree of motor coordination, mental readiness for complexity, and attention spans present in different children. For example, the lines in Level 1, Leo the Lion, represent very simple circular or boxed abstracted shapes, while the lines in the carousel horse, Level 3, represent complex relationships of subtle curves and delicate muscle patterns. The Level 2 project of the tropical birds has been designed to present a range from a simple rendition of one bird to a more complex version of many birds in a montage.

If working with children, be sure to read and share the drawing tips with them. Very young children may not be able to use all of the drawing tips, but they are ready to hear about them and be aware of them for the future.

Drawing Tips

Before you get engrossed in a project, there are several hints I want to share with you to increase your satisfaction with your drawings. If you help your children incorporate these ideas, they will get more feeling into their drawings, will risk more complex compositions, will have more options to correct unwanted results, and will incorporate more variety in their detail embellishments of color and shading. The section on adjustments and changes is very important. It is designed to

help you let go of your fears about making a mistake and gain knowledge of changing things as you go along.

KEEP THE FLOW AND FOLLOW YOUR FEELINGS

When you are first learning to draw, you usually give more attention to the technicalities. But your intuition and feelings will help your drawing as much as the specific techniques and processes that you master. Personal involvement and projection of the artist's feelings into the drawing is what we all respond to in our favorite works of art. If you look closely at the famous artworks in Fig. 2.3, you'll notice that each drawing is not necessarily technically accurate or even well rendered, but conveys a particular mood. If the artist were to get too analytical, the results might be technically correct but unevocative because of an overall rigid, hackneyed, or sterile presentation.

It is the artist's connection with energy, life, light, feeling, and mood that captures our attention. Here are some suggestions to help you develop these qualities:

- Pick a subject or some part of a subject that you have a connection to or feelings about.

- If you feel insecure about drawing an object, take a piece of scratch paper and force yourself to draw it without even looking at the paper. Just let your hand flow with your feelings, and experience the quality of lines that develop. When you decide to begin your finished drawing, try to retain some of that same fluid feeling.

- As you draw the subject be aware of your feelings about it and what you want to convey. Some artists describe how they project their feelings from their emotional center onto the subject and then read those feelings coming back through their eyes as they visually observe the subject. They say this helps them portray feeling and inject mood into their drawings.

- Try to familiarize yourself with the action or function of what you are drawing. It is more important to give the object energy and movement that is natural to it than to cor-

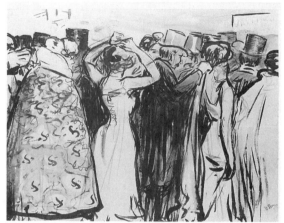

"Le Vestiaire, L'Opera, Paris"—
Kees van Dongen

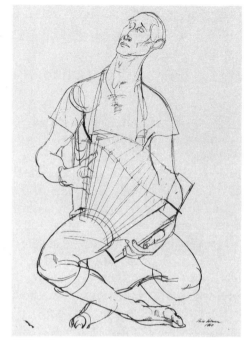

"The Accordion Player"—Rico Lebrun

"Decorative Composition"—Maurice
Prendergast

FIG. 2.3 *It is not necessary for your drawings
to be technically perfect. Notice the
inaccuracies and so-called mistakes in these
famous artists' renderings. Personal
involvement and projection of the artists'
feelings is what we respond to in our favorite
works of art.*

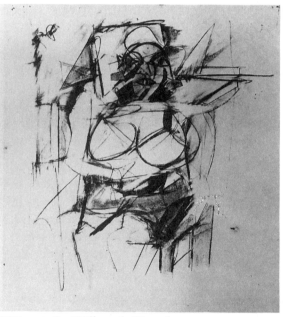

"Woman"—Willem de Kooning

rectly duplicate its visual appearance. For instance, if you were going to draw a cat, it would help for you to study cats, watch what they did with their time, try to imagine how they felt as they engaged in different activities, and actually pretend you were able to move and feel like one. After a movement session in which a mime had us all understand the movement of a cat, I found I was able to draw one with much more feeling.

OVERLAPPING

Once you learn how to draw objects that are in front of each other, you have far more variety in your choices of composition. Overlapping objects portray dimensionality of foreground and background and lend far more sophistication and interest. The key to overlapping objects is to remember this advice:

1. Draw the object in front first!

2. Begin drawing the object that is behind next, and *when you run into something, stop, jump over, and keep going.* Your hand should actually jump over the object in front and then keep going with the same line on the other side. You will be able to use overlapping in any of the projects in this lesson. Study the examples of placing objects in front of each other shown in Fig. 2.4, and then try the overlapping exercises displayed in Fig. 2.5.

3. A note to parents: Don't worry about the inaccuracies at first, especially with a very young child. The "jump over" can be awkward, and the "keep going" can end up in a place that isn't visually accurate. This is one of those things that just takes a little practice, so if a child isn't satisfied, just encourage him to be patient and to keep on trying; techniques will improve with practice.

MAKING ADJUSTMENTS AND CHANGES

When dissatisfied with the way you drew something, you don't have to experience the frustration of starting over or quitting. Instead, stop and quietly think of ways to alter things to your liking. Learning how to change things as you go along

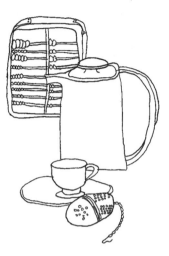

Molly Adams—age 9
FIG. 2.4 *Examples of drawings with objects overlapping each other.*

Karen Kim—age 7

FIG. 2.5 OVERLAPPING EXERCISE *Try copying the combinations of overlapped components, and then make up more of your own.*

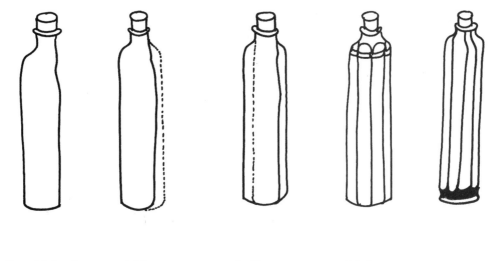

| Oops! I don't like that line! | a. Add any lines you need to get it the way that you want. | b. Repeat the so-called mistake. | c. Make a symmetrical design out of it. | . . . or |

FIG. 2.6 *Making adjustments by adding on.*

Oops! I don't like the baby elephant! Baby elephant transformed into a bush.

FIG. 2.7 MAKING ADJUSTMENTS BY TRANSFORMING *Children can come up with unbelievable ways to transform an object they don't like into something else.*

will enable you to draw with a lot more freedom and enjoyment. When six-year-old Alexandra Berger expressed great sorrow at "getting silly and ruining" a stunning drawing of a horse by giving it toes with red fingernail polish, she decided to try for an adjustment. I'll have to admit, this one had me stumped. I learned that I could count on the six-year-old imagination if I just kept encouraging her to think. An added apple tree, with falling apples and apples over the formerly red toes, worked perfectly. As one of Alexandra's favorites, it was framed and hung in many art shows. We both laughed as spectators commended her on such an original idea as the beautiful falling apples, never suspecting the red toes beneath.

As suggested earlier, it is best to completely stop using the word *mistake* so that you can remember there is no mistake possible. If the child is satisfied there is no need for change, whether someone else thinks there is or not. If the child is really dissatisfied, here are a few suggestions that will help her alter things. Use your own imagination to think of others.

Adding on. One of the best ways to accommodate an unwanted line is to repeat it somewhere else and make a symmetrical design out of it, as shown in Fig. 2.6.

Transforming. One of the most challenging ways to make changes is to completely transform the object you don't like into something else, as in Fig. 2.7. The texture and pattern of the area that you want to transform can give you ideas of what will work well. Children are very good at this and can come up with lots of creative suggestions when you solicit them.

Covering up. There is no end to the kinds of shading, design, or textures that will cover up an unwanted line or portion of a drawing. Use some thought first, and create a pattern that blends in with the subject and mood of the drawing, as is evidenced in Fig. 2.8.

Tracing and rearranging. Tracing as an artistic trick of the trade can be one of the most liberating things that can happen for you. It just doesn't make sense that it wouldn't be acceptable to retrace your own artwork in order to rearrange or change things. Taking the parts you like out of a drawing and tracing them into a new drawing, as in Fig. 2.9, helps you accomplish your ends. It is important to let children know this is an artist's option and not "cheating."

I am convinced this was one of the main things my aunt Beverly showed me that allowed me to develop as an artist. I

Oops! I went in the opposite direction than I wanted!

Cover it up with texture that complements the drawing.

FIG. 2.8 CREATING ADJUSTMENTS BY COVERING UP
Shadings and textures can go a long way to cover up unwanted lines or portions of a drawing.

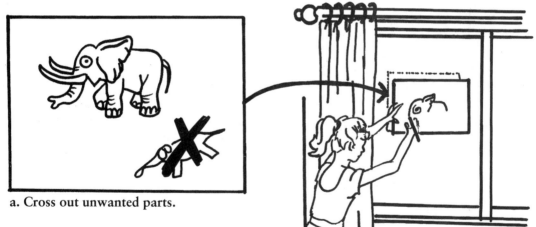

a. Cross out unwanted parts.

FIG. 2.9 MAKING ADJUSTMENTS BY TRACING *It's not cheating to delete and add on parts of one of your old drawings into a new one.*

b. Trace in wanted parts on a new paper through the window light.

understood that it caused dependency to trace other people's drawings, but I never could understand how other children didn't know they could trace and rearrange parts of their own drawings.

Where to start. As there is no right way to draw an object, there is really no right place to start. But because I have found that one of the biggest blocks to drawing comes from not knowing where to start, I have developed some general suggestions. These come from the observation that most objects have a central focus or basic function that leads you to a good starting place.

Examples of starting places:

- Most flowers have a center.

- Most plants have a central stem.

- Most still life containers have a hole.

- Most living creatures have eyes.

- Most buildings have a central door or archway.

You can't go wrong if you decide what the central idea of an object is and use these hints. So for the sake of learning, follow these suggestions. When you are confident about your drawing you can start wherever you want.

Projecting the image on the paper. Children tend to have little conception of how to incorporate a piece of paper into their drawing and use it as a whole. They usually make a small drawing right in the middle of the paper, which does not tend toward a finished or integrated look. They might put a blue line across the top of the empty paper for a sky, or a brown line across the bottom for the ground, or a lot of scribbly lines around to cover up the white spaces. Actually, left to their own, these are the children who quit drawing and are the same adults who later in life tell me they can't get beyond the starkness of so much white paper. I think the missing ingredient is the inability to look at the paper and project ideas of images onto it without actually drawing yet. As an artist, I found I did this naturally, and had no idea that everyone didn't do the same.

Projecting images onto the blank piece of paper allows you

to know where to start, how to make the beginning shapes the sizes that will allow for everything to fit, and how to keep track of where you want everything to go. If you already know how to do it, you know exactly what I mean and no further explanation is necessary. Telling someone who hasn't experienced it how to do it is the trick.

The secret to helping someone see images on a blank piece of paper is to start with the simple and gradually build up to the complex. You might get a child to imagine a straight line running right through the middle of the paper, or a red dot in each corner of the paper. Slowly add more detail until he sees his entire general composition on the paper. You are helping him mentally project intangible but very visible marks on the paper. These imaginary marks are used as guidelines or reference points during the drawing process. It is the rare person who cannot do this when informed of the process. Anyone having difficulty will come around quite rapidly after a little exposure. Of course, this is one of the most valuable tools you can develop, so play around with imagining images on blank surfaces as often as you can.

Making preliminary sketches. Take a piece of scratch paper and sketch a few small boxes on it that are the same general shape as your drawing paper. Use these boxes to organize the figures in your drawing and plan various compositions. These sketches involve only the general structure and need no detail, as seen in the preliminary sketches by a child in Fig. 2.14's Leo the Lion project.

Using a Test Paper. Put a piece of the same kind of paper next to your drawing to use for exploring difficult shapes, shades of colors, and blending of colors.

Using thick and thin line. If all the contour lines in a picture are the same thickness, it can make for a rather stilted look. One way to create interesting detail is to vary the width of those contour lines, as seen in the child's drawing in Fig. 2.10. You can achieve this by using different thicknesses of marker points or by simply taking the same marker and choosing some of the lines to retrace and broaden.

Creating flat, textured, or shaded areas. When you put the finishing touches on a drawing, you want to explore as many ways of creating color and texture as you can. Here are just a few of the main effects you can use.

Ellen Moody—age 10
FIG. 2.10 *Using thick and thin line to create interesting detail.*

- *Flat color* simply means using one color to fill in an entire space. Take your time and be complete, because little white specks of paper showing through can be a tremendous distraction in a beautiful drawing. When filling in large areas, avoid using zigzaggy lines of color for the same reason. Unless an area is very small, avoid coloring in with fine-tipped, streaky markers.

- When *shading,* pick several broad-tipped markers that you think go together and try them on your test swatch first. You will find that some combinations just won't work. Refer to Chapter 5 in my book *Drawing for Older Children and Teens* when you are ready for more complex shading. But for these beginning projects it is enough to give the child the basics. Simply pick one direction for the dark sides of objects and stay consistent throughout the composition, as described in the section Warming Up to the Light and Dark in Lesson 4. You can add to the beauty by using gradations of three or four shades of dark to light, instead of the starkness of just a dark and a light side.

- In developing *texture* there is literally no end to the variety. This is one time when you can use any and all kinds of markers in endless combinations. For example, you could use a flat, light background in an area and then overlay thin-lined textures on top of it; you could use several broad-tipped markers and let them bleed into each other in blotchy effects; or you could devise dotted or striped areas intertwined with each other out of several varieties of markers. The trick is to use your test paper and play with your imagination.

Each time you are stuck for ideas or are dissatisfied and think you have to start over, stop, give it some thought, and you probably will think of several ways to get started again or change things to your satisfaction. Rather than hoping nothing will go wrong and dreading a mistake, begin to think of altering things as a part of the drawing process itself. It will free up your drawing and include changing and fixing things as a part of the experience.

Level 1: Leo the Lion

We will use a photographed image of Leo (Fig. 2.11) and a simplified drawing of the basic elements that compose its shape (Fig. 2.12) as our samples for this drawing project. Leo comes from an embroidery that was inspired by a design on my shower curtain, years ago. Leo serves to give you only the general shape of the lion and to stimulate your imagination. You will add detail designs, other animals, or background and foreground figures to create your own original drawing.

WARMING UP

Before you begin the project be sure to do your body and eye relaxations, review the five elements of shape from your chart, and do some kind of warm-up from Lesson 1.

PLANNING

Arrange Your Sample

Place the photocopy of Leo in front of you at your drawing place. Since propping the book up causes an awkwardness in following the printed instructions, it is suggested that you take time out to make copies of all the samples suggested in the section How to Use This Book. You will be adding background and foreground ideas to the drawing, so gather any other graphic materials you may have collected for this purpose and place them in front of you as well.

Choose the Paper and Supplies

Select the size and type of drawing paper you will use and your regular-tipped black marker to draw with. Use smaller paper for very young children. Have the other narrow- and broad-tipped markers at the drawing table to use for detail and color.

FIG. 2.11 *Photo of Leo the Lion embroidery.*

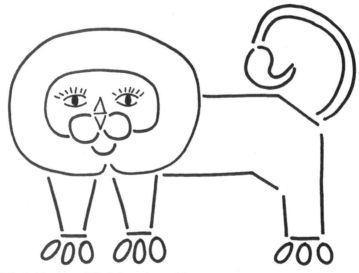

FIG. 2.12 *Simplified drawing of Leo.*

Imagine Your Main Subject in the Drawing

Look at Leo and begin to imagine how you want to place him in your drawing. Consider what size you want him to be, where you want him in the composition, and in what direction you want him to face.

Imagine Your Whole Composition

Begin to project with your imagination different arrangements of the things you want in the drawing on the blank paper. Consider a variety of solutions by asking yourself the following kinds of questions: Do I want just one lion, or more? Do I want a stylized lion with designs, or a more realistic-looking one? Do I want to draw the lion on a field of solid color, on an abstract background, or in a scene? If I want a scene, where do I want my lion to be—in a jungle, in a zoo, in a circus, or in my room like a stuffed animal? What other figures or items do I want to put in the drawing with my lion? Figure 2.13, the student exhibition of Leo, may give you some ideas.

Make Preliminary Sketches of Your Ideas

Take a piece of scratch paper and draw some planning boxes for your preliminary sketches, as discussed in the drawing tips and shown in Fig. 2.14. When you feel you've exhausted your ideas for compositions, choose the one you want to begin your drawing with.

BEGINNING

As you take the blank piece of paper to begin, remind yourself and the children to project the image of the composition onto its surface with your imaginations. Make any necessary guideline dots or marks to remind yourselves of where things will go. Get a sense of how large Leo will be and where he will sit on the paper. Since we are dealing with a living creature, we will follow the suggestion to start with the eyes. You can save a lot of paper and frustration with children if you ask them to show you with their finger where they are going to start the eyes. This allows time to make an adjustment if the choice could lead to spacing problems. Then follow the step-by-step suggestions and guide the child through the experience of

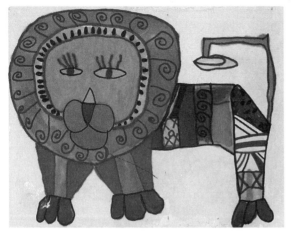

Maia LeMay—age 5

Cassie Skidmore—age 9

Lana Wolverton—age 8

FIG. 2.13 *Student exhibition of Leo. Consider the variety of environments you can put Leo in.*

Lana Wolverton—age 8

FIG. 2.14 *This child drew some boxes to plan in and tried different ideas for compositions in a very general drawing style.*

choosing which part to draw next, what basic elements are involved in its construction, and how to render them on the paper. Remember, the dotted line is to represent the shape currently being discussed; you will, of course, draw in regular lines.

1. *Begin with the eyes.* Place the eyes so there will be room for the large mane, the body, and the legs. Draw an *oval dot* for each one of the pupils, a *curved line* over and under each one of the dots to define the outer edge of the lids, and tiny *straight or curved lines* for the eyelashes. When choosing the next thing to draw, try to build off the part you just drew by drawing what touches it or what is the next closest thing. So in this case, the next thing would be the nose.

2. *The nose.* Draw the *straight line* in the middle of the nose first. Then put a *tiny guideline dot* where you want the triangle points to end up. For the upper triangle, draw *straight lines* from the guideline dot to the ends of the midline of the nose. Do the same for the lower triangle.

3. *The cheeks and chin.* Start a *curved line* in the middle of the nose and bring it around to the tip of the bottom of the nose. Keep it small, or your lion will get too large. Notice it comes out about as far as the middle of Leo's eyes. Then draw a *curved line* on the other side, going the opposite way. Then draw another *curved line* to create the chin.

4. *The face and mane.* As you create the line for the face, remind a small child to stay close to the eyes, or the lion's head will be too large. Use a *guideline dot* over the nose and above the eyes a bit if you think you need to. Notice that as you draw you are always checking how close or far away things are in relation to each other. This is definitely one of the secrets to drawing things in proportion.

Start near the middle of one of your cheeks and create a *curved line* that goes all the way around to the other side and becomes the face line. Make a *guideline dot* above the face to mark how wide you want the mane to be. Leave a wide enough space to allow for the decorations you will insert later. Then start closely under the chin and create another *curved*

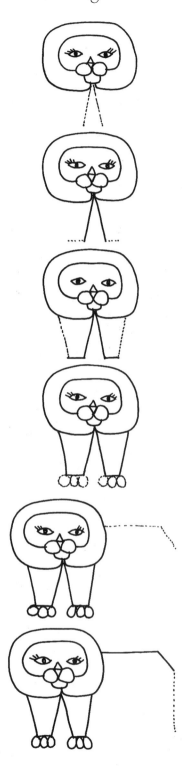

line that goes all the way around the face and becomes the edge of the mane.

5. *The legs.* In order to get the legs the way you want them, it will help to do some analyzing first. Project the image of them onto the paper before you draw. You want to plan them to be wide enough to incorporate designs and to be slanted in such a way as to leave a triangular space between them that meets directly under the chin. It helps to make the triangular space in the middle first.

Draw an *angle line* with the point directly under the chin and as long as you want the legs to be. Notice that the angle comes out about as far as the middle of the eyes above it. Draw a *short straight line* for the end of each leg. Then draw a *straight line slanting out* and up to the edge of the mane to form the outside of the leg. Make it nice and wide so Leo won't be too skinny.

6. *The toes.* Draw three *circles* on the end of each leg. Don't make them too small, or your lion will look as if it may topple over.

7. *The body and the back leg.* Start somewhere on the side of the head and draw an *angle line* to create the back and the bottom. You can use another *guideline dot* where you want the point of the angle to drop down for the bottom, since you don't want the body to be too short or too long. Then draw a *straight line* for the back leg that ends at the same length as the front legs. Now you need to decide where to branch off next. Since the width of the stomach can turn out too small if you go up to it from the back leg, do it next. Use a *guideline dot* if you need it to designate where you want the stomach to bend into the back hip. Draw an *angle line* that starts near the bottom of the mane for the stomach and then dips down for the back hip. Draw an *angle line* to form the inner side of the back leg that bends to close off the end of the leg, and attach the three *circled* toes for the back foot.

8. *The tail.* Make your tail go in any direction you want with *double curved lines* to form it. Make two *curved lines* that start out wide and taper down to a point to create the

hairy end of the tail. The basic shape of Leo is completed, and you are ready to add the rest of your composition.

FINISHING TOUCHES

Make a general drawing of the rest of the objects in your composition before you begin to color in and decorate your lion, in case you want to retrace Leo onto a new piece of paper and start over for any reason. As you draw the remaining parts of the picture, begin to use other dark-colored fine-tipped markers for variety. Use a darker color to draw with than the broad-tipped markers you color in with, so that you don't lose your outline edge. For example, you can use a fine-tipped dark green to draw in leaves and then use lots of different lighter-green broad-tipped markers to color them; or you can use a fine-tipped dark brown to draw in contours of trunks and branches and then use several shades of lighter-toned browns to color and shade.

Finish the picture by coloring in and adding all the detail. Refer back to the drawing tips if you need to refresh your memory about using test papers, thick and thin line, and flat, textured, or shaded effects. Aim for using the whole paper to create a finished and organized look. If the child has a difficult time doing that, start with smaller paper.

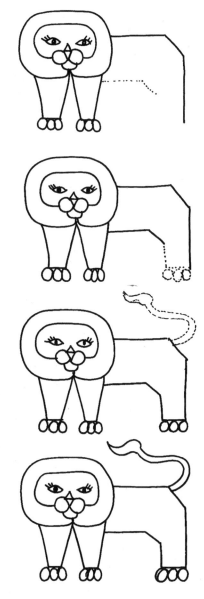

Level 2: Tropical Birds

For this project we will use a montage drawing (Fig. 2.15) of different tropical bird illustrations that were collected from greeting cards, wrapping paper, and coloring books. The simplified renderings of the individual birds (Fig. 2.16) will help construct your drawing. Step-by-step instructions will be provided for the parrot, and then you can use the same general steps to draw any of the other birds in the montage. You can use this project in a variety of ways for different levels of readiness. Refer to the student exhibition in Fig. 2.17 and notice the wide range of interpretations that resulted from using the same images.

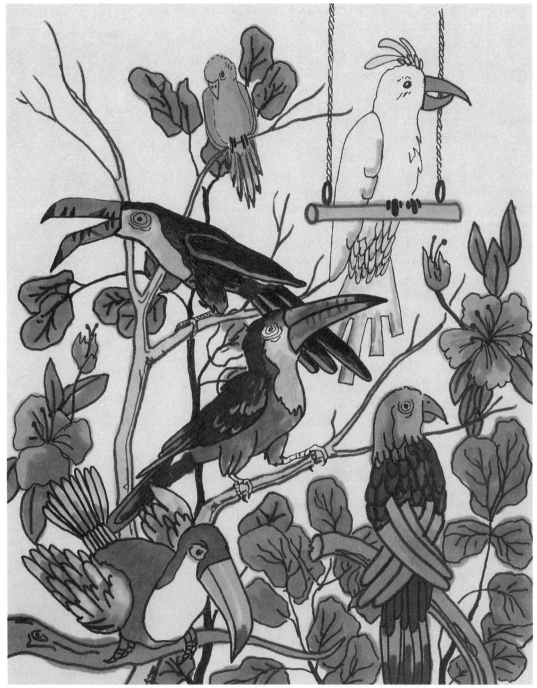

FIG. 2.15 *Tropical bird montage, sample.*

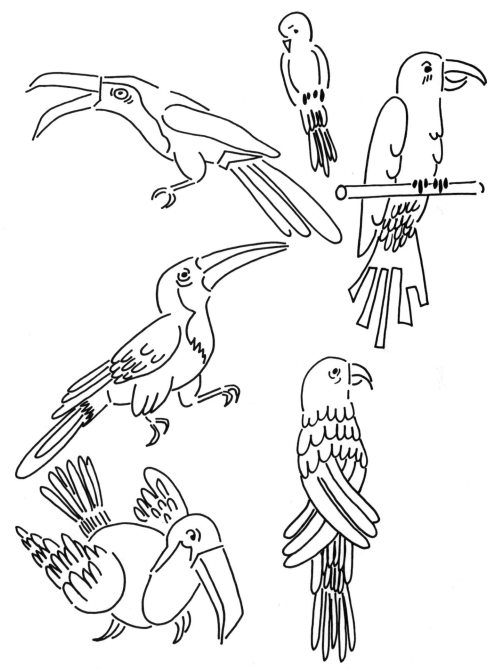

FIG. 2.16 *Simplified drawings of individual birds.*

Ramsey Bernard—age 5

Victor Webster—age 8

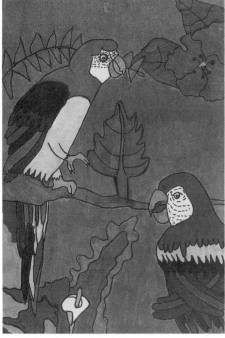

Vanessa Bezic—age 9

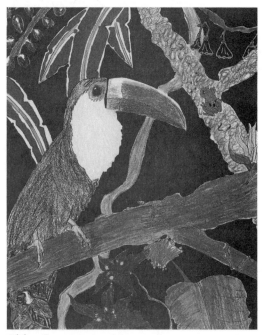

Chloe Lyon—age 11
FIG. 2.17 *A wide range of interpretations come from using the same images.*

WARMING UP

Remember to do your body and eye relaxation exercises, review the five elements of shape from your chart, and do some kind of warm-up exercise from Lesson 1.

PLANNING

Arrange Your Sample

Place your photocopy of the bird montage (Fig. 2.15) and the simplified drawing of the individual birds (Fig. 2.16) in a comfortable spot near your drawing place.

Choose the Paper and Supplies

Select the size and type of drawing paper as well as the fine- and broad-tipped markers. Use a black thin-tipped marker to draw the bird or birds of your choice.

Imagine Your Main Subject in the Drawing

Since step-by-step instructions will be given for the parrot, you will use it as your main subject. If you want to make another drawing without the parrot in it, you can easily do so afterward. Project the image of the parrot on the paper with your imagination and decide where you want it to be, how big it will be, and what general style you want to render it in.

Imagine Your Whole Composition

Ask yourself how you want the bird to be in your drawing, and what other things you want in the picture. For example: You might place the bird on a branch in the jungle, or with two of the other birds in an abstract design field, or in an elaborate cage sitting in the corner of a lovely room. Collect any samples of additional ideas you plan to add to your composition, and put them at your drawing space.

Make Preliminary Sketches of Your Ideas

Take your scratch paper and draw boxes to plan alternative compositions within. Remember that these sketches are just general shape concepts roughly sketched out to get you started. Then choose the one that you like and begin.

Beginning

Birds are so similar in character that the general format for one can be used for most of them. The instructions will be for the parrot, but you will be able to use this sequence in the future to draw almost any bird. We will begin with the eye, since the parrot is a living creature and we know we can build out from it. The dotted line will be used for the current line being discussed, but remember that you will be drawing in regular lines.

1. *Begin with the eye.* Have the child point to the place on the paper where she plans to start, so you can make adjustments before drawing. This allows you to make sure you have enough room for the whole body and a long tail.

Place a *dot* where you want the eye, and then place a *small circle* around it. Watch that it doesn't get too large or your whole head will become too big to accommodate it. Then add some *little wiggly curves* around it for detail.

2. *The beak.* Really study the beak. The line that is attached to the head is the most grounding place to start on most birds.

Draw the *straight line* where the beak joins the head a bit away from the eye in whichever direction you want the bird to face. Draw the *curved line* in the middle of the beak to the length that you want. When doing the outer edges of the beak, it is best to start at the point and work back to the head, since this will help the beginner or small child get the point to be connected properly and appear sharp instead of rounded. Form the upper edge of the beak with a *curved line* that goes up to the top of the face, and the lower edge of the beak with a *curved line* that starts in the center of the midline and goes down to the bottom of the face.

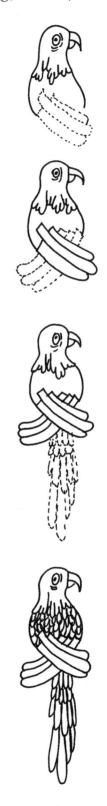

3. *The head.* Draw a *curved line* from the top of the beak, over the eye, and down to where you want the body to start, for the top and back of the head. Form the throat area with a *small inward curved line* from the bottom of the beak. Finish it off by making *scalloped curved lines* across the bottom, to form the first row of feathers.

4. *The back.* Make a *curved line* on both sides of the bird to form the back.

5. *The wings.* Since, when drawing overlapping things, you want to draw what is in front first, start with the wing that is on top.

Draw a *short straight line* to designate the first feather, slanting it upward to create the slanting wing. Then draw a long *U-shaped curved line* that extends beyond the other side of the body. Make as many feathers as you want until you reach the center of the back. Repeat the exact same process for the wing that is underneath, only stop, jump over, and keep going with each one of the long *U-shaped curves* that form the individual feathers.

6. *The tail.* You never need to have the exact same shape and number of feathers that you see in the sample. Just look at the type of feathers that are involved and make them similar, in order to duplicate the type of bird you are drawing.

Use *long and narrow U-shaped curves* to form rows of feathers. Make your tail fit the size and style of bird that you have drawn, allowing for the other objects in your picture.

FINISHING TOUCHES

Draw any other birds that you want in your picture next. You can use the same progression of steps, but you will have to adjust for front-view or side-view birds. With front-view birds you may have two eyes showing, or you may need to draw feet and branches first that overlap the tail. With side-view birds, you may need to draw chests and legs. If so, do the chest after you have completed the back and wing, then the thigh and leg in front, then the leg in back, and finally the tail.

As you draw other subjects, along with background and foreground, into your picture, use different types of markers

in order to get away from the stylized look of too many black-line outlines. This is where other graphic images will inspire you with ideas for scenery and environmental moods, foliage variety, textures, and color. Complete your drawing by coloring and shading your birds and any remaining objects. You may want to refer to the drawing tips to refresh your memory about flat, textured, and shaded areas.

Level 3: Carousel Horse

The photograph that we will use for our Level 3 project is of a carousel horse (Fig. 2.18). A simplified drawing (Fig. 2.19) of the elements that compose the outline shape of the horse is included to assist you. Many people have blocks about drawing horses; they're intimidated by the subtle, curved lines and complex limbs and joints of the animals. But horses simply take more concentration than do other visual subjects. Along with using your concentration, let go of your need for perfection, and encourage the children to do the same. Look closely at the student exhibition of this project in Fig. 2.20 and notice how the charm of the horse is not diminished in any way by inaccuracies in the proportions. Let that encourage you to relax and learn from your first attempts.

WARMING UP

Take a moment to do your body and eye relaxation exercises, and review the elements chart. Instead of doing a warm-up from Lesson 1, take a piece of scratch paper and try a quick sketch of the carousel horse by looking at the simplified drawing in Fig. 2.19. Make your sketch about the same size you intend your drawing to be. You may surprise yourself by how capable you are and find that you don't need to follow step-by-step instructions. If this is true, you may be able to copy it or trace it onto your drawing paper and be well on your way to the finishing touches. If you are not satisfied with your sketch, proceed with the instructions.

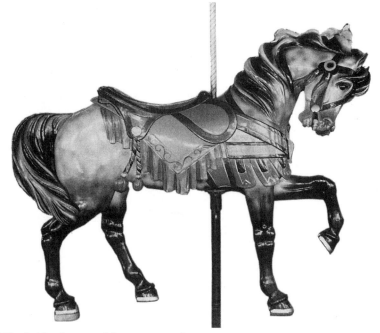

FIG. 2.18 *Carousel horse, sample.*

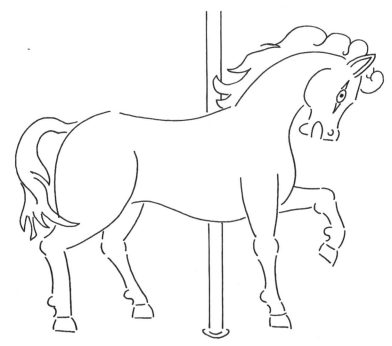

FIG. 2.19 *Simplified drawing of carousel horse.*

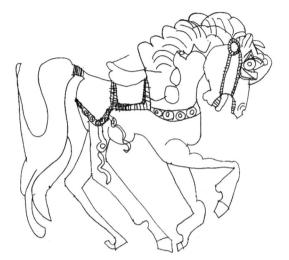

Lauren Barnhizer—age 5

Rachel Stepka—age 8

FIG. 2.20 *Notice how the charm of Lauren's version of the horse is not diminished in any way by the inaccuracies of proportions.*

PLANNING

Arrange Your Sample

Place your photocopy of the horse (Fig. 2.18) and the simplified drawing of it (Fig. 2.19) at your drawing place.

Choose the Paper and Supplies

Be sure to select paper that is large enough to accommodate the legs. Draw the general shape of the horse with the regular-tipped black marker, then you can draw all the designs and fill in with a variety of colors later.

Imagine Your Main Subject in the Drawing

Study the general shape of the horse and begin to project the image of it onto your paper with the placement you desire.

Imagine Your Whole Composition

Think about how you want your carousel horse to appear in your drawing. You may want to draw it alone, you may want to put it against the backdrop of part of a merry-go-round, or you may want to draw it within an entire merry-go-round.

Make Preliminary Sketches of Your Ideas

If you are going to draw the horse by itself, it is not necessary to make further sketches. If you are going to add background or parts of a merry-go-round, make your planning boxes and try out your ideas. Once you have arrived at the general format of your composition, you are ready to begin.

BEGINNING

Since you know you are drawing a subject that requires a lot of concentration, be sure to watch for distractions and tiredness, and take little breaks with the younger children. Keep reminding them to eyeball things and use guideline dots if they need to, especially when drawing the legs. The secret to drawing a series of curves is to recognize them as separate curves; this reduces the complexity. The visual example will use a dotted line to identify the current instruction, but you will draw with regular lines. In order to explain a series of curves as separate units, it becomes necessary to make a break in the dotted line example. Of course you will not want this break in your drawing and will join each part to the next as you go along. We will follow the suggestion in drawing tips and start with the horse's eye.

1. *Begin with the eye.* Have the child project the image of the whole horse on the blank paper, paying attention to how much space will be needed for the legs and pole. Ask her to point to where she thinks she will start the eye. This allows for adjustments before false starts can be made.

Draw the central *dot,* but since it will actually determine the size of the head, watch that it is not too small or too big. Then add the *circle* around it and the *angle* shapes that complete the corners. It is not necessary to copy it exactly, but get the points of the angles to be up and down rather than sideways. A sideways eye tends to make the horse look bug-eyed.

2. *The nose.* Make the *straight line* for the forehead a bit in front of the eye. Again, go slowly and concentrate. If you get too far away from the eye or make it too long, the head can become enormous. Then draw the *sloped-in curved line* that forms the bridge of the nose. From here on isolate each curve and see it individually. Now draw the *curved line* that makes the nostril bump, and put the *little circle or curve* in for the

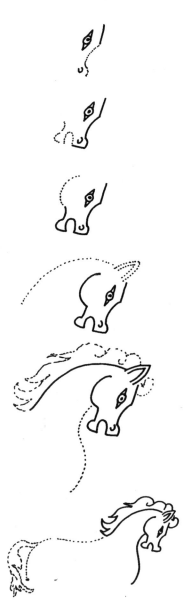

nostril hole. Then draw the *straight line* that creates the flat end of the nose.

3. *The mouth, chin, and jawline.* Make a *U-shaped curve* to form the mouth. The curve can be as wide as you want the mouth to be open. Then draw the *C-shaped curve* that makes the bottom lip, and the *slightly curved-in* underside of the jaw, which stops approximately across from the bottom of the eye. Then draw a full *rounded outward curve* to form the jaw, noticing that it stops across from where the eye ends at the top.

4. *The ear, neck, chest, and mane.* Make an *angle line* to create the ear. You can *double* it to create the rim, and of course make it in any direction that you want it to tip. Establish a guideline dot where you want the neck to end, and draw a *swooping curve* for the back of the neck. Make another guideline dot where you want the chest to end, and draw one *curve that goes slightly in* for the front of the neck and another *curve that goes out* to form the chest. Now use your imagination and create a flowing mane. It is not necessary to copy the same hair pattern as the one in the example.

5. *The back, bottom, and tail.* Draw a *gentle curve* for the back. Then establish a guideline dot for where you want to end the bottom, noticing that it ends at the same level as the chest does. Be sure to eyeball the amount of space that you will need for the legs and stomach, and don't let it curve in too much. Then draw the *curved line* for the bottom. Use your imagination for the tail and let it flow in any direction you want.

6. *The front-side legs and the stomach.* Remember that when overlapping you need to draw what is in front first. As you draw the legs on your horse they may have to take a completely different size and slant of angle due to the differences you have already created in your interpretation of the horse. So the remaining steps will be a little more general to accommodate this. Do the front leg first, and slowly work down section by section.

Use *slightly curved lines* to form the upper thigh, then bend the leg by making a kneecap out of two *little curved lines*.

Bend the leg again, and form the fetlock (which is the bump on the back side of the leg above the hoof) out of two *very gradually curved-in lines* that extend down to the hoof. Study the example carefully to note the *many little curved lines* that construct the hoof, and draw them one at a time, progressively toward the end of the hoof; use a *straight line* to close off the bottom.

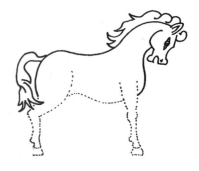

Notice now how the back leg is formed differently, and follow the same procedure; isolate each section, from the hip down to the hoof, by slowly observing the elements that you see and duplicating them.

Now draw the stomach line. Notice that it is actually two curves joined together in a gradual backward **S** shape. Use one *curved line* in the front that is a continuation of where the chest ended on the other side of the front leg and another *curved line* that tapers up into the back hip.

7. *The back-side legs.* Use the example as a guide only in how the legs are formed. It may be impossible to end up with the exact same configuration of legs as is shown in the example with the size and shape of your horse. In fact, every child's drawing will be different at this point, and their horses' legs will need special adjustments to fit properly. But don't worry; as long as you use the general elements to guide you and start at the top and work down, you will come out fine. Use the "stop, jump over, and keep going" principle to adjust to overlapping of legs and tail.

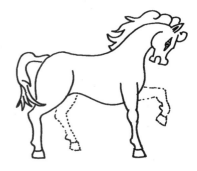

8. *The pole.* Simply draw in the *double straight lines* to form the pole, remembering to jump over when the body of the horse or legs overlap.

Warning to parents: Keep reminding beginners and small children not to be too particular. Encourage the learning process and tell them that each horse they draw will get more and more accurate. If they express total dissatisfaction, refer to the hints on how to trace the parts you like and redraw the parts you don't. These instructions will work with any horse and many of the four-legged animals, such as zebras, that have similar shapes.

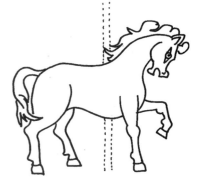

FINISHING TOUCHES

If you are adding other things to your drawing, go ahead and draw in the outlines first, using different types of markers for variety. Use very intricate and detailed designs on your carousel horse and refer to the drawing tips on color, texture, and shading if you need some inspiration. Of course, the ultimate would be to visit a merry-go-round and make sketches of the whole thing, so that you could develop your drawing even further.

Choosing Other Projects

During this lesson you learned about most of the essential drawing tips that will free up your creativity. The more you choose projects and draw them, the more you will learn to incorporate these tips. The problem solving that you were exposed to will grow as you choose to challenge yourself and not worry about what might be "too hard." So relax and take on projects that you like, even if you are a little leery of them. Figure 2.21 presents a student exhibition of some beautiful examples of results you can achieve.

In many cases, you will learn so much from the first experience that you will be ready to go to the next level right away. If you started out at Level 1, you probably can go right on to Level 2, and if a child is not too young you probably can subsequently go right on to Level 3. If you started at Level 2, you have probably already learned enough to go right on to Level 3, and you could of course enjoy doing Level 1 at any time. If you started at Level 3, I recommend that you go back and do Leo and the Tropical Birds and make them challenging for yourself and the children.

The drawing projects all follow the same sequential steps, which you can use with any project that you plan for the future. Here is the sequence of steps for you to see as a pattern. You might list them on the back of your sketch pad, so that you have them with you in your travels.

Greeting card

Ethan Witt—age 8

Greeting card

FIG. 2.21 *Student exhibition of projects inspired by other graphics.*

Jennifer Higa—age 11

WARMING UP

- Do body and eye relaxations.
- Review the five elements of contour shape.
- Do some kind of warm-up exercise.

PLANNING

- Arrange your sample materials.
- Choose the paper and supplies.
- Imagine your main subject in the drawing.
- Imagine whole compositions.
- Project them on the blank piece of paper.
- Make preliminary sketches of your ideas.

BEGINNING

- Choose the central point to start with.
- Project that starting point onto the blank paper.
- Observe the elements and duplicate them.
- Go to the adjacent part next.
- Observe those elements and duplicate them.
- Draw what is in front first.
- Draw the general shape of an object first.
- Draw the objects first and then add backgrounds.

FINISHING TOUCHES

- Add the details of the objects.
- Add color, shading, and textures.
- Add background ideas.

Don't worry about this much structure spoiling creativity. All artists use this much structure, or they would never pro-

duce the works they create. They do it automatically, without thinking about it, and therefore don't tend to talk about it, write it down, or know how to tell someone else to do it. As you get used to these guidelines, you can throw away the list and do them automatically yourself.

The next lesson will focus on still life and how to draw objects from the environment. But you will notice that the same basic sequence of steps will be used in dealing with the drawing process itself.

The more you draw, the more visually stimulated you become, and the more projects you will begin thinking of. So keep your sketch pad with you, take down ideas that can be combined in future drawings, and you will quickly integrate all the learning into a system that works for you. You will soon have the confidence to tackle any subject you want and feel comfortable guiding the children in your life to do the same.

Drawing from a still Life

In Lesson 2 you learned how to draw the general structure of objects by looking at two-dimensional graphics. You learned to do this by deciding on a central place to start, observing the outer edges, recognizing the five elements and how they constructed those edges, and drawing those elements in a way to produce a recognizable picture of the object.

In this lesson, you will learn how to draw the general structure of three-dimensional still life subjects from your environment. Still life means an arrangement of inanimate objects that are used for the purpose of drawing. You will essentially use the same steps to accomplish drawing from still life as you did for observing and drawing from two-dimensional graphics. The main differences will be in training the eye to see the elements of shape on real objects and in planning lessons so that the child or the beginner is not confronted with perspective in the first few experiences.

You will be amazed at how quickly and proficiently you and the children make the transition to drawing from real objects. Children as young as four are very capable of working with still life if you demonstrate one article at a time and allow them to place the objects into their own groupings. You will find that with the ability to recognize the five elements of shape, the freedom to move objects, and a general demonstration by you, children can draw from objects in the environment as easily as they did from graphics. Figure 3.1 shows the beauty and sophistication that can be attained by introducing

Ba Nhi Balin—age 6

Meredith De Meules—age 5

young children to this experience. After you both get used to the nature of three-dimensional objects and develop an awareness of the spaces in between them, you can leave arrangements as they are and add the challenge of drawing them from a particular perspective.

To draw from still life, you will need to collect real objects. For the sake of this approach, however, it's important for me to be able to refer to specific objects in a predetermined still life model. So in order to draw together by the book, we will have to first use a photograph for consistency of visual data. After we draw this lesson together, you and your child will be ready to build your own arrangements from things you choose and explore the transition to real objects.

Even though you will be using a photograph to study the still life, you will not be limited in individual interpretations. The Fig. 3.2 photograph is followed, in Fig. 3.3, by two different renditions by each starting level that resulted from it. All six of the students were in the same drawing situation and used the same instructions that you will be using, yet all maintained their individuality and creativity throughout the

FIG. 3.1 *Introducing young children to still life adds beauty and sophistication to their experience; they also learn to see the elements of shape on three-dimensional objects.*

FIG. 3.2 *Still life you'll be using.*

process. The instructions will give you a format that is applicable for all future still life projects that you set up for yourself and your children.

The photographic model (Fig. 3.4) and the resulting simplified drawing (Fig. 3.5) that you will use for the project is a still life composite of all the objects to be drawn for the three different starting levels. Levels 1 through 3 will start with Level 1 instructions to draw the teapot and the vase; Levels 2 and 3 will go on to add the cup and kitchen utensils; and Level 3 will go further to add an abacus. In this way, each level deals with more complexity of composition. In addition, the higher levels will be asked to use more imaginative detail in the rendering itself. As usual, use your discretion to alter the starting level and complexity as you go along to challenge or simplify conditions for any particular child.

Level 1: The Teapot and the Vase (Levels 2 and 3 Also Start Here)

All levels will begin with the same instructions and draw the first two objects together. Levels 2 and 3, however, will need to plan from the beginning for all the other objects that will be included.

WARMING UP

As usual, do your eye and body relaxations, review the elements of shape from your chart, and do some form of the warm-up exercises from Lesson 1.

PLANNING

Arrange Your Sample

Place the photocopy you made of the still life model (Fig. 3.4) and the simplified drawing of it (Fig. 3.5) in front of you at the drawing space.

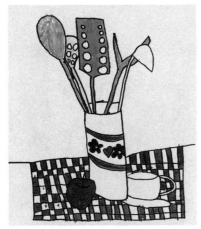

Adrienne Blum—age 5

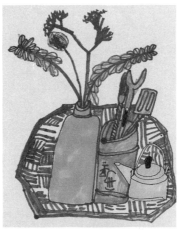

Claire Lauer—age 5

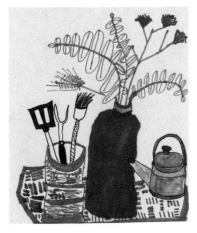

Carrissa Giordani—age 7

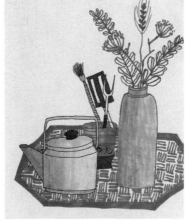

Angela Sikich—age 10

Amanda Bergevin—age 9

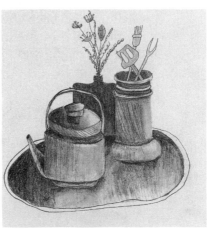

Jeffrey Girouard—age 7

FIG. 3.3 *Two renditions of each starting level.*

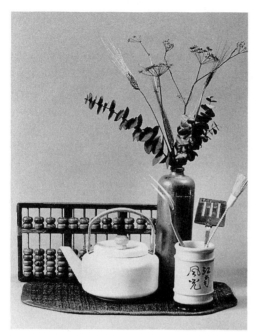

FIG. 3.4 *Still life sample.*

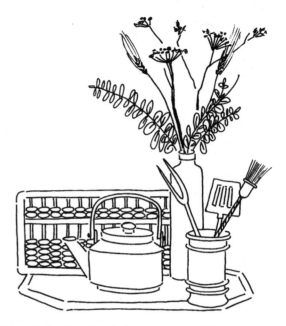

FIG. 3.5 *Simplified drawing of still life.*
© 1986 by MONA BROOKES/Published by Jeremy P. Tarcher, Inc.

Choose the Paper and Supplies

I recommend a paper at least 9" × 12" for Level 1, to allow for the grosser motor coordination and room for the tall flowers. For Levels 2 and 3 you can easily use sheets 12" × 14" or 11" × 13". If you don't have the larger paper, just do more eyeballing and keep the scale of things small. We will stick with the markers this time, but after you read about other media, you might want to come back and redo this lesson with pastels or pencil.

Imagine Your Main Subject in the Drawing

Since the central theme seems to revolve around the teapot, we will draw it first. Begin to project the image of it around on the blank paper; consider its location, and imagine how big you want it.

Imagine Your Whole Composition

For the sake of following the lesson, we all have to start with the teapot. So no matter what composition you plan, you will need to consider your teapot down front somewhere. This will make us consistent, since we all need to draw what is in front first. Start turning the paper itself from the tall direction to the sideways direction and imagine your composition both ways. The two examples drawn in Fig. 3.6 show how the composition can work either way, but notice how the height of the vase and flowers are altered. If you are doing the drawing at Level 1, play with different arrangements of the teapot and vase. If you are starting at Level 2, add the kitchen utensils to the planned composition, and if you are at Level 3, further add the abacus. All levels will add the mat last, in order for it to mold itself around all the drawn objects.

Make Preliminary Sketches of Your Ideas

Take a sheet of scratch paper and draw your freehand boxes to plan your composition in. Remember to use some tall

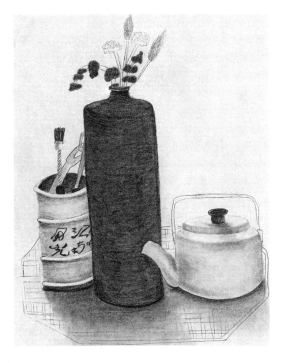

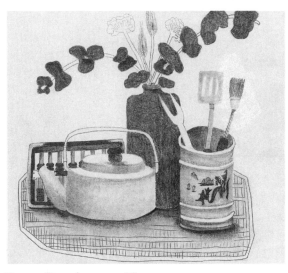

Renee Corwin—age 10

FIG. 3.6 *You can alter the sizes of things to create the composition you want.*

and some sideways examples to play with. When you and the children have chosen your composition, you are ready to start.

BEGINNING

Since we have already determined the teapot to be the central theme and are choosing to put it in front, we will naturally start with it. Draw the general outline of all your objects by following the same steps as the instructions. Get all the objects into your composition and then go back and insert all the detail, decoration, texture, shading, and coloring in.

As in the previous lessons, the elements being discussed will be drawn in dotted lines and then converted into solid ones as we pass on to the next instruction.

The Teapot

In deciding what part of the teapot to start with, we will follow the same process of considering what its central purpose is. Most basically, a teapot is a container that pours out its liquids. So the two most central points would be the hole in the pot and the hole in the spout. I've found it's far easier to build off the hole in the pot than the one in the spout, so we will start there. But wait: This time the hole of the container is covered by a lid. So we'll start with the lid. And since the knob is the most central part of the lid, we will start our drawing with the knob.

1. *Begin with the knob in the lid.* Have the child show you where he intends to start his knob, in order to avoid premature starts. Check that the knob starts low enough on the page to allow room for a taller vase and long-stemmed flowers. Then check that the knob is high enough for the body of the pot not to go off the bottom of the page.

Draw an *elliptical (flattened) circle* for the top of the knob. The size of your knob will completely determine the size of the teapot, so eyeball it well and keep it small. With four- and five-year-olds who have not quite controlled their small-motor coordination, you can take a piece of scratch paper and help them practice small circles first. Having started with a small knob, the rest will go fairly well. Then draw two *straight lines*

to form the stem of the knob and a *curved line* across the bottom to define the edge.

2. *The lid.* Notice how the circle that forms the top rim of the lid goes behind the knob and is broken into a curved line. You can have a small child trace the swing of the curve with his finger in order to check out how big he plans to get. You need to keep projecting the image of the whole teapot on the paper, to avoid running off the bottom.

Draw a *curved line* from behind the knob, around the front, and back to the opposite side of the knob where you began. Then draw two *straight lines,* one on each tip of the ellipse, to make the sides of the teapot lid. To make the bottom edge of the lid, draw a *curved line* that follows the same curvature as the top edge above it.

3. *Body of the teapot.* Draw two *straight lines* slanting out and down from the bottom edge of the lid, in order to form the sides of the upper portion of the teapot. Then create the edge that runs around the front of the pot by drawing another *curved line* that follows the same curvature as the bottom of the lid above it. Draw two *straight lines* for the sides of the midsection of the pot, and then another *curved line* to create the edge around the bottom of it.

4. *The foot.* Draw two tiny *straight lines* to indicate the sides of the foot, and then come around the front with yet another *curved line* to form the bottom of the pot.

5. *The handle.* You can draw the handle in a simplified way for Level 1 and a more complex way for the higher levels. The instructions will be given for the simple version, but if you look at the photograph, you may decide to try a more complex construction of the brackets and handle attachments.

Simply make an upside-down *U-shaped curve* on either side of the upper portion of the body, to form the brackets that your handle will attach to. Next draw a *curved line* from the inside of one of the brackets over to the inside of the opposite bracket. Don't worry about making your handle have the same curvature as the model. Make your handle curve fit the size and style of your teapot. Then *double that curve* and close

off the end with a tiny *straight line,* so that your handle will have the thickness it needs. Make the bolts that hold the handle onto the brackets by placing one *flattened dot* on either side of the bracket and handle where they join together.

6. *The spout.* It is very common for young children to be displeased with the appearance of teapot spouts. I find the main reason has to do with them starting the spout on the side of the pot, doubling it, and then realizing it is too skinny and slants in the wrong direction. This problem is pretty well eliminated if you have the child start with the central idea of the spout and the hole, and then build back down to the pot.

Place a small *squashed circle* somewhere across from the handle brackets on the side you want your spout to be. Notice where the top edge of the spout attaches to the side of the pot, and draw a *straight line* slanting over to it. Then notice where the bottom edge of the spout attaches to the side of the pot, and draw another *straight line* slanting down to it.

Save any shading, texturing, or adding of detail to the pot until after you have drawn the general structure of the rest of the objects. It's less frustrating this way, if you want to make any corrections.

The Vase of Dried Flowers

Since the central function of the vase is to contain, we will start with the hole. The hole of the vase in the photograph is much higher than some of the examples in the student exhibition. This is definitely a case of the artists taking the liberty to shorten it, in order to make the most of the paper and leave room for tall and beautiful flowers. If you intend to place the vase a bit behind the teapot, take your time drawing in the opening. You want to plan it so that at least some of one side of the vase shows from behind the teapot, or it can look quite cut off and stunted.

1. *Begin with the hole.* Have the child show you with her finger where she plans to start the opening of the vase. If you want an overlapping effect, place the vase hole above the teapot at any point that will allow the vase to fall partially behind it. If the child is a bit off, get her to eyeball again and move her finger herself. She needs to retrain her own eyes

rather than become dependent on your finding the spot for her. Keep talking about and showing her the relationship of the different objects to each other, while she projects the images of the shapes on the blank paper.

Draw a small *squashed circle* for the opening of the vase. Don't let it get too big, just big enough to allow several stems of flowers to fit down inside it.

2. *The rim.* Draw two short *straight lines,* one on each tip of the ellipse, coming down for the sides of the rim. Come around the front of the vase with a *curved line* to form the bottom edge of the rim.

3. *The neck.* Draw two short *straight lines,* one on each side of the rim, coming down to form the neck of the vase.

4. *The body of the vase.* Use the principle of mirror imaging as you attempt to make the two sides of the vase the same; be alert and take it slow. Your vase is not going to be the exact same shape as the one in the photograph, so after you draw one side of your vase you don't need to refer back to the photograph. Look at the photo model to get the general shape, draw one side of your vase, and then study the shape of your own vase and duplicate that shape in reverse on the other side.

Draw one short *curved line* for the bulge at the top of the vase. Draw the side of the vase by using a *straight line* to come down to where you want the vase to end. If you are going to put the vase behind the teapot, it should end before the bottom level of the teapot. This will create the appearance of the vase being farther back in the picture than the teapot. Then use your mirror image trick: Reverse a *curved line* on the other side for the bulge, and come down with a *straight line* to form the other side of the vase. If you are overlapping and run into something, jump over and keep going where appropriate. Then close off the bottom of the vase by using a *curved line.* If you have overlapped, part of the bottom of the vase may be hidden and your curved line may go directly up against the teapot.

5. *The anise plant.* Many small children begin their stems on the outer edge of the hole of a vase and need to be shown how to place stems all the way down into the hole. If the stem

a

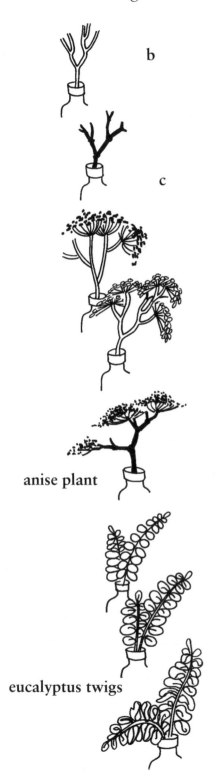

b

c

anise plant

eucalyptus twigs

is light in color, the line depicting the opening of the hole will show through. This is a natural phenomenon in children's art and doesn't need any correction. As you both grow in sophistication, you will be able to plan as is necessary to avoid such lines.

The stem. Consider some possible options shown at the side of the page. You may want to draw the stems with a fine-tipped marker, as in examples a and b. You could draw with a color that is darker than you plan the color of the plant to be and then color it in with that lighter color later. Or you may want to draw them with a broad-tipped marker, as in example c, and let the bulges occur where the branches join. This effect is created by letting your hand hesitate momentarily at the joint of the branch and allowing the ink to blot a bit before continuing.

It is common for beginners and young children to forget to allow enough room for the blossoms at the top, so you might need a tiny *guideline dot* somewhere to indicate the height of the branch. Don't even attempt to make the same branch designs as the one in the examples. Make as many *straight, angled, or curved lines* as you need to form the type of branch that will fit your composition.

The blossoms. Again, look at the different options in the examples and decide which type of effect you want. Of course you are not limited to these choices and may think of other ways to use the markers.

Draw some combination of single or double *curved or straight lines* to form the little twigs that hold the seed pod endings that are left on the blossoms. Since these are dried anise plants, the petals have all fallen off. Then use any style of *dots or little circles* to form the seed pods on the tops of the plant.

6. *The eucalyptus twigs.* To add variety to your picture, you may want to start using colored fine-tipped markers to draw in the stems and leaves. It is not too early to think about what color they are going to be, so that you can use a marker that is complementary and darker. Draw as many as you want to work in your composition.

First form the number of stems you want by drawing thin single or double *curved lines. You* may have to start making them fit between the anise stems, so remember to jump over and keep going as you run into something. Consult the margin for three examples of ways to draw leaves, and then draw some of your own using those guidelines. Suit the complexity of the arrangement to your level. Notice that in all variations the leaves get smaller as they progress to the top of the stem.

7. *The wheat stalks.* Things may be getting fairly crowded at the vase opening by now, but you don't have to show each stem actually going into the hole. One wheat stalk by itself can look pretty lonely, so make several popping out from behind the other flowers. They have such skinny stems that it works out fine.

Draw thin *curved lines* for the stems, breaking them to allow for overlapping if necessary. On the end of each stem, draw a *pattern of dots,* then swing some *curved lines* out from the cluster.

wheat stalks

FINISHING TOUCHES FOR LEVEL 1

These instructions are for Level 1 only. Levels 2 and 3 may jump to Level 2, Adding the Kitchen Utensils, and continue adding objects to their drawings.

At this point you will not be drawing any more objects, so let's complete your composition. You can always take the liberty at the end of a project to add more. When you are finished drawing all the objects in the still life, you will want to ground the objects in some way, or they will look like they are floating in air. Study Fig. 3.3 again, and notice the different ways that placemats were incorporated for this purpose. Draw in a mat, making the back-edge line jump over the objects and show between them.

Finish the drawing by coloring and adding detail. Give free reign to your color choices. After years of working with people on color theories, I find they usually know best what they want and are capable of working out beautiful ideas that don't quite fit any of the theories. Refer back to the drawing tips section to make use of ideas on flat, textured, and shaded effects if you wish. It is highly recommended that you do not try to color in the backgrounds of still life with flat color. The mark-

ing pen doesn't seem to lend itself to this, and you will usually end up with a streaky and distracting result. Discourage a child from making a lot of zigzag lines to cover up the blank paper in the background. Zigzag lines, with white paper showing through, pull the eye right to them and away from the subject at hand. The background of white paper makes a lovely contrast to set off the articles in the still life. When you later use other media, such as watercolor or pastel, it will be possible to lay in a light background color that won't be distracting.

After you complete this project, you can jump over to the section Building Your Own Still Life and begin your adventures together.

Level 2: Adding the Kitchen Utensils (Level 3 Continue Here Also)

Refer back to your preliminary sketches and determine where you are going to place the cup of kitchen utensils in your drawing. You can alter your plans and make more sketches if you wish. Level 3 needs to allow for the addition of the abacus, along with any changes. Help children find where they will want to add the object by talking about it first, eyeballing the distances, and imagining how overlappings will work out, depending on where they start.

The central function of the cup is to contain, so we'll follow our formula and start with the hole. But this time we'll draw the hole opening so that the line won't show through the objects that go down into it. Level 2 and 3 children usually have no problem in grasping this idea. They will simply draw the front of the opening and put the back edge in after the utensils are in place. Since there is no way for me to tell how your cup of utensils may overlap with other objects, I will draw them standing alone and let you make any adjustments necessary to fit them into your composition.

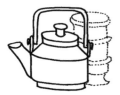

BEGINNING

1. *Begin with the hole in the cup.* Consider some kind of overlapping this time. The drawing in the margin is an imaginary example. Get the child to show you where he intends to place things, and talk him through it. Be sure to project an imaginary image of the utensils onto the drawing, along with the cup, in order to allow enough room for them at the top.

Draw the front half of your oval circle, including the tips, by using a *curved line.* If your curve is interrupted by another object, jump over and continue on the other side. If it would be too long to continue on the other side, let the curve butt up against the object and stop.

2. *The rim.* Double the front edge of the opening of the cup by drawing another *curved line* all the way across the front.

3. *The body of the cup.* Notice that the body is a series of straight sections, which are spaced apart by rims made out of double curved lines. It is not important how many of these rims you put on your cup. Simply draw as many as you need to fit the size and placement of your particular cup.

Draw a *straight line* down each side of the cup to where you want your first rim. Then make a *curved line* across the front of the cup. When you double the rim by adding another *curved line,* let it bulge out each side a little to form the extended appearance. Repeat this same process for the number of sections you choose. Then make a final *curved line* to form the bottom of the cup.

4. *The foot.* Draw two *inward curved lines* to form the sides of the foot and another *curved line* to finish off the bottom of the cup. If you have placed the cup behind another object, then you want the cup to end above the bottom of that object, in order for it to look as if it's farther back in your picture.

As you add utensils into your cup, you will notice that you and the children will all be confronted with different instances of overlapping. Due to the differences in placement and sizes of objects, some of you may already have flower, stems, or the handle of the pot to deal with as you sandwich in the utensils.

In order to help you know that it will all work for you, I don't want to make the example in any one form. So with each instruction, I will change the arrangement of articles. This will give you many examples to observe and will help you develop solutions to the arrangements you and the children have arrived at.

5. *The fork.* You can place the fork in any part of the cup and at any angle that works for your arrangement of objects. If you are near the top of the paper, you may want to make a shorter handle to allow more room for the prongs of the fork. We will draw the handle first, so that it will fit into the cup properly, and then add the fork on the top.

Make a *guideline dot* where you want the prongs to begin. Draw a *straight line* from that point down to the front rim of the cup. Use another *straight line* to double the handle, but notice that it is narrower at the top than the bottom. Draw a *curved line* from the handle up to the point of the prong on each side of the fork. Then make a long *U-shaped curve* that starts at one point of the prong, dips down to the middle of the fork, and then rises to form the other pointed prong.

6. *The basting brush.* There are endless ways to draw the spiraling handle of the brush. Examples a, b, and c in the margin give you some ideas to play with. If things are getting crowded, don't hesitate to run the handle behind other objects.

Draw a *dotted straight line* this time to place the handle in the cup. The dotted line allows for individual interpretations of the spiral effect on top of it. Now double the handle with another *dotted straight line,* but keep it skinny, and add your way of creating the spiraling. Make a *U-shaped curve* to form the pocket for the brushes to fit into, and run a *straight line* across the top of it to make the edge. Make the edge double by two little *C curves* at the ends and another *straight line* across the top. Then draw a lot of *thin straight or curved lines* for the hairs of the brush.

7. *The spatula.* Things are probably getting quite crowded by now, but challenge yourself to get everything in there. We will do the handle first again, in order to fit it into the cup properly. But before you draw the angle of the handle, it will

help to project the image of the spatula turner into the overlapping problems. Then you can make a handle that will facilitate the direction of the turner. Have a child make a couple of guideline dots if she needs to.

Draw the little square on the end of the handle first with four *straight lines* converging at *angle corners*. Draw a *straight line* to form the bottom edge of the turner. Notice that the top edge is shorter, jump up to where you want it to be, and form it by drawing another *straight line*. Then make the sides of the turner by drawing two more *straight lines*. Make as many holes as you want in the turner with *long ovals or rectangles,* depending on what fits your style.

8. *Back edge of the hole in the cup.* Complete the oval circle shape of the hole by making *short straight or curved lines* between the utensils in the cup along the back edge.

FINISHING TOUCHES FOR LEVEL 2

These instructions are for Level 2 only. Those who are at Level 3 may jump to Level 3, Adding the Abacus, and complete the drawing.

You will not be instructed to add any more objects to the drawing, but if you have something else you want to place in it yourself, take the liberty to do so now. If you feel confident after this experience, you may be ready to go on to Level 3 and add the abacus.

After you have all the objects that you want in your still life, notice how they seem to float on the paper in midair. In order to ground the objects and finish off the picture, we will add a mat for them to sit on. Go back to Fig. 3.3 and study all the different ways this can be accomplished. Use your imagination and draw in the outline of the mat you want. Don't worry if some of it runs off the paper; this can have a lovely look. Jump over all the objects as you draw the back edge of the mat, so that it shows between them. Consider original ways to decorate the mat and finish off the edge of it.

As you color and shade your drawing, free yourself as much as possible regarding detail design. Encourage the children to try out ideas on their test paper, and really put thought into your choices. It is recommended that you leave the white paper as a background. Marker ink does not work well in still

life backgrounds; it becomes streaky and can cause a distraction to the beauty of the overall drawing. Especially discourage the tendency to make zigzag lines to fill up spaces. These create a great distraction to the eyes.

When you have finished your project, jump over to the section Building Still Life Arrangements, and begin the process of setting up future drawings together.

Level 3: Adding the Abacus

The reason I chose the abacus for Level 3 is because this object requires a high degree of concentration and patience from the artist. In this way, children can learn to enjoy the time-consuming aspect of drawing fine detail, instead of feeling it is a drudgery. Drawing takes an appreciation for patience and discipline that most of our children lack. If they try to rush through drawing this object without that appreciation, it will show. Chances are their abacus will be quite crooked, the rows of beads will be jumbled, and it may have a nonfunctioning appearance. As children learn to meditate on the task and have patience and focus, parents tell me they transfer this attitude to other aspects of their lives. We can certainly all gain from this type of relaxed concentration in our busy and pressured lives.

Refer back to your preliminary sketches and decide where you want your abacus to fit in the drawing. If you have made changes during the drawing and want to alter your plan, take the time to make some more sketches before you decide. Think of the size and direction that will complement your drawing, and project the image of it into your composition.

This object has such a uniform design, there is no central point in its construction. Its outer edge is actually the characteristic that is most basic to its shape and how it will fit into your drawing, so we will start with forming its outer edge. Most of you will have only a portion of it peeking out from behind, unless your arrangement is highly unusual. So you and the children might start by putting a guideline dot at each place one of the corners will show. Notice that the corners of the abacus are slightly rounded when you deal with joining them to the straight edges.

BEGINNING

1. *Begin with the outside edge.* Make very short *open curves* at each corner of the abacus that will be showing in the drawing. Draw *straight lines* from one corner to another, with breaks in them wherever something overlaps. If this entails a lot of objects and overlappings, eyeball the line as a whole first, then use your trick of "stop, jump over, and keep going."

2. *The frame.* You have drawn the outer edge of the frame. Now you need to draw the inside edge, the brackets, and the main bar across the middle. Notice that the bar that divides the two sections of beads is above the middle, and that there are two rows of beads on the top and five rows on the bottom. This is one of those lessons in which you can add a little history and explain to children what the abacus is and how the beads are used to calculate mathematics.

Place a *guideline dot* in each one of the corners again, on the inside edge of the rim. The corners of the inside rim are not rounded and you can use *straight lines* to join them together. Make the rim wide enough to allow for the bracket to fit in between the edges. Divide the space left inside the abacus with the middle bar of the frame, leaving more room in the bottom section than the top. Draw two *straight lines* across that create the same width as the outside rim of the frame. Study the shape of the bracket and add one to your drawing that will fit the size of your frame. It does not have to have the exact same design as the one in the example, but since its function is to hold the two pieces of frame together, it needs to make a T shape over the spot where they join.

3. *The counting beads.* It is not necessary to make all 13 rows of beads, but in order to keep the character of the abacus it is important to make 5 beads in the bottom rows and 2 in the top. Since you don't want the sticks to show through the beads, we will draw the beads first.

Use *flattened circles* to draw in the beads, and then *double straight lines* to form the sticks that hold the beads.

It is not necessary to make every bead perfect, but you will have to concentrate more than usual just to get them similar. So if you see a child rapidly making circles to "get it over

with," don't be surprised if he is dissatisfied with his results. Encourage your children to build the patience and attention span necessary for developing themselves as artists. As an added reward they will also be building the kind of concentration and patience necessary for achievement in other areas of their lives.

FINISHING TOUCHES FOR LEVEL 3

After you have drawn in the general shape of all the objects, you will notice them floating around on the white paper as if they were in air. Placing a line across for a tabletop can be a bit simplistic, so let's make a fancy mat to contain and ground the objects. Refer back to the student exhibition in Fig. 3.3 and get some ideas from the different mats you see in the drawings. Then draw the outer edge of your mat into your composition, being sure to go between all your objects on the back edge. There's no problem if it runs off the paper at some point; this can actually cause an interesting effect.

Some real thought and planning should go into your color and finishing touches. Any drawing that takes a lot of energy and focus for its general outline needs an equal amount of consideration and development for the detail completion. If the child is tired, you might put the drawing up to finish another time.

When you are ready to continue, talk about ideas and use your scratch paper to develop beautiful color blendings. Consider uses of thick and thin line, shading, flat color, and texture. It is recommended that you do not try to color in your background. Going in between all the flowers and objects after the fact causes a rather blotchy and distracting look with the streakiness of markers. Other media, such as watercolor or pastels, are more appropriate. In general, white paper for a background is most effective, but you can also try light-colored papers for still life. Of course, discourage any zigzag lines to "fill up" leftover spaces. This causes a real visual distraction.

You have really learned all you need in this lesson to go on to creating still life arrangements for yourselves. Whenever you are ready, read the next section, and look forward to a truly limitless source of challenging projects.

Building Still Life Arrangements

With this lesson completed, you can now construct projects of your own. You will follow the same steps for them as you did in this lesson, so let the experience you had with it guide you in your choosing and arranging. For example, if a child had trouble overlapping more than one object in the lesson, then you know to stick with a couple of objects for a while; or if a child had difficulty with the complexity of the teapot, then you know to pick some objects that are even simpler. Most important is to develop that attitude of it being part of the process to explore and learn together. The minute you set performance expectations and want to produce framable products, the fun can go out the window.

Open yourself to your whims and your fancies. Any inanimate object can be used. One of my greatest lessons was inspired by a six-year-old who wanted to draw the bottom of her shoe. Once we stopped laughing and listened, it turned out that the form of Miss Piggy was depicted in raised images on the sole of her tennis shoes. She took them off. Some students drew Miss Piggy, while others drew the tennis shoes themselves. After I witnessed the incredible results I listened more attentively to the children's suggestions. Consider everything in view as a possibility. A race car's exhaust pipe, cut up, mounted, and filled with dried flowers, became a wonderful subject, as Fig. 3.7 reveals. A Garuda statue from Bali, Fig. 3.8, presented an exciting challenge in detail and line.

As you choose and arrange objects for still life projects, keep in mind some general suggestions:

- Consider all objects as possibilities.

- Consider parts of any object as usable in some way, even if only a small section, an aspect of the design, or the particular color or texture of it.

- Imagine objects in combination with other objects, or abstracted in a design with each other.

- Explore where you live, both indoors and out, and look at everything as a possibility for drawing.

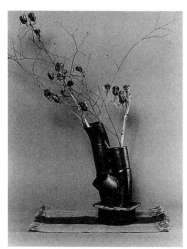

FIG. 3.7 *Consider everything as a possibility. A race car exhaust pipe filled with dried flowers becomes a beautiful subject.*

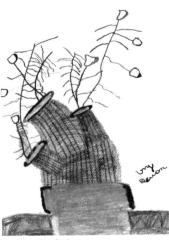

Devin Holiday—age 9

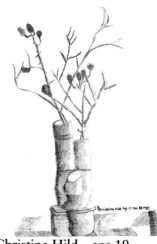

Christina Hild—age 10

FIG. 3.8 *A Garuda statue from Bali becomes a challenge in exciting thick and thin line.*

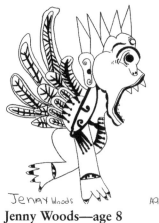

Jenny Woods—age 8

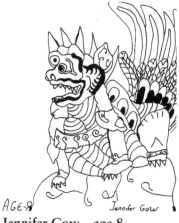

Jennifer Gow—age 8

- Collect the possibilities that interested you the most, whether you are sure they go together or not, and take them to your still life table. If you have trouble choosing, you can always save alternate choices for later projects.

- Play around with the arrangement. You may have to make a few exchanges in order to come up with a combination you like. Remember, you don't have to put them into your picture in any particular way, and you have the freedom to abstract, overlap, change, and add on as you go along.

- Choose at least two to start with. Or perhaps use one object, such as an animal statue or toy model, as a center of interest, and then make up an entire background scene from your imagination. You could try drawing a toy truck into a scene with farm animals and a barn, for instance, or into a construction site with office buildings in the background.

The student exhibit in Fig. 3.9 displays some typical still life arrangements. Here are some additional suggestions for traditional objects you can use:

- Teapots, canisters, and similar kitchen utensils.

- Bowls, cups, glasses, bottles, and jars.

- Plates, trays, or similar flat objects.

- Vases, flowers, and potted plants.

- Fruits, vegetables, and foodstuffs.

- Baskets, cornucopias, weavings, placemats.

- Candle holders, candles, knickknacks, and statues.

- Drapes, textured or patterned clothes, and scarves.

As less typical objects occur to you, remember to consider things that are important to the person who will be drawing the objects. The student exhibit in Fig. 3.10 offers some unusual and individual subjects that encourage creative results. Here are some more:

Tamara Sheanin—age 9

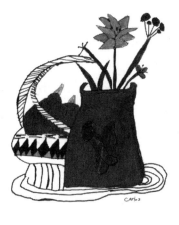

FIG. 3.9 *Typical still life subjects.*

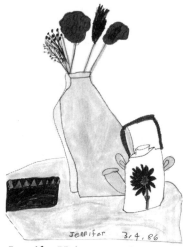

Jennifer Heim—age 6

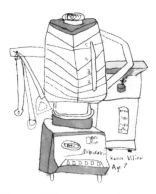

Kareen Vilnai—age 7

Kristen Todd—age 14

Susan Van Blaricum— age 11

FIG. 3.10 *Unusual still life subjects.*

- Sports equipment: a tennis shoe, roller skates, a hockey helmet and stick.

- Desk and school items: a clown-shaped lamp, a lunch box, cans of pencils, a typewriter, books.

- Toys: stuffed animals, dolls, dollhouse, trucks, statues of favorite characters, knickknacks.

- Personal items: a fishbowl and the package of fish food, a musical instrument and the music stand, a favorite modern statue in the living room.

Needless to say, any object, texture, mood, or shape can inspire a rewarding and successful drawing experience. The trick is to keep an open mind, teach yourself what you like, and enjoy exploring the process that each project leads you through. Remember, as an artist you might not like many of the finished products, but they all serve as growing experiences toward the ones that give you a rush of satisfaction and appreciation.

In this lesson you have learned to incorporate real objects into your drawing world. Now you have a formula for choosing projects from graphics and inanimate objects and rendering them into realistic drawings. You have learned how to use a drawing process that involves training your eyes to see the edges of everything and to duplicate their shapes on paper. You are now well on your way to handling any subject that you wish.

Many students come to me from drawing classes that have started with shading and that teach drawing objects by their volume. In other words, they are expected to capture the volume of the objects and the background by duplicating the subtle gradations of light patterns and shadings, without using any lines to denote the contour edges of the objects. These students tell me that they have found that the more the teacher asked them to "see" the shadings, and not represent shape by contour line, the more lost they felt. It has been my experience that once children or beginners are allowed to experience contour drawing first, they really have no difficulty adding volume and shading to their repertoire later. If you take the approach that is offered in the next lesson, I expect you will follow suit.

You will learn the process I call volume drawing in the next lesson. Instead of defining objects by creating the contour edges, you will learn to see the difference between positive and negative space and block in contrasting areas of light and dark to define objects. Some very young children may need to wait a bit to take in this added dimension, but it all comes at the right time, and there is never any need to rush it. After some exposure to volume drawing and some practice with live subjects and landscape, you will have covered a full range of experiences and truly be able to tackle any combination of drawing styles.

Volume drawing can provide a different kind of expression. It is the road toward drawing with the subtleties of other media, such as watercolor and pastels, as well as the excitement of live models, such as people and animals. And if you are interested in oil painting, it is a good background for that transition as well. So I encourage you to approach the subject with an open mind and a lack of concern.

After your experiences with contour drawing, the transition to volume drawing should come easily. Follow the same advice and take pleasure in the process. I encourage you to eventually blend contour drawing and volume drawing into a synthesis and style of your own.

Volume Drawing

So far you've been doing contour drawing, which is looking at the edges of an object and creating lines on the paper to represent those edges. You were also indicating volume as you finished up your pictures with shading and texture. In this lesson you will learn a new way of creating shapes and indicating edges. You will focus more on creating a three-dimensional quality, where the edges of objects are not defined by lines.

In volume drawing, the contrast between areas of light and dark or differences in texture form the edges of objects This technique can have a more sophisticated look and lends itself to subtle gradations of shadings and a more realistic appearance to objects. For this reason, it is essential to use volume drawing principles in order to draw such things in the environment as landscapes, animals, and people. The student drawings in Fig. 4.1 demonstrate this technique applied to many different types of subjects—flowers, still life, landscapes, and people.

In this lesson we will study the characteristics of positive and negative space by drawing some tiger lilies. Since flowers do not present problems in perspective, things will be kept simple. In the next lesson you will be able to use this technique with more complex subjects—life drawing, faces, and landscapes.

Beginners often lack confidence when it comes to this technique, so don't be surprised at a few groans and furrowed brows. We won't teach the lesson at different levels, so that everyone can start with the basic steps. Encourage a balance between relaxation and concentration with children, if they have difficulty. Some four- to six-year-olds may not be quite ready. Continue with contour drawing projects, and reintro-

duce the idea every two to three months until they find their way. There is no "right" age to be "ready," so there's no hurry.

To accomplish volume drawing, it becomes important to develop a visual awareness of positive and negative space. You have been dealing with these concepts spontaneously as you learned to eyeball how shapes related to each other on the page. Let's consider what the terms mean.

The Positive and the Negative of Space

The fact that the terms *positive space* and *negative space* don't represent the observer's experience seems to confuse people. Everyone can understand that the term *positive* relates to putting (positing) lines and shapes on the paper, but as soon as the word *space* is added, they falter: "How can a mark or shape on a paper be represented by the word *space*, when space is empty?"

The concept *negative space* seems to elude us even more. People resist being told to pay attention to the shape of *negative space* when they believe that negative space represents *nothingness*. So without having to argue the age-old problem of nothingness versus somethingness, let's find a way to make them equal in consideration. All spaces are equally full when I think of them as containing different densities of matter. Some matter is dense enough to be seen with the human eye, and some so fine that it can't be seen. But just because we can't see what is there doesn't mean it is empty or should be disregarded. Scientists use their instruments to record some of the various types of matter to be found in so-called empty space. I will use the term *positive space* for space that is occupied with matter dense enough to be seen with the human eye, and I will use the term *negative space* for space that is occupied with matter so fine that it cannot be seen with the human eye. This may seem trivial and unrelated to the subject of drawing, but it isn't. The person who thinks of air as nothingness disregards its shape. You need to regard the shape of the spaces between objects in order to perceive the whole picture and draw the objects in proportion.

Brian Dodero—age 12
Chalk pastel still life.

Krisztianna Ecsedy—age 12
Pencil study of own hand.

Michelle Bourke—age 14
Pastel pencil of live birds.

Barbara Barr—adult
Oil pastel still life.

Michael Powell—age 11
Pencil study of local house.

Brook Adams—adult
Oil pastel inspired by the Masters.

FIG. 4.1 *Student exhibition of volume drawing.*

Treating positive and negative space as equal visual components is one of the keys to developing your ability to draw. By drawing the shapes of the spaces between objects (negative space), as well as the objects themselves (positive space), you become more accurate and can solve proportion and composition problems. We'll do some warm-ups that will train your eyes to observe the differences between negative and positive space.

WARMING UP TO POSITIVE AND NEGATIVE

The following exercises are designed to help you get used to seeing positive space and negative space as two equal aspects of the same field. Once you understand the process, you and the children can invent your own exercises to train your eyes.

1. Study the example in Fig. 4.2 and notice how it is the same design on both sides, with the black and white reversed in the two images. For the sake of these exercises, we will call the white portion of the design the negative space and the black portion of the design the positive space.

2. Use a black broad-tipped marker and your photocopies of the exercises shown in Figs. 4.3 through 4.6.

3. Take the first exercise, Fig. 4.3, and notice the shapes of the white negative space. In order to draw this negative space, take the black marker and copy the size and proportions of those white shapes into the empty box at the right. You will have duplicated the white negative spaces in black ink and created a reversed pattern like the one shown in the example.

4. As you draw with the black marker you can make a general outline of the shape you are forming, but notice as you color in the shape it will not retain an outlined edge. In fact, you can make adjustments to the edges and change the shape once you start coloring it in. This is one of the advantages of volume drawing. It means that you have not boxed yourself in with an outline edge and can continue to shift the shape of things by altering the sizes. The severity of black and white doesn't lend itself to this as easily as the shadings of color that you will use in drawing projects. It is

FIG. 4.2 REVERSED IMAGES *Notice how the positive and negative space reverses in the two images. For the purpose of these exercises we will consider the white portion the positive space and the black portion the negative space.*

FIG. 4.3 *Positive and negative space exercise.*

FIG. 4.4 *Ending up with a white figure.*

FIG. 4.5 *Ending up with a white tree.*

the training of the eye that is important, not a perfect like-
ness of the example. So if the first attempts are a bit off, just
try again and don't suffer over it.

5. Follow the same process for the next two exercises, as
 shown in Figs. 4.4 and 4.5. You should end up with a re-
 versed design image, the man with the hat being white with
 a black background, and a white tree with a black back-
 ground.

Drawing negative space this way makes you aware of its
presence and importance. You can make up this kind of exer-
cise and use it like puzzle games with children in moments
between drawing sessions. You can take three-dimensional ob-
jects, set them against a white background, and play the same
game. The photograph of the bentwood chair and its negative-
space drawing in Fig. 4.6 is an example of how this is done.

The simplicity of the black and white causes a condition in
which it is easy to see the positive and negative. It helps the be-
ginner to be visually aware, but it is too stark a result to be
used in drawing itself. Life is never as simple as black and
white. We need to expand our awareness, use gradations of
shading, and develop a more realistic interpretation of what
we want to draw. The next exercise will explore this by using
gradations of gray between the black and white.

**FIG. 4.6 NEGATIVE SPACE DRAWING OF A
BENTWOOD CHAIR** *You can place objects
against a light background and make studies of
the negative spaces.*

WARMING UP TO SHADES OF GRAY

This time you will be copying the patterns in the shading exercise shown in Fig. 4.7 instead of reversing images.

1. Use a black and two shades of gray broad-tipped markers, along with your photocopy of the Fig. 4.7 exercise.

2. Study the exercise and notice how there are now four shades of light to dark instead of two. The white paper represents the negative space and the gray and black represent the positive spaces.

3. Use the blank square to copy the images of the sample. Start with the lightest gray and block in the shapes that you see. You may find that you draw the edges of the shape a bit with the marker as you block in the color, but you are not actually drawing an edge. As you shift the size and shape with the broad tip you will end up with flat areas of color with no outline edge. Notice how the shape you are drawing relates to the shapes of the white negative space, as well as the shapes of the dark gray and black positive space.

4. Now copy the shapes of the darker gray in the same manner, watching how the shapes you are blocking in relate to the white negative space and the light gray and black positive spaces. Notice that you can alter the edges of the light gray, if you want to, by overlaying the darker gray on top. You now can experience the advantage of volume drawing. If you start with the lightest color, you can continue to alter shapes as you overlay darker and darker colors on top of each other. This will be true in using watercolors, pastels, oil pastels, and eventually oil paint. With ink and watercolor you can never reverse the process and overlay light on top of dark, but with pastels and paint you have the added advantage of being able to overlay colors in either direction.

5. Lay in the shapes of the black, noticing that you can alter the shapes of the grays even further if you wish.

6. Follow the same process to complete the other two shading exercises, in Figs. 4.8 and 4.9.

FIG. 4.7 *Shading exercise.*

FIG. 4.8 *Shading exercise.*

FIG. 4.9 *Shading exercise.*

As usual, don't fret if you end up with inexact replicas of the samples. It is the process of training your eyes that is important, not the finished product. Encourage children to be as accurate as possible without causing stress. When you use this technique in drawing it will not be important to accomplish exact duplication. You will need only to accomplish similar structure of shape and gradations of shading to make a recognizable drawing of an object. This will allow the freedom for individual interpretation of feeling and style.

You might want to refer to other drawing books for ideas on how to shade and create volume in your drawings. Since most of them do a good job of covering the basics, I felt it was not important to repeat the information in the same format. Nonetheless, I do want to share a few tricks I use to help young children begin to feel comfortable with the complexities of shading. What is important is that you begin to see these gradations of shading in color as they appear in the real world. The shadings follow consistent patterns that come from the source of electric lights or the sun. If you don't follow these natural patterns, your drawing can look "off." If you simplify things and control the light source for the beginner, it can speed up the process of learning.

WARMING UP TO THE LIGHT AND DARK

The eventual goal is to be able to look at a scene in the environment and duplicate the gradations of light and dark shadings that you see into your drawing. It is usually too big a leap to expect beginners to deal immediately with the complexities of shadings in their environment. Since multiple light sources can cause conflicting shading patterns, the problems can become overwhelming to a beginner. One way to break in slowly is to control your light sources. Here are some suggestions for drawing from the environment, from two-dimensional graphics, or from your imagination. First we will deal with the three-dimensional world of our environment.

Outdoors

The natural light source of the sun is your ideal condition. When you are outdoors you will notice that everything facing the sun is in the lightest shades, everything inside of holes or

away from the sun is in the darkest shades, and all the areas in between are gradations from the lightest near the sun to the darkest away from the sun. The main way you can control conditions outdoors is to pick a view that makes the most of the light. Best is to sit in a position with the sun over the back of either shoulder; the objects in the scene will have a consistent pattern of all being light on the same side and dark on the other, as in Fig. 4.10. Sitting with the sun directly behind you, as in Fig. 4.11, can cause more problems for the beginner, since the middle of an object will be light, and variations of shading will appear on either side of the same object. If you sit facing the sun, as in Fig. 4.12, you will cause a strain on your eyes and have to deal with silhouette patterns.

Indoor Light at Night

Since the sun is down and there is no natural light inside, you will be dealing with electric light. If you shine one bright light onto your subject you can create the same conditions as the single light source that comes from the sun. Any other lights in the room that are close enough to throw shadows need to be turned off. Place the main light to the side of the subject in order to create the half light-side and half dark-side view. Avoid shining the light directly at or directly behind the subject.

Indoor Light in the Daytime

This condition is the most difficult to simplify. Natural light comes in unnatural patterns through windows and bounces off mirrors, while electric lights confuse the issue even more. It actually helps to diffuse the natural light by closing curtains, turning off all conflicting electric lights, and shining one single electric light onto the subject. Place the light in the same manner as above.

When you are drawing from graphics or your imagination, you need to create an imaginary light source. Here is a little trick that even children as young as four can grasp:

1. Place your drawing on top of scratch paper that is larger than your drawing paper.

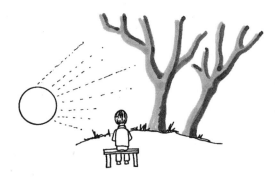

FIG. 4.10 *For the best view of shading outdoors, sit in a position with the light source over one shoulder, providing objects with consistent patterns of light on one side and dark on the other.*

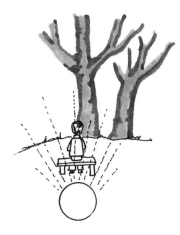

FIG. 4.11 *The light directly behind you can cause confusing light patterns, with variations of shading appearing on both sides of the object.*

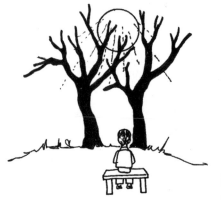

FIG. 4.12 *Facing the light source can cause eye strain and produce silhouettes rather than highlights.*

2. Decide which side of the objects in the drawing you want to be the "light sides."

3. Draw a sun on the scratch paper in a location that will cast the rays of light onto that side of the drawing, as in Fig. 4.13. Use your imaginary sun as a guide. It will remind the child that the surfaces of objects facing the sun will be the light sides, and the surfaces at the other side of the objects will be the dark sides. The child will quickly understand to grade the colors in between from light to dark. This is the procedure we will use for our tiger lily project

FIG. 4.13 *Draw an imaginary light source on a piece of scratch paper to remind the young child which side will be light and which will be dark.*

Levels 1, 2, and 3: Tiger Lilies

In the drawing of the tiger lilies in Fig. 4.14, the negative space (or the background) is a plain light color, while the positive spaces (or the flowers) are portrayed in many shadings of graduated color. You will be using several shades of colors to draw the flowers, while you observe the negative shapes of the background to help you form the correct proportions. You will draw the flowers first, leaving the background white, and then fill in the background.

In the prior projects, it was not important to draw objects in any particular size, combination, or placement. This time, in order to learn how to duplicate gradations of shading and pay attention to the sizes of positive and negative spaces, we are going to copy the photograph of the tiger lilies as accurately as possible. Expecting exact perfection is not necessary; just get as close as you can.

We will do the tiger lily project in the colored markers. Since you will not be drawing outlined edges, you will use the broad-tipped markers and complete the coloring of objects as you draw them. You are faced with the added challenge of having to translate from the black-and-white photograph into color. But this will actually encourage children to use original color schemes, instead of being tempted to copy one from the book. As you try to duplicate the shadings of color in your world, it is very valuable to be able to translate in this manner back to the black and white. Imagining what you see in shades of gray simplifies the complex world of color. This will be explained more fully in the project, as you are told to compare

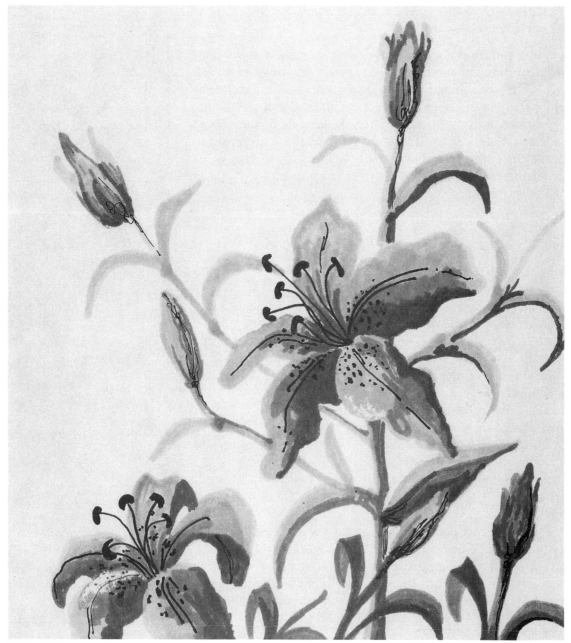

FIG. 4.14
Tiger lilies.

the lightest gray in the picture with the lightest color you will be using.

WARMING UP

With volume drawing, you need deep concentration, so your predrawing preparations are essential. Do your body and eye relaxations and some type of warm-up exercise from Lesson 1.

PLANNING

Arrange Your Sample

Place the photocopy you made of the tiger lilies in Fig 4.14 in front of you at the drawing table.

Choose the Paper and the Supplies

Since you are going to try to make a duplicate of the positive and negative spaces, it is recommended that you use the same size paper as your photocopy of the tiger lilies. If you want a larger rendition, you could have the photocopy enlarged. Place your drawing paper on a larger piece of scratch paper and draw in your imaginary sun to guide you regarding your light source.

This time you are going to choose the color scheme before you begin the drawing. You will be using the broad-tipped markers only, except for the few fine-line details on the stamen and dots of the flowers. First, decide on the color you want the tiger lilies to be. Tiger lilies are white, red, yellow, or orange, but you can choose other colors if you want. I have seen some beautiful renderings in shades of violet, blue, and even brown or gray. Now look at the black-and-white version of the sample and notice that there are about three shades of gray in the petals of the flowers. Pick a light, medium, and dark shade of the color you chose for your flower to represent those three shades of gray. Pick several shades of green for your stems and leaves and the color (or shades of colors) that you want for your background. Then pick a dark-colored fine-tipped marker for the stamen and detail lines and dots of your flowers. Test the colors that you pick for blending and compatibil-

ity on a swatch of the same paper. You can change as you go along, but this will orient you enough to get you started.

Imagine Your Subject and the Composition

Since you will duplicate the same composition, notice the placement, size, and arrangement of all the flowers, buds, leaves, and stems. Project the image of that composition onto your blank drawing paper. We will follow the where-to-start formula and begin with the center of the main flower in the drawing.

BEGINNING

Start with the center of the large open flower that is most prominent. It will not be necessary to give step-by-step visual instructions this time, since you already know how to copy shapes. If you follow the verbal instructions and take time to concentrate on the relationships of the positive shapes to the negative spaces, you should be able to duplicate the shadings in the drawing.

1. Have the child point to where he plans to start the center of the large flower. Take the dark-colored fine-tipped marker that he chose for the stamens and have him place a dot in that place.

2. Draw the stamens coming out of the central dot, then form the kidney-shaped dots on the ends of them.

3. Take the lightest broad-tipped marker that you intend to use for the petals, and block in the entire shape of the whole flower. Once you have the whole shape of the flower in the lightest color, you can go back and overlay the darker shadings on top of it.

4. Take the darkest marker; noticing the darkest shade of gray in the photograph, duplicate those dark areas on your petals. Notice how they fall in the undersides of petals or the surfaces that are away from the rays of your sun source.

5. Use the medium shade of your petal color to block in the shapes of the shading between the dark and the light sides.

6. Take your dark-colored fine-tipped pen and draw in the detail of the central lines of the petals and the dots. It isn't necessary to duplicate the same pattern and numbers of dots.

FINISHING TOUCHES

As you follow the steps to completion, notice that you continue to block in an object with the lightest color, establish the darkest areas, and then complete the shadings in between.

1. Follow the same process as above for the other flowers in the drawing.

2. Take the lightest flower color and block in the general shape of the buds. Overlay the darkest shade and the medium shade in between.

3. Take the lightest color you intend to use on your stems, and block in the entire shape of all the stems.

4. Shade the dark side of the stems with a darker green. Continue to notice how the dark side is away from your sun source.

5. The leaves on any one plant are never all the same color, so use as much variety as you can. Block in the whole shape of the leaves, with the lightest greens you intend to use.

6. Shade the dark sides of the leaves with the darkest greens, and fill in between the light and dark side with medium shades. The black-and-white photograph does not allow for a differentiation between shades of green, so this is where your judgment comes in to create a variety of leaves. As long as you make the side toward your sun source the light side and graduate the shadings toward the dark side, you will maintain the proper pattern.

7. Now you can lay in the background. Choose any color, and use either one flat shade or else several different shades. First, go around all the edges of the flowers and the edges of the paper; then fill in the negative spaces between them.

That's it. You have added one of the most valuable abilities to your artistic repertoire. This new technique will open multi-

ple doors, beyond which lie endless projects to explore. Let's put some thought into how you might choose them.

Choosing Other Projects

You can render any drawing with this technique, but some projects lend themselves to it more than others. Begin by reconsidering the subjects that you think may be too difficult to draw. In most cases you will discover it is because of the lack of contour lines around the edges. Now that you understand volume drawing, you can handle it more easily than you thought. Photographs or paintings are well suited for inspiration. Of course, your own three-dimensional environment does not have outlines around the edges of things and will endlessly provide you with subjects.

With your new ability to use shading and produce volume in your drawings, a much wider range of possibilities is open to you. You can choose to render a drawing with either contour lines or volume shading, or a combination of the two. After the next lesson, you will have the added potential of using these styles with many more subjects and a variety of media.

Keep exposing your child to projects that lend themselves to this technique. Encourage her to be patient and to be willing to experiment. Volume drawing is a road that leads to painting, so once you feel comfortable with it you will be ready to tackle a canvas.

LESSON 5

Widening Your Horizons

Now you are ready for some drawing projects that are considered more advanced. This lesson will offer tips on other media, concepts on design principles, and some guidance in figure drawing, portraiture, and landscape. The lesson is meant to give you some general principles to follow, rather than specific step-by-step drawing instruction. You will follow the same warm-up, planning, observation of elements, rendering styles, correction techniques, and finishing touches that you have used in all the preceding lessons.

As you explore the drawing of designs, people, environments, and nature, what you've learned about one area can be applied to the others. Go through this lesson doing one project for each subject, then go back and alternate between them. Be brave and try it all. On those of my class days when there is free choice of media or project, the ten-year-olds who have been around for five or six years have started opting for challenges instead of the things they know they can be successful at. Last week, a student announced with no hesitation that she didn't like the way she drew faces, went and got a mirror, suffered through thirty minutes, didn't give up, and then slowly began to smile as she said she really liked what she was doing. The secret is to drop that silent critic and get involved in the learning.

If you combine the contour line and volume drawing styles from Lessons 1 through 4, continue to use the markers. But if you are feeling confident about your drawing ability, you may

want to begin experiencing other media. While felt-tip markers are perfect for young children and beginners, they can be limiting when you want to portray the subtleties of life drawing and landscapes. This lesson's first section offers ideas for using different kinds of media. If your child is not quite confident yet, he can use the markers for a little while longer. But go ahead and try the new materials yourself, and he will learn along with you.

Media Tips

We do not propose here to give you complete information about the basic composition, nature, and uses of other media. This subject is quite extensive and is covered in a thorough and similar manner in many good drawing books. It will help if you expose yourself to some of these books before trying out your new materials. *Drawing and Sketching,* by Stan Smith, and *Drawing for Fun,* by Alfred Daniels, are a couple of good sources.

Nonetheless, some additional information on introducing these new drawing materials to beginners may be helpful, along with some tips on purchasing them with a minimal investment. Following are some of the exciting new media you might consider. They are listed from the simple to the more complex. Introducing them to young children in the order they appear here will enable them to integrate the experiences.

Conté Crayon

This refined type of compressed chalk comes from France and is available in wooden drawing pencils and little square sticks, as Fig. 5.1 shows. I prefer it to charcoal, since it doesn't smear as much and comes in a wider range of colors—black and white and several brownish earth tones. I recommend the sticks over the pencils because they are softer and easier to blend. The sticks come in three different softnesses, and it is best to get the softest you can. An entire box is quite expensive, but most stores allow you to buy them by the stick. Two sticks of each color are plenty for four people to get started with. You will also want to buy a pad of variegated shades of charcoal paper, a pad of inexpensive newsprint paper, and

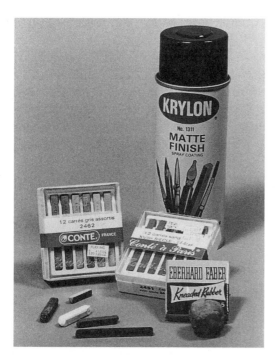

FIG. 5.1 *Conté crayon and kneaded eraser.*

some spray fixative, which will keep the finished drawing from further smearing and give it a protective coating. As you begin using these new media, you will find most helpful the appropriate types of erasers that accompany them. The loose and flexible drawing with the soft Conté calls for adjustments and control of smearing with an eraser. No other eraser works as well with Conté as the Eberhard Faber kneaded rubber eraser. Get a couple of the large-sized ones.

Conté is an excellent material with which to introduce beginners to the more sophisticated drawing techniques. The still life in Fig. 5.2 and in Fig. 5.3 attest to the beautiful effects that can be achieved. Even with its smearing problems and difficulty in erasing, it is the easiest of all the materials to capture the subtleties of life drawing, still life, and portraits. Following are some tips on how to use this material with the young artist.

- Take the kneaded eraser and stretch it out, wad it up, and stretch it out again. This takes advantage of its self-cleaning feature. Shape it into different kinds of points to discover how you can best erase marks.

Akemi Hahashi—age 11

FIG. 5.2 *Conté still life.*

Michelle Stitz—age 10

FIG. 5.3 *Conté still life.*

- Play with the Conté on the newsprint paper and explore how it works. Learn to draw with your hand raised off the paper, to lessen the smearing problems. Use the corner, the flat end, and the side under various amounts of pressure to explore the range of shading possibilities. Notice how difficult it is to erase the darker marks, and take that as a warning to draw lightly in the beginning stages of your drawings.

- As smearing begins, here is one of the most valuable tips I can share: Take the kneaded eraser and *erase the Conté off your hand.* Then erase the smearing on the paper as you go along. It makes things worse to wash your hands, because any wetness fixes the smearing to the paper permanently. Also, get used to turning the drawing so that your hand is not on top of the drawn portions. You can also lay a piece of scratch paper on the drawing under your hand, to protect the completed sections until you are done.

- As you experiment with shading, don't hesitate to use your finger and your eraser in any manner that creates a desired effect. Use the eraser to form a lighter highlight in the shading. Or make a thick swatch of Conté on a separate paper to dip your finger into and use for shading. Don't worry if the sticks break; that's part of the process. Learn how to make the most of the little pieces.

- When finished, spray the entire paper with fixative. You won't be able to erase anymore, but it will still be possible to add something, if you want. Then spray it again.

Try this medium with the contour line and the volume drawing techniques that you learned in Lessons 3 and 4 as well as the projects in this lesson.

Chalk Pastels

Pastels are used in the same manner as the Conté crayon, but they come in a full range of colors. The type that you can buy in separate sticks is usually more expensive than the sets depicted in Fig. 5.4, so compare the two. You will use the same techniques with charcoal or construction paper, kneaded erasers, and fixative with this as you did with the Conté crayon.

Noel—age 5
Original cover of Drawing with Children.

Noel—age 7
Inspired by graphics.

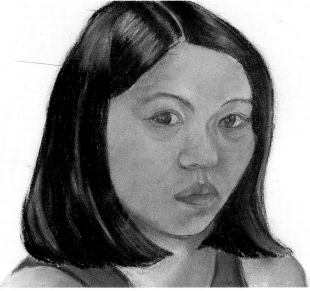

Noelle—age 21
Portrait of her mother.

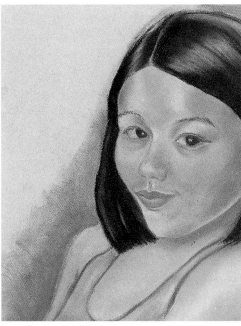

Noelle—age 21
Self-portrait.

NOELLE (NOEL) CHEN-OKI, *one of the original Monart students in 1979, is now an art major in college and plans a career in art.*

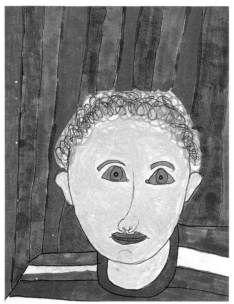

Trevor Habermeyer—age 5
Self-portrait.

Andrew Dunn—age 6
Life drawing of "Sara."

Andrew Foster—age 13
Self-portrait.

Jessica Bardwil—age 9
Self-portrait.

THE HUMAN FORM *Once children desire to accomplish realistic drawings of people, they need information about proportion and form. The instructions, in Lesson 5, lead them to the success they hope for.*

Andrew Rothberg—age 6
Art history project. Inspired by Matisse.

Chara Ferris—age 9
Inspired by graphics.

Melissa Lago—age 10
Life drawing of "Dietmar."

Johnny Gutierrez—age 7
Inspired by graphics.

Peggy Tautz—age 6
Colored pencil.

Kariann Deshler—age 8
Marker and pastel.

Masahiro Hongo—age 9
Marker and oil pastel.

Angus Chin—age 7
Marker.

THE ANIMAL KINGDOM *Learning about the creatures in our world, and the environments they inhabit, is enhanced through the drawing experience. The concentration and self-esteem that results from the experience transfers to other subjects and motivates reading and writing activities.*

Susan Van Blaricum—age 10
Marker.

Joey Fischetti—age 13
Marker and colored pencil.

Timmy Fischetti—age 7
Marker.

Tony Fischetti—age 7
Marker and colored pencil.

Brian Solari—age 7
Markers.

Samantha Henrie—age 5
Markers.

Damien D'Amico—age 12
Markers and colored pencil.

Chloe Lyon—age 9
Markers.

ENVIRONMENTS *As students draw the creatures in our environment, they can also learn about the places they come from, draw maps and study geography, be involved in science lessons, and have exposure to environmental awareness.*

Damien D'Amico—age 11
Watercolor.

Sara Sammons—age 12
Oil pastel and ink.

Karen Moncharsh—adult
Watercolor.

Dylan Axelrod—age 8
Watercolor and oil pastel.

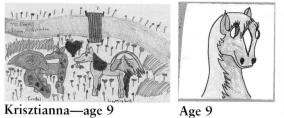

Krisztianna—age 9　　　　**Age 9**

Prior to Monart, Krisztianna produced fairly
typical drawings, looking at other graphics
and using symbolic images.

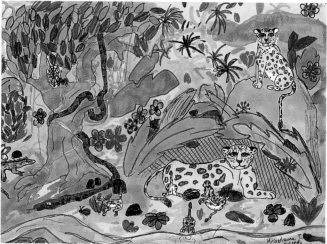

Krisztianna—age 10
Within a few weeks of instruction she could create
complex compositions using graphic ideas and her
imagination.

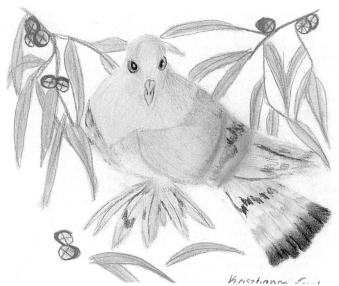

Krisztianna—age 11
This drawing resulted from studying a live bird in
motion, a challenge to any artist.

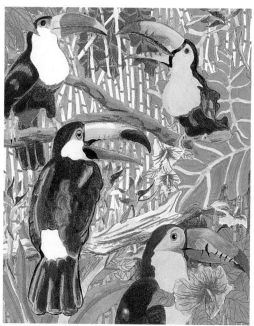

Krisztianna—age 12
The art director of Disney's Family Fun
magazine was very impressed when
Krisztianna created this original piece for
a three-day deadline.

KRISZTIANNA ECSEDY This student is an example of how structured drawing lessons
add to the creativity and individual expression of a child.

Age 13
Scratchboard has become a favorite medium.

Krisztianna—age 14
With amazing speed, Krisztianna can use her imagination to create illustrations for stories she plans to write one day.

Krisztianna—age 13
Studying a full vase of flowers, she stunned her adult classmates with this simple and sophisticated interpretation of the still life.

Krisztianna—age 14
Looking at a photo of a man, Krisztianna began to transform her drawing into a young girl. Many who knew her feel it approaches a self-portrait.

Meredith De Meules—age 5
Marker.

Mallory Byers—age 7
Marker and colored pencil.

Genevieve Du Bois—age 10
Watercolor.

Maryellen Bess—adult
Marker and graphite.

STILL LIFE AND PLANTS *From the youngest student to the adult beginner, mastering the alphabet of shape gives them the confidence to handle an endless variety of interpretations.*

Laura Bolton—age 8
Marker.

GiGi Miller—age 19
Gouache.

Brook Adams—adult
Marker and graded pencil.

Shannon Ifergan—age 9
Chalk pastel.

Ryan Berg—age 6

Ernie Leyva—adult
Studying the life of Picasso and being inspired by Drawing with Children *helped Ernie explore painting. He is now selling his work and considers himself an artist.*

Alisa Berman—age 6

Sherman Lai—age 10

ABSTRACT INTERPRETATIONS AND GRAPHIC DESIGN *Abstract styles and graphic design add freedom of expression and excitement to the art experience.*

Allison Magee—age 5

Elizabeth Howard—age 5

Alysha Edmundson—age 8

Andrew Reveles—age 13

DIFFERENT INTERPRETATIONS OF THE SAME PROJECT *Enough* structure *leads to success and enough* freedom *leads to individual expression. We all need both.*

Jan Rains
Oil pastel.

Dorothy Loebl
From a figurine. Colored pencil.

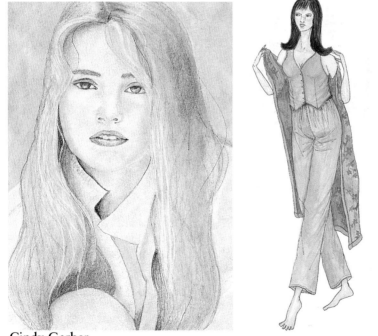

Cindy Garber
Monart helped give her the confidence she needed to enroll in Fashion Institute, graduate with straight As, and go into business.

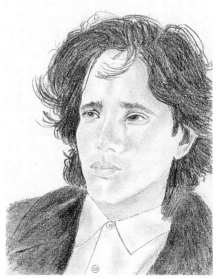

Linda Kelsey
Pencil portrait.

ADULTS WHO THINK THEY CAN'T DRAW *simply need the same structure and nonjudgmental environment children need. Within the first few lessons, they are amazed at the results they can achieve.*

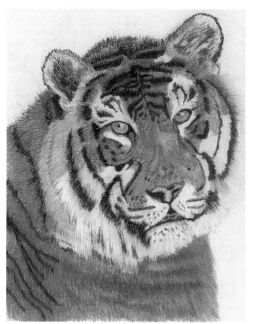

Darcy Ritzau
Pastel pencils and sticks.

Wendy Teichert
Markers.

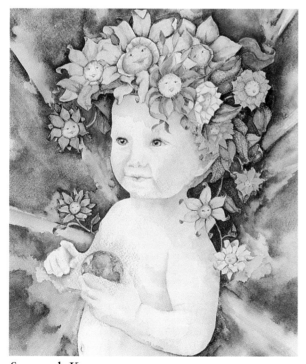

Susannah Kaye
Watercolor from her imagination and a photo of a child.

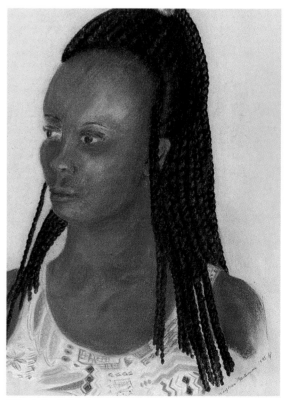

Virginia Martinson
Pastel portrait of a live model.

Lauren Colburn—age 5
Marker.

Jed Teter—age 6
Inspired by Laurel Birch.

Stephen Salisbury—age 8
Conté and pastel.

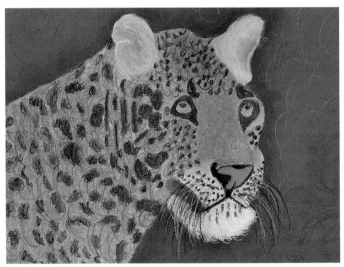

Leah Davis—age 11
Oil pastel.

ENDLESS VARIETY OF EXPRESSION *Everyone* can *draw. All you need is a noncompetitive and nonjudgmental environment, some basic instruction, and the freedom to use information any way you wish.*

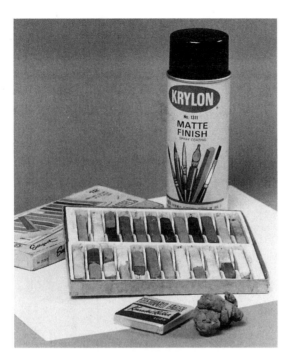

FIG. 5.4 *Pastels, kneaded eraser, and fixative.*

The still life pastel in Fig. 5.5 lost something in the translation to its black-and-white reproduction—mainly, its vibrant colors. Children love pastels and can experience the beginnings of blending colors the way they will in painting. You can overlay colors and blend them more efficiently than you can with the marking pens, so challenge yourself and experiment a lot.

Drawing Pencil

Carbon pencils give you all the variety of line and shading that you could possibly achieve in the subtleties of drawing. Now that you feel more confident about your drawing, you can deal with the potential dependence on the eraser. But if you get to where you erase as much as you draw, your eyes are getting sloppy and you need to draw with ink for a while again.

Pencils are graded by H for hardness and B for softness. A hard pencil creates lighter lines and shading than the deeper blacks of the softer leads. The price of a pencil directly relates

Ryan Ritzau—age 8

FIG. 5.5 *Pastel still life.*

FIG. 5.6 *Drawing pencil and Mars eraser.*

**Kui Loo—age 14
From a pelican statue.**

FIG. 5.7 *Shaded pencil drawings (above and next page).*

to its quality, so it may be worth buying the better brands. Get drawing pencils that don't have an eraser on the end and the white or clear type of stick erasers, such as the Mars brand shown in Fig. 5.6. I recommend a basic set of one #H, one #2B, and one #5B or #6B Berol drawing pencils for each artist in your group. Test your pencils on different kinds of drawing papers, and notice the different results.

The still life pencil drawing in Fig. 5.7 shows the lovely quality you can enjoy with pencil. The secret is to draw very lightly with the #H, slowly add some shading and detail with the #2, and then put in the final darkest shadings with the #5B or #6B. This is one of the most convenient and versatile media you can use. Get into the habit of carrying a sketch pad and a set of pencils with you so you can enter the world of drawing in your spare and relaxed moments.

Colored Pencil

Colored pencils are used in the same basic way as drawing pencils. Try them out in the store for softness before you buy. Some of the cheaper and harder leads result in a dulled color range and a limited ability to blend the colors. They should be soft enough to be erasable and to allow for lighter shades to be overlaid on top of darker ones. It saves money if you buy a basic set like the ones in Fig. 5.8, and then supplement with a few additions of your favorite colors.

The colored-pencil drawing in Fig. 5.9 shows how children can make the most of this medium. The challenge is patience. It takes three to four times as long to render the same composition in colored pencil as it does in marker. But the experience is well worth it. The secret is to use smaller paper and to make the layers very thick. If you lightly fill in areas and don't get rid of the white paper showing through, the result looks something like crayons and is not worth the effort.

Vanessa Sorgmann—age 11 Inspired by Roger Dean poster. *Carbon pencils.*

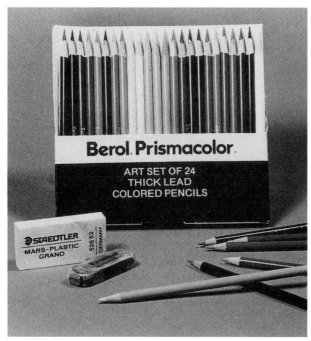

FIG. 5.8 *Colored pencil and Mars eraser.*

FIG. 5.9 *Inspired by graphics.* **Joseph Rye—age 13** *Carbon pencil.*

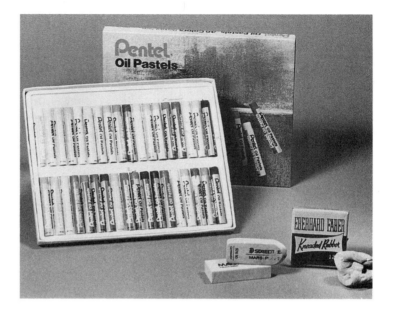

FIG. 5.10 *Oil pastels and kneaded eraser.*

Monica Andrews—adult From imagination.

FIG. 5.11 *Oil pastel.*

Oil Pastels

Oil pastel sticks look something like crayons but have an entirely different quality. Figure 5.10 shows a basic set, but you can buy separate sticks as well. When used thickly, they can build up like oil paint and produce a stunning result. I recommend both the Mars and kneaded erasers to deal with corrections and special effects, and different-colored charcoal papers to complement your composition. You can overlay light shades on top of dark ones, so blending and shading potential is at its best. Explore the possibilities on test paper before starting to draw. Oil pastels will break like the Conté and the chalk pastels, but you can take advantage of the sharp edge of the broken pieces by using them to make thinner lines.

Figure 5.11 shows how this medium can be developed. The challenge is patience, since this process can be even more time-consuming than that of colored pencil. The secret is to do a little at a time and to be willing to wait for the more-than-satisfying results in the end. Form the undersketch with a very light color and then build on top of it. Use the tips of your fingers to blend the shadings. If you want to change an area, you can use a fingernail to scrape off and then erase it all the way down to the paper. You can use a little baby oil on a Q-Tip for

blending. Teachers report that the focus that is necessary for this type of work shows up in a student's ability to concentrate and have patience in other subjects.

Watercolor

A watercolor painting usually starts with a light pencil drawing. If you look at unfinished watercolors, you will see some form of a light pencil underdrawing as the artist's guide. You'll need a piece of watercolor paper taped to a board, a #H drawing pencil, a kneaded eraser, a tray of watercolors, three sizes of brushes, a container for water, and some paper towels (see Fig. 5.12). Children's favorite medium seems to be watercolor, so it's worth the extra planning it takes to prepare and clean up. Having your supplies organized and working properly is important to the success you can expect.

The inexpensive type of watercolor paper that comes in a pad is fine to start with. Tape it onto a piece of cardboard with masking tape so that it won't curl when it gets wet. If you put the masking tape around the edge in a straight line, it will create a lovely white border around your painting when you remove it. Have the watercolors as close to the child's painting hand as possible, with several loose sheets of paper towel

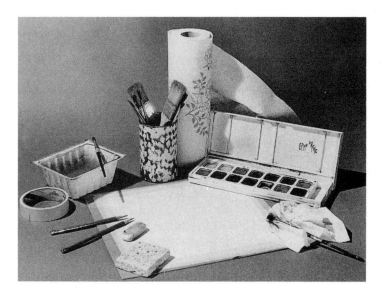

FIG. 5.12 *Watercolor setup.*

Kate Dennis—beginner adult

Natalie Gerdes—age 11

FIG. 5.13 *Watercolor.*

handy. Have the brushes in the type of container that does not tip over easily, and change the water periodically to keep it fresh.

Pick your subject and draw in the general shapes of your composition with the #H drawing pencil, keeping it as light as you possibly can. The watercolors in Fig. 5.13 were inspired by other graphics. The students who did them can attest to the usefulness of the following steps in controlling the wetness and keeping paintings fresh.

- First, do any large backgrounds—sky, water, or grassy areas. Mix the color for that area in a very watery form. Mix it in the lid of the paint pan, making more than you think you might need. If you have to stop in the middle to mix more paint, it can start streaking and drying up on you. Take the largest brush and simply paint the entire area with *plain water* first, going around the edges of the area, and around any large objects. Then fill the already wet area with the premixed paint and it will stop spreading at the edge of the dry areas of paper. This keeps the main objects in the composition free from paint and ready for fresh use later. Have children paint in one direction only, and keep

the tip of the brush wet and pointed. The biggest challenge for children is to stop scrubbing the paper with the brush, keeping the bristles in one smooth direction, and painting with a pointed tip. Continue laying in your premixed color on the already wet area. If you want to shade with other tones, lay those in right away before the background dries.

- Paint all the large areas on the composition in this same manner, and then put the painting aside for several hours. Check that it is completely dry before you start again.

- Once all is dry, paint in the detail of the object in the painting with a thicker mixture of paint. Use your lightest colors first, and then slowly build up to the darker shades.

- After the painting dries again, you may want to go in and add a few more touches of detail. If very young children don't have the fine-motor coordination it takes to handle a tiny brush, they can use fine-tipped markers for these finishing touches.

- After the painting is thoroughly dry and the paper has returned to its flattened condition, tear off the tape and remove it from the board. Warning! Tear the tape *away* from the painting, or you may end up ripping it.

This method should bring you and the children a high degree of success. But don't stop there. This is only one way to approach watercolor. Study other watercolors and try to imagine how the artist achieved different results. Get books from the library and read about the ways artists think about and use watercolor techniques. One of my watercolor teachers actually put salt on his painting. It made lovely white areas when it dried and caked off. He also taught us how to use laundry bleach to lift paint off sections of the white paper, which provides a great solution to making clouds in blue skies. Again, you are encouraged to explore and experiment. Use other media in conjunction with watercolor and see what new techniques you can create for yourself.

As you proceed with this lesson, enjoy and try different combinations of media with the children.

Design

Design is actually a component of every piece of artwork, no matter what the subject or the medium. In this lesson we will refer to the type of designs that use abstract shapes or abstracted objects to create the composition. Here are some general suggestions on how to develop this type of design work. As you read the five pointers, study how they are reflected in the two student examples in Fig. 5.14.

RELATING TO THE WORLD OF DESIGN

1. *The five elements as your repertoire.* The average person, when asked to fill a space with design, will most likely make a combination of nothing more than Xs or V shapes. Seldom are there patterns of interweaving curves, circles integrated with angles, or groups of dots used in the composition. With five known elements as a guide, you have a repertoire to play with and greater potential for creativity.

2. *Using the whole space.* Plan as you would for any other drawing. Consider the whole paper as the area of your composition and integrate your ideas until they make the best use of the entire space. The only thing that keeps some doodles from being framable abstract designs is that they end up on an edge of some inappropriate piece of paper.

3. *Repetition of ideas.* Repetition is one of the main keys to an integrated design. Most beginners insist on using too many shapes and colors, with chaotic and disappointing results. You can't miss if you stay simple, repeating similar colors in different shades or repeating the same shapes in different sizes and patterns.

4. *Balancing the composition.* As you develop a design, keep an eye on balance of size, color, and shape. For example, notice if your shapes represent a variety of small to large sizes, with the emphasis on one or the other. If your design is mostly cool blues and greens, add a few hot reds or yellows somewhere for variety. If most of your shapes are angular, add a few curves or place a dot in a significant space. Unless you

Erik Muenchow—age 10

Suzy Prudden—adult

Brent Iloulian—age 5

Hazel Kight—age 8

FIG. 5.15 *Free-flowing design organized around the five elements of shape.*

are trying to achieve a psychedelic effect, avoid using every color in the spectrum. Choose a simple color theme, with repetition of the same color in many shadings and a little of another complementary color.

5. *Creating a center of interest.* Most beginners end up feeling that their first attempts are boring and can't figure out why. It's usually the lack of a center of interest that is the culprit. One of the best ways to create a center of interest is to alter one particular area of the drawing so that it features shapes and textures opposite to those used in the rest of the design. As a rule it is more aesthetically pleasing if your center of interest is not directly in the middle of the paper. And if it is too near the edge, it can lead your eye right off the paper, never to return.

DEVELOPING DESIGN PROJECTS

Here are some suggestions on ways to construct exciting design projects. Try to think of more on your own.

Free-flowing Designs

The spontaneous and lovely designs in Fig. 5.15 show how sophisticated design can become when it is organized around the balance of the five elements. These children were aware of using the elements and talked about them as the design unfolded. Markers are well suited to this process, but tempera and watercolors can be used for a freer feel.

Template Designs

Templates, found in the drafting section of art stores, are plastic forms that you can use the holes or edges of to guide you in drawing shapes. Figure 5.16 shows a nice variety. The designs that grow from templates can have an extraordinary quality. I was actually inspired to use templates in a drawing class in which the teacher challenged me to draw the live model in a way I had never imagined. Since I was a realist, I did a flip to the other extreme and agonized over abstraction,

FIG. 5.16 *Templates can be used to develop sophisticated abstract design.*

using textures and templates to deal with negative spaces and interacting shapes. The results were designs that seemed to have no relationship to a model. I was now experiencing the world of abstract design for the first time.

Templates can be difficult to work with for children under eight, since they may need a little assistance in holding the form still. Help them hold it, lightly, and then ease up more and more until they can do it on their own.

Template designs with shapes floating around randomly on the paper tend to be disorganized and unattractive and are unsatisfying to the artist. Notice how the successful template design in Fig. 5.17 has shapes touching each other and making repetitive and symmetrical patterns. Children under twelve seem to need constant reminding to plan the design. I think the fun of using the templates makes children lose their concentration so that they begin drawing shapes all over the paper without much thought. Teenagers love this project. They have the motor dexterity to control the templates at a very professional level and can experience tremendous success. Template projects are a sure way to bring a reluctant teenager into the world of drawing.

Grids

Working with reversed and repetitive patterns on grid paper, as shown in Fig. 5.18, can be challenging and stimulating. Teachers report that children who have difficulty concentrating can sharpen their general learning skills by working on these patterned grids. Ready-made graph papers are available at most art stores, or you can make your own larger versions with rulers. You can facilitate the young child's understanding of how to plan the repetitions by having them place guideline dots to highlight the pattern of boxes that you want to work on.

Objects

If you've been collecting unusual objects, as I recommended in the section Building Still Life Arrangements, now is your chance to draw them. The design in Fig. 5.19 from kitchen utensils shows how uniquely these can be used. It helps to forget the name or purpose of an object and pay more attention to its shape and energy while you are planning the composition.

Placing objects into an abstract line composition, as in Fig. 5.20, is one of those surefire projects everybody can get involved in. First make lines all over the paper, and then use a few objects to place in the spaces that are created. Don't overdo the number of lines, or your spaces will be too small to work with. If your child is too young to hold the ruler by herself, let her decide the placement and help her hold it. Then help her less and less until she can hold it alone.

Notice how the object is only partially drawn, abstracted, or repeated in different ways. Study how the objects are drawn up against the edges of the spaces. The design can lose its organization if you float objects or shapes in the middle of spaces and don't integrate them to the edge of the space. You can use templates to make aesthetically perfect circles and lines, or you may prefer drawing freehand for a looser composition.

Rebecca Robbins—age 10

FIG. 5.17 *Template design.*

Carrie Norred—age 11

FIG. 5.18 *Working with reversed and repetitive patterns on grid paper can be challenging and stimulating.*

Kristen Todd—age 13

FIG. 5.19 *This design from a group of kitchen utensils shows how you can use seldom-drawn objects in a unique way.*

Karen Stewart—age 11

FIG. 5.20 *Placing objects in an abstract line composition is a project all ages enjoy.*

Gina Hirsch—age 9

FIG. 5.21 *This drawing was inspired from the fabric on a student's jacket.*

Fabrics and Textures

Fabrics and wallpapers are one of the best sources for inspiration, but train your eye to look everywhere for textures and designs. Even the plank in the ceiling offers potential design ideas from the textures in the wood. You can add lovely texture to a drawing by using strips of decorative preglued paper for a border. This usually works best if you do not surround the entire drawing, but choose the sides or top and bottom only. You can incorporate the same color scheme or types of textures into the design for the beauty of repetition and balance. The student's design in Fig. 5.21 was inspired by a piece of fabric.

People

People are not harder to draw, they just seem that way because something is blocking you from dealing with the subject. It may be due to any or all of the factors that follow.

DISCOMFORT WITH A LIVE MODEL

Whenever I speak to a group, I ask them to call out things in their environment that represent the five elements of shape. It is rare for anyone in the audience to look at other human beings and call out a shape on them, whether it be a body part, clothing, or accessories. When I point this out after the exercise, the room usually fills with embarrassed laughter. Needless to say, if you aren't comfortable looking at a subject, that subject will be difficult to draw.

Confront any problems you or the children might have with staring at and being watched by people. Children under six have little difficulty with this. Children from six to twelve become more and more self-conscious, and by the time they are teenagers it is almost impossible. Practice sessions of staring at each other help everyone get the giggles out and become more comfortable.

Tocaloma student—age 6

Laura Bolton—age 8

Raphaella Bennin—age 11

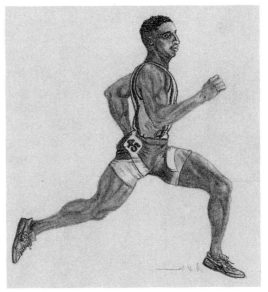

Tyler Neumann—age 13

FIG. 5.22 *Student exhibition of people, inspired by illustrations and photos.*

LACK OF CONCENTRATION AND FOCUS

The body is a complex instrument, and its parts have a structured set of relationships. It is more important to accurately represent the shape of an arm than it is the limb of a tree or the petal of a flower, which have more variation and flexibility. Therefore it takes more concentration and more time to draw the human figure than it does to draw most other subjects.

Be willing to spend this extra time and effort, and train yourself on the relationship of parts to the whole. For example, when the arm seems awkwardly drawn, check out things like how far the elbow is from the waist, where the wrist is in relationship to the torso, or how far the shoulder is from the chin. With a realistic set of expectations and a change in attitude you can draw people just as easily as you can anything else.

USING OTHER ILLUSTRATIONS

You will use the same step-by-step process for drawing people from illustrations as you did in Lesson 2, Drawing from Graphics. The only difference is that you will pay more attention to proportion and those relationships of the parts of the body to the whole. The student exhibition of people in Fig. 5.22, which was inspired by illustrations, shows you how charming the effects can be. In general, start with the features of the face; then finish the head and torso and add the limbs.

As your child learns to draw full-bodied people during drawing sessions, she may continue to draw stick-figure people at other times. There is no need to stop or judge this activity as regression. The two styles of drawing need not be compared and are engaged in for different reasons. Nonetheless, it is good to have the child notice the differences and be aware of the options. If you don't keep the child active in both experiences, she will be limited to stick-figure drawing only.

USING LIVE MODELS

Now that you are ready to study drawing a live person, you and your child can draw each other. Make the pose simple at first by avoiding twisting torsos, complex overlappings of

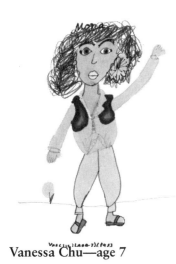

Vanessa Chu—age 7

Stephanie Kleinman—age 8

Krisztianna Ecsedy—age 11

FIG. 5.23 *Drawing from a live model, using simple poses at first.*

limbs, and limbs sticking straight toward the artist's view. The student exhibition in Fig. 5.23 offers some examples of simple poses to use. Here are some techniques to help you orient yourselves to drawing from live models.

Draw Without Looking at the Paper

One of the best ways to get over the fear of drawing people is to draw without looking at the paper. It removes the artist from the responsibility of result, and allows him to study the subject more closely.

A regular-tipped black marker is recommended for this type of drawing, since it flows the easiest on the paper. You can use large sizes of inexpensive newsprint or butcher paper, at least 10" × 13", to encourage freedom of movement. Start with the model's eyes. Force yourself to stare at the model and study each and every line, letting your hand duplicate those lines on the paper without looking at it. Give yourself two or three peeks to place your pen in a new starting place if you feel totally lost, but don't let it move until you look away from the paper and back at the model again.

The amount of resistance you feel is equal to the amount of worry you need to get rid of. The exercise is more about learning to see and to feel the mood of the model than having a likable drawing. You are trying to accomplish letting go of caring about the results. This is one of the major ways to practice get-

Devon Holiday—age 8

FIG. 5.24 DRAWING WITHOUT LOOKING AT THE PAPER *This technique helps loosen you up and train your eyes to see.*

Whitney Minson—age 7

Jenna Driscoll—age 8

Ruben González—adult. From a live model.

FIG. 5.25 GESTURE DRAWING *As you begin to take quick peeks at the paper, and keep the same looseness you had when you didn't look, you will be amazed at the accuracy, feeling, and movement you can accomplish.*

ting feeling and aliveness into your life drawings. Most of the results will be a mass of scribbles, as Fig. 5.24 shows. After you do a few of these, allow yourself to quickly look back and forth from the model to your drawing. Figure 5.25 shows you the type of quick gesture-type drawings you can accomplish.

Use the Circle-and-Tube Formula

Seeing the whole body as a group of circles and tubes, as in Fig. 5.26, is very helpful in drawing humans and some animals. Whenever you tackle a different pose, it allows you to quickly get the proportions accurate and make a general sketch of the model's position. The sketches look like mannequins and are very stiff, but this is only an undersketch that you establish as a guideline, and it can disappear in the final drawing. If you build in the proper tilting and directions of the energy flow of the body, a sensitive and feeling drawing will grow out of such an undersketch.

As you explore drawing people, try different media possibilities. You can use Conté crayon on large newsprint paper in the undersketch and through a shaded and finished drawing. You can use light pencil on drawing paper and finish up in shaded tones of pencil. Or you can use a light pencil for the undersketch, go over the final sketch in ink, erase the pencil lines, and finish up in ink.

Do the following exercise on scratch paper with a fine-tipped marker. First, you be the model and then switch with the child. You will learn from both experiences. This is for practice, so don't take time to erase. If you get stuck, just go on and start a new sketch. Stand where the child can see your whole body, and put the Fig. 5.26 diagram within view. Stand in a simple, straight posture, with one arm hanging at your side and the other bent with your hand on your hip.

As you go through the exercise, talk the child through each step and make a demonstration drawing along with him. As you demonstrate feeling your body parts, have the child get up and feel the corresponding part in his own body. Notice the sequence that you draw the body parts in. If you learn to follow this sequence, you can develop the ability to confidently sketch the general shape of a person, whether moving or still.

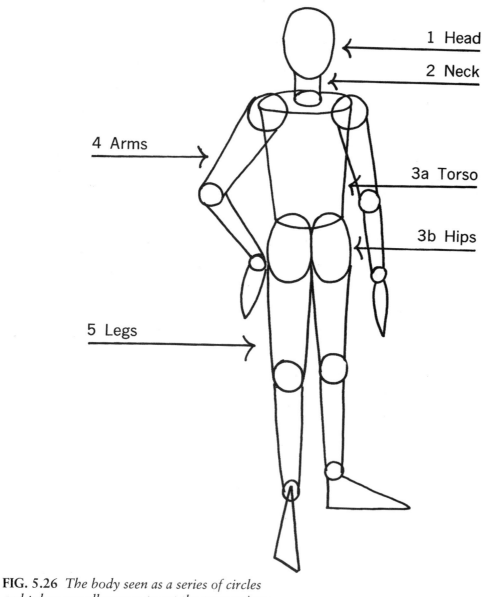

1 Head
2 Neck
4 Arms
3a Torso
3b Hips
5 Legs

FIG. 5.26 *The body seen as a series of circles and tubes can allow you to get the proportions quickly in an undersketch. Then you can develop a sensitive and feeling drawing as an overlay.*

1. *The head.* Look at *the head as an oval,* the shape of an egg with the chin being the tip. Feel your head and notice how much volume is in the skull and behind the hairline. Most beginners have a tendency to make the top of the egg too small and create a flat head, with the eyes way up in the forehead area. Practice drawing egg-shaped ovals until you can make them with ease.

2. *The neck.* Both you and the child feel your own *neck as a tube* and notice where it enters the side of the egg shape of your head. Rotate your head around on its tube and feel the relationships change as you bend your neck from one direction to another. Look at the examples of the different directions of heads and notice how the egg extends itself out in the side view. Make several sketches of the different directions in which you can turn your neck and head, using just the egg and the tube.

3. *The torso and hips.* Think of the entire *torso as one big tube.* Feel how far the shoulder edges extend beyond the size of the head and form its length to the waist with about two more head sizes. Now feel the full-volumed *circles of your hips,* pretending they are two large, flattened balls that meet in the center of your body, from the waistline down to the crotch. Make some more sketches of torsos and hips as they relate to the head and neck.

4. *The arms and hands.* Feel the three *circular joints* of your shoulders, elbows, and wrists. Dig your fingers down into the joint and feel the full volume of them, noticing that the elbow is about half as big as the shoulder, and the wrist is about half as big as the elbow. Many beginners make the shoulders too big, because they don't notice that the shoulder circles are inserted into the top of the torso tube. Draw the circles for the shoulders. Notice where your elbows are in relation to your waist, and draw them, half as big as the shoulders. Notice where your wrists are in relationship to your hips and draw them, half as big as the elbows.

Always draw the circular joints of the limbs first, and the tubes will automatically taper properly as they go from the larger joints down to the smaller ones. Now join the joints together with the *tapering tubes* of the upper and lower sections

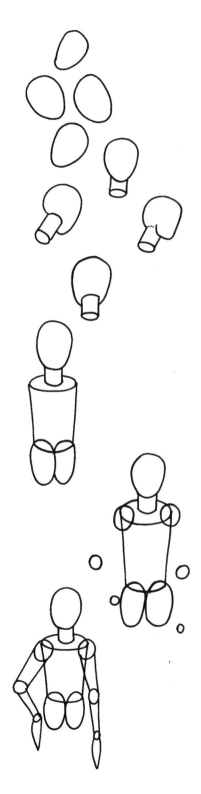

of the arms. You can use a simple *leaf shape to indicate the hands* for these study sketches. Put your hand on your face, with the tip of your middle finger at the hairline of your forehead, and notice how long the length of your whole hand is compared to the length of your face. Make your leaf-shaped hand as long as the face in your drawing. Most beginners make hands too small, due to their fear of drawing them.

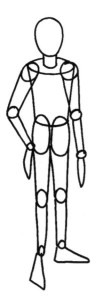

5. *The legs and feet.* The *circular joints* of the hips, knees, and ankles follow the same pattern as the joints of the arms. They get progressively smaller as they go down the leg. Feel their relative sizes on your body, and then draw them into your sketches. Next join them together with the *tapering tubes* of the upper and lower sections of the legs. You can make a general *triangle shape for the feet,* but compare them with the size of your hands and face. Beginners also tend to make tiny little feet out of fear of drawing them wrong.

Make lots of sketches of each other, from the front, side, and back. The only time you need to change the sequence is when the legs need to be drawn before the arms. This happens when a more complex pose has the legs falling in front of the arms in some way. When you are drawing a side view notice that you have to overlap the hip circles on top of each other and adjust the shoulder circles to the degree the body is turned (see Fig. 5.27).

Use Arrows to Capture Body Direction and Energy Flow

Study more complex poses, as in Fig. 5.28, and notice how the neck can be tilted in one direction while the torso can be bent in two different directions or twisted at the waist. Capturing this kind of body flow is what gives your people their feeling and aliveness. The circle-tube formula will work for every pose if you add this additional factor. Notice how the arrows designate the energy flow and movement of the model. When a person is not standing straight and still, you need to watch which way the different sections of the body tilt. Of course with people, more than other subjects, you want to capture that feeling. The process of focusing on the movement of a subject is essential when trying to capture a quick position of a person who may move or leave the area. It allows you to

get sketches of people that you can finish later at home and a freedom from the pressures about proportion.

Concentrate Specifically on Hands and Feet

Study the examples in Fig. 5.29 of hands and feet, and get the basic shapes that are involved. You can draw your own hand in many positions with the circle-tube process. But feel the joints and study their positions in relationship to each other. Remember to do all the circles first for the fingers, so the proper tapering will occur. When you draw a side view of a foot, notice how it is built from the circles of the ankle, the heel, and the ball. When you draw the foot from the front, you will be working from an angle that is longer on the side of the big toe.

It is a bit much for children under eight to draw hands and feet with this much detail, and I use the simplified versions in Fig. 5.30 when teaching them. It is just a matter of making long U-shaped curves for fingers, instead of all the joints, and U-shaped curves for the whole foot, instead of the heel, arch, and ball segments. Drawing feet with young children is really more about drawing shoes; this saves the anatomical understanding for when they are ready.

USING YOURSELF AS A MODEL

Drawing themselves gives children a new appreciation of who they are and what they look like. It can be done by using the mirror or by the imagination. Teachers say that even the most withdrawn child tends to reach out socially after this experience. When people draw themselves into an environment, they tell me they feel as if they have been there or that it is something they imagine will happen to them. The student exhibition of self-portraits in Fig. 5.31 shows the foreseen joining of a baseball team, a walk in nature, and a tai chi instructor's image of his dancing spirit.

USING YOUR IMAGINATION

If you don't have any understanding of how the body is constructed or the capacity to see a model in your inner vision, you will feel blocked from drawing people from your imagina-

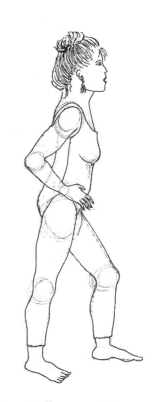

Aimee Kelley—age 12
From a live model.

FIG. 5.27 *Side view. Notice how hips overlap.*

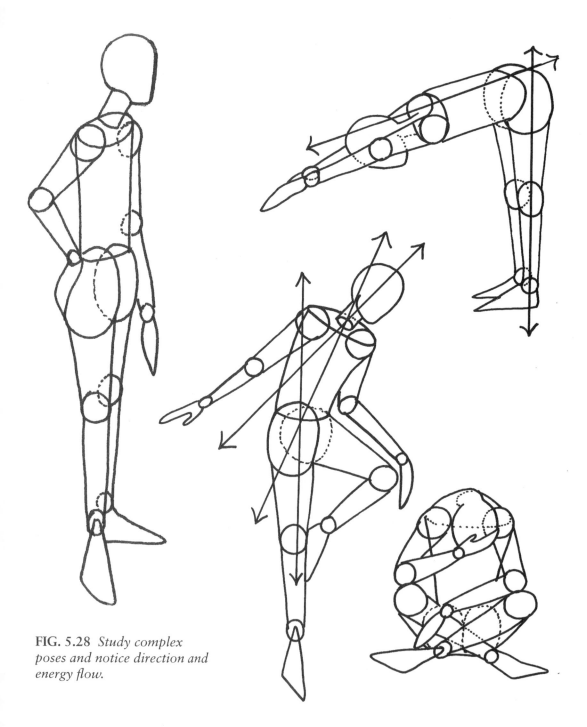

FIG. 5.28 *Study complex poses and notice direction and energy flow.*

FIG. 5.29 *Hands and feet.*

FIG. 5.30 *Hands and feet. Simplified versions for very young children.*

Jeffrey Nason—age 6

Windsor Lai—age 4

FIG. 5.31 *The self as a model.*
a. Joining a baseball team.
b. A magical walk.
c. Tai chi instructor's dancing spirit.

Will Ortiz—adult

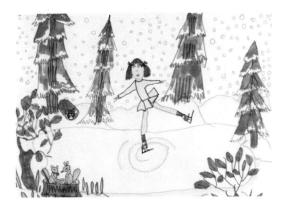

Alexandra Berger—age 5

FIG. 5.32 *A drawing of herself from her imagination, ice-skating on a pond.*

tion. But once you have used the circle-tube method, drawn from models and illustrations, and practiced the general proportions of people, you will begin to see them in your imagination. Children who are not so hard on themselves about proportion can enjoy this to its fullest. They will work people all through their drawings and create an enormous amount of movement, story telling, and emotional content. They need only a few reminders about the general shapes of the body and limbs. The five-year-old's imaginative drawing of herself ice-skating in Fig. 5.32 came after a brief demonstration of how the body parts fit together.

Faces

The issue I feel needs attention when drawing someone's face is the question of *likeness*. I can find nothing in the dictionary that says a portrait has to be an exact likeness of the model, let alone a recognizable one. However, I find this to be the main reason people give as to why they can't draw the face of a model. When I tell them that art students use the model only to create from and are not that concerned about likeness, they are amazed. For the purpose of learning to draw faces, I see no reason to be concerned with specific likeness. We want to capture only the general type of person we are drawing. The change in attitude about how much likeness is really necessary can increase your ability to draw faces before you ever begin.

MEDIA TO USE

If you and your child are ready to draw more realistic faces, you are confident enough about your drawing ability to begin using pencil, Conté crayon, or pastels. Even if your child isn't quite ready to use pencil in other subjects, let her do so with portraits. The harshness of the ink is a bit much to control with the subtleties of the face, unless you are really good with volume-type shaded drawing. So use the light #H pencil we discussed in the Media Tips section of this lesson. If you can't come by a #H, use a regular #2 or # 2B and don't press too hard. Try to use a special clear or white drawing eraser if you can, rather than the pencil-end eraser, which sometimes leaves a pinkish tinge.

Amir Marcus—age 11

FIG. 5.33 *A Japanese lady, inspired from a magazine photo, and an exotic man, inspired from an illustration and the artist's incense burner.*

Mark Hall—adult

Damian Akavi—age 6

FIG. 5.34 *A contour line drawing of his uncle.*

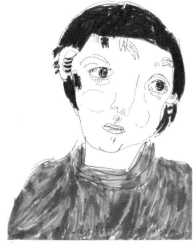

Alex Moyer—age 8

FIG. 5.35 *A self-portrait, after one lesson in the sequence of drawing faces.*

PICKING YOUR SUBJECT

The Japanese lady and exotic man in Fig. 5.33 were inspired by a photo and an illustration. "Sean," the six-year-old artist's relative (Fig. 5.34) was done from life, and the self-portrait in Fig. 5.35 was achieved after learning the procedure that follows.

Decide what you are going to use for a model. If you are using an illustration or a photograph, put it in good light close to your paper and follow the shading patterns that you observe. If you are using a live model, have him near you and in the kind of light we discussed in Lesson 4 about shading, where the light is to one side and makes one side of the face darker than the other. If you are going to draw yourself, get a mirror placed where it is comfortable to sit still and just glance up and down at yourself. Put a light on your face that creates the half-light, half-dark pattern.

A SEQUENCE TO USE IN DRAWING FACES

All you need for exploring on your own is some general information on the structure of the head and face. The illustrations of head and facial structure in Fig. 5.36 show the basic shape of the head on the neck, the positioning of the features on the face, and some studies of isolated features. Since you may be drawing from an illustration, a model, or your own face, I can't draw along with you this time. But follow the sequence of suggestions and you should be pleasantly surprised at the results.

1. *Basic shape of the head on the neck.* Even though there are enormous differences in people's head structures and individual features, the basic shape of an egg sitting on its small end is enough to get started with.

- First, draw the oval-shaped head, noticing any tilt.

- Place the tube of the neck into the head, at the angle it is tilting.

1. BASIC SHAPE OF THE HEAD ON THE NECK

The oval and the neck tube.

A head tipped back.

Adjust the egg to conform to a side view.

Add the beginning indications of the shoulder slant.

2. POSITIONING THE FEATURES ON THE FACE

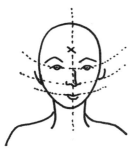 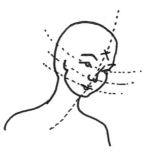

Front view.

Three-quarter view.

Side view.

FIG. 5.36 *Head and facial structure.*

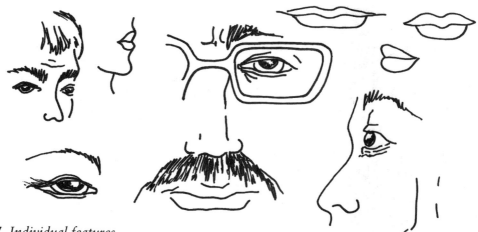

FIG. 5.37 *Individual features.*

- If from the front view the head is *tipped backward,* the chin line will reverse and cause an upward curve, as in the example.

- Add any *side view of the skull* to come around to the side or back of the neck, and *adjust the shape* of the egg to conform more to the individual head type you are using as the model.

- Add the beginning indications of which slant the *shoulders* will take.

2. *Positioning the features on the face.* Notice the dotted lines on the drawings of the three heads in Fig. 5.36, as well as their direction and tilt. If you make a light pencil line of dots as guidelines for the features to fit into, you will seldom have problems with proportion and placement.

- Place a *midline* right down the center of the face, noticing how it curves out with the volume of an egg shape. Put an X about where the hairline starts. Most beginners place the hairline too high and cause a blunted head, with eyes that are up on the forehead.

- Eyeball the spaces between the eyes, nose, and mouth and form a light dotted line for the *eye line.*

- Form a light dotted line for the *nose line.*

- Form a light dotted line for the *mouth line.*

- Recheck everything before you commit yourself to putting features into the drawing. It helps to stand the paper up somewhere or hold it out at arm's length to see.

3. *Inserting individual features.* Studying how to draw features from books will give you a better understanding of their general shapes. The isolated features shown in Fig. 5.37 give you some examples. But you are going to have to look straight at your particular model to get the feeling and mood of that kind of person. Here is where you need more concentration than you have used in the previous lessons. Checking out the distances between the separate parts and determining how they relate to the edges of the jawline—or temple line or cheekbone—is important. If you want to capture likeness, sim-

ply pay extraordinary attention to these details, since an infinitesimal shift in a line is what allows likeness to happen. The biggest secret in either case is to *draw lightly!* Some hints on sequence follow.

- Make the marks very light until all is in place.

- Establish the basic placement of the eyeballs.

- Make the curvatures of the eyelids and folds around the eyes, noticing how they cut off the top and bottom of the eyeball circle and eliminate buggy eyes. Study the model closely.

- Add the beginnings of the shading for the eyelashes and eyebrows and bridge of the nose.

- Make a little curve to establish the end of the nose, but don't draw any further in case of changes.

- Make the midline of the mouth, noticing your model's length, in relation to the eyes above.

- Lightly sketch in the upper and lower lip line.

- Double-check that the eyes and mouth are in the right place on the face before going further.

- Put in the nose, avoiding dark nostril holes that tend to create a piglike effect.

- If the ear shows, just put in the tip of the lobe, unless you have a full side view. Drawing the whole ear tends to create an elephantlike effect. Take your finger and run it across from the midline of the mouth to the bottom of your ear; it should be straight across. This is true of almost all people, no matter how different we all look. Don't worry about all the detail. Take it slowly, and simply draw what you see.

- Darken up a few of the places that you are satisfied with, making further adjustments with the other parts of the drawing.

- Begin to experiment with a few lines to indicate the hair. Make your drawing lines follow the direction the hair grows in, picking the main folds to emphasize.

- Drawing faces is a process of making continual adjustments until you are satisfied. Begin to look at the light and dark areas and shade them in the same way you did with volume drawing.

Be willing to challenge yourself, relax, and draw lots of faces. Carrying a sketch pad really comes in handy. You will learn there are lots of occasions when you are waiting in areas with people and can practice on them. If you let people know you are just practicing and would like to sketch them, they usually relax along with you and don't mind.

Environment

The entire world is now open for your drawing ideas. You can look at any object, break it into its components of shape, change it any way you want, decide on your own composition and style, and make a statement. You can begin to consider every scene in your environment as suitable for a drawing project, especially since you know how to isolate pieces of objects and scenes and integrate them into your various drawings.

This section offers suggestions on how to deal with indoor environments and outdoor scenes. You can incorporate ideas from paintings, illustrations, photographs, or from the location itself; the basic formulas to constructing a landscape or environment are about the same. Study the environmental scenes in Fig. 5.38, and notice the different elements and media. If you use a system like the one that follows, you should have no trouble.

PREPARING FOR THE ENVIRONMENT AND MEDIA

How you plan to draw environments is crucial to a successful experience. Preparing to work from paintings or illustrations requires considerations totally different from those of a field trip. Take time to think through the various kinds of experiences you want to have and what you will need in order to create them.

Photo of house

Rennie Nelson—age 9

Brian Dodero—age 13

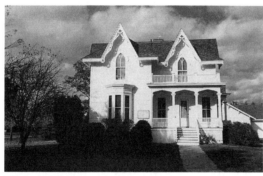

Photo of house

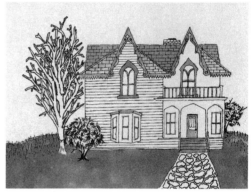

Evin Wolverton—age 11

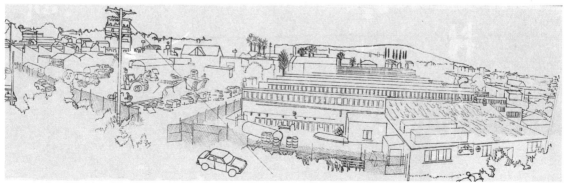

Ruben González—adult. Out of his apartment window.

FIG. 5.38 *Student exhibition of environments.*

If you choose to draw in an indoor environment, there are many places to go to that will provide you with people who will stay fairly still for long periods. But it is very important also to consider the working conditions. Imagine the different supply needs and environmental problems you'd face in the following situations: pencil sketches of people in a restaurant while you eat a leisurely lunch; pastel drawings of animal statues in a museum; or watercolor drawings of the customers in a bank. Even if the site is in your own living room, you have to consider the same issues. This checklist could save you complications.

- Does the location offer things you really want to draw?

- How can you transport the supplies?

- Where will you sit and arrange the supplies for use?

- Do you need to plan who, what, when, and where with any managers or owners of a site?

- Did you make the whole agenda clear to the children?

If you choose to draw in an outdoor environment, much more planning is necessary. The corner street scene in Fig. 5.39 was drawn on a field trip with several six-year-olds, and it went well because of prior planning and attention to potential needs and problems. We had to deal with traffic dangers, hunger and bathroom needs, a child who suddenly wasn't feeling well, and the adjustment to passersby who naturally wanted to watch but distracted the drawers. With this in mind, add to the above checklist some of the following questions:

- Did you plan the hours at a good time for light?

- Are you prepared for any possible changes in the weather?

- Will bathroom or eating facilities be needed?

- Could any other events in the area cause conflicts?

Main Street, Santa Monica, California

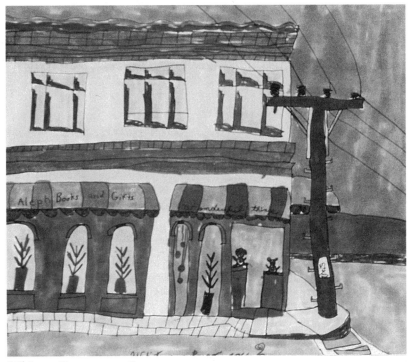

Whitney Rugg—age 6

FIG. 5.39 *Field trips can be wonderful adventures if planned well. The basic drawing can be started at the site and finished in the studio from sketches and photographs.*

MAKING THE DRAWING WORK

Once you settle on the particular method you will follow to draw a scene, the procedure you use to compose the drawing is the same. You want to create a drawing that has some statement of movement, interest, or feeling. Here are some of the things I find myself helping students consider while they are planning their scene:

Preliminary Sketches

Never stop planning drawings if you want to achieve results that you like. Be sure you have supplies to do some rough sketches of composition ideas, so that you can try out several arrangements. You can make a sketch of one thing and then move to another area and add other ideas. You can also make further sketches to help you remember things and finish at home. Of course you can go on a site for the purpose of sketching or taking photographs only, with the intent to draw from them later.

Center of Interest

Going to the beach may be a good idea, but if you end up on a long, empty sand dune with waves and water, you may be in trouble. Instead, pick a spot where there is a building, a tree, a boat, a person with a big umbrella, or an old log with a bird on it. If you are having trouble finding your ideal scene, you can put in a center of interest from one site and combine it with ideas from another site. You can get your central ideas into the drawing with light pencil line. Remember to draw what is in front first, and follow your "stop, jump over, and continue" procedure for the overlapping that results.

Creating Distance and Proportion

Most drawing books adequately explain technical methods for creating the illusion of perspective. I find that most beginners and children do quite well from just attuning their eye to the changes they see and creating a natural kind of observed perspective. The play-yard scene in Fig. 5.40 is a perfect example of this process. The child worked out in preliminary

sketches the composition and how to make the buildings look as if they were receding. Then he was able to follow his plan on the main drawing. Since he was only five years old and tired easily, he actually worked on the drawing three different times for about half an hour each time. The preliminary sketches of the distance and proportions and the freedom to work on it gradually was what made this complex drawing possible for such a young child. Along with any technical information you study on perspective, I recommend that you begin to do the following:

- Use your observation and duplicate what you see in terms of things diminishing in size as they get farther away. Notice the direction the edges of buildings or roads slant as they recede and become smaller.

- Study how things in the distance become duller in color and less defined.

- Notice how large areas are never really one solid color. The sky may be gradations of very light blue-gray near the horizon, all the way to a bright blue as your eyes move above it. A field of grass may be yellowy green near where you are sitting and slowly turn to streaks of bluish green in the distance.

- Use darker shades inside holes and recesses and lighter shades on surfaces of things turned toward the light source.

- Notice how a scene is a series of layers (sometimes referred to as foreground, midground, and background). Draw the objects in the foreground first, and then lay in each receding layer behind it.

- Place the main objects in the drawing first and then fill in the detail of the spaces between them. You can take liberties with how much of the detail you want to portray.

Point these things out to your children, and they will begin to make drawings that have depth and perspective. They will no longer be limited to a blue stripe across the top of the paper for a sky, or a tree with all the leaves the same color.

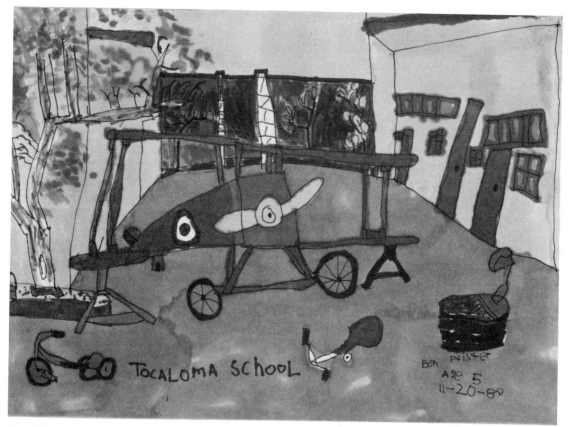

Ben Pfister—age 5

FIG. 5.40 TOCALOMA PLAY YARD *This five-year-old student captured the memory of his nursery school. Since he was so young it required three different drawing sessions of about twenty minutes each to complete. He did preliminary sketches with the guidance of the instructor and planned his composition first.*

Filling in the Spaces Between the Objects

I find that there is a tendency for beginners to scribble in some random color between things in their pictures. This appears to come from lack of experience rather than aesthetic choice. So use your imagination and look at lots of artwork to observe ways you can create texture and shading to indicate grassy areas, bushes, cloudy skies, or large areas of water. It helps to use at least two or three shades of a color for a particular area. A green hill rendered with short strokes of five different green colors imparts a totally different feeling than does a hill with one green color zigzagged back and forth across the space. Try to color in any white paper showing through, since this condition tends to create too much contrast and interest in background areas. If you've drawn a lovely sailboat in the water, you don't want your viewer's eye to gravitate faster to the annoying spots of white paper showing through the ocean than to the center of interest.

How you create the foliage patterns, hills, water, sky, and other background and foreground areas in the drawing is entirely up to you, so explore all possibilities to see what you like. Study other drawings and paintings to develop ideas. You might plan some trips to the museum to observe how the Masters solved these problems.

Reaching Special Education and At Risk Students

During the 1980s I traveled to school districts throughout the United States, training teachers to use the Monart drawing method in their classrooms. Most schools had special education classes, with particular teachers assigned to helping what they called *Learning Handicapped* children. The children who failed in these special classes were sent to state certified non-public schools, where they received more intensive care. In my first two years of devising the drawing program, I worked at several of these schools. Two years later I received California Arts Council funding to field-test my drawing curriculum at Educational Resources and Service Center, or ERAS, and Poseidon, two leading special education schools.

ERAS Center's students were diagnosed with emotional, learning, and even chronic medical problems. Most suffered from a history of poverty and abuse. Many were diagnosed by the system as *Dyslexic, Autistic,* and *Developmentally Disabled.* Poseidon had a population of gang oriented teenagers who were designated as *Learning Disabled* and *Incorrigible* in the school system. The directors of both schools believed in the value of teaching through the arts. Both schools were pioneers in using special teaching tools, and I saw tremendous

changes occur in their students. The changes were clearly related to both lower teacher-to-student ratios and special teaching methods. More significant was the fact that teachers had different expectation levels for these students, in spite of the labels that had been assigned to them.

Teachers from special education programs all agreed that children with learning problems responded to the arts. They reported that Monart was one of the most effective tools in achieving academic growth in their students. The four drawings in Fig. 6.1 through Fig. 6.4 are some examples of the creative and skilled work done by such students.

In the 1990s it became politically incorrect to use labels that included the words *Handicapped* or *Disabled*. Acronyms were used instead, and children became designated as DD (*Developmentally Delayed*), ADD (*Attention Deficit Disorder*), AD-HD (*Attention Deficit-Hyperkinetic*), SED (*Severely Emotionally Disturbed*), and ARS (*At Risk Students*). With the exception of the possibly irreversible problems we are seeing with *crack babies,* these students have the same problems and symptoms as the children who were called *Learning Disabled* (LD) in the '80s. The sad part is that there are ten times more of them. Now every teacher in the system has many of these students in his or her regular classrooms. There are too many of them to create special programs for them all.

Along with the rise in *At Risk* students, there is a tremendous influx of students who do not speak English, students whose attention deficiencies are directly related to drugs, and gifted children who are bored and turned off in overcrowded classrooms. Teachers are desperately trying to address the needs of the large numbers of problem learners, but are often handicapped by shrinking budgets. Many parents and teachers struggle to understand the wide variety of learning problems and the labels assigned to them.

As a parent you don't have to remain deadlocked by the conflicting opinions of doctors and educational psychologists. And as a teacher your frustration need not overwhelm you. With the right tools you can create the kind of environment that will make learning less stressful and more productive, no matter what label has been given to a particular child. Learning difficulties *can* be turned around.

FIG. 6.1 *When this student first came to the art class, he was physically explosive and needed to be restrained from biting. He loved drawing. Within a couple of months his behavior problems had been solved and he began improving in his regular studies.*

FIG. 6.2 *This student was very standoffish and declined to participate at first. He discovered a real love for drawing and came out of his shell.*

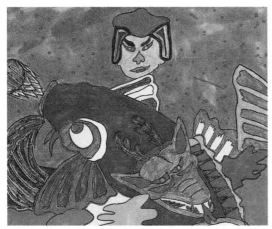

FIG. 6.3 *This student's interest in martial arts led him to combine several graphic ideas into his own creative composition. His original tough exterior and gang-oriented behavior slowly melted away and he became able to relate on a personal and friendly level.*

FIG. 6.4 *While looking in a mirror during a guided self-portrait lesson this girl took off into her own abstract interpretation. The positive feedback from her friends and teachers encouraged her to pursue drawing seriously.*

Letting Go of the Labels

My first serious job was as a play therapist. I learned then that the first step toward success was to get rid of the labels that had been assigned to my patients. I realized that many therapists expected certain symptoms to go with labels and created a *self-fulfilling prophecy.* Labels can lock you and the child into old behavior patterns and foregone conclusions. I found that, to the contrary, high expectation levels could be set and lived up to if I focused on the students' potential and how to create brand-new experiences for them. I watched new behavior patterns become habits as positive experiences were repeated and reinforced.

If a label has medical-sounding terminology, don't be fooled into thinking that it represents an unchangeable condition. I am personally familiar with virtually every label you could use to categorize a person with a problem. After the play-therapist job, I worked as a youth counselor in a psychiatric clinic, an intelligence test and psychiatric test technician for a group of psychologists, a probation officer with delinquent children in prisons, an art therapist for physically handicapped, blind, deaf, and brain damaged patients in special schools and hospitals, and a drawing teacher in regular and special education schools. Of all the thousands of patients, clients, and students I have worked with, I have never known one to completely fit the labels assigned to him. Every person is a unique individual to me. Far too often their potential has simply been misunderstood or overlooked.

First I will explain the different kinds of labels that are used for children with learning problems and then I hope to convince you to dispense with these labels. Then we will learn how to recognize the basic conditions that impede learning and how to set up environments and systems that will create growth and change.

DEFINITION OF THE LABELS

1. *Learning Disabled or Learning Disorder* (LD): This is a general term referring to any person who has a problem learning in school or in life. The causes of this problem are said to be any one or a number of environmental and physical factors.

Environmental factors include emotional problems or lack of exposure to those things that stimulate a child's intellectual development. For example, due to economic or cultural conditions many children grow up in homes with little relationship to books or stimulating verbal conversations. Physical factors can involve genetic birth defects, physical injuries, disease, or chemical use. The combination of causes and degrees of severity are many, but the general outcome is usually confusion, low expectation level, and low self-esteem. Thus the child's competency is affected well beyond his or her diagnosed problem.

The term *Learning Disabled* is usually assigned by a school counselor or a psychologist in connection with a child's difficulty in learning the basic subjects of reading, writing, and math. It is interesting to note that learning problems in nonacademic areas do not end up with labels that imply a disability. For example, if a person has difficulty learning a sport, he is simply thought of as less coordinated. If he has trouble with machinery, he is considered unmechanical. If he has trouble mastering one of the arts, no disability is implied, since it is usually accepted that only certain people are born with what is called *talent*. If one is not *talented* one is simply *normal*. If the arts were considered as important as reading, we might have decided to label nonartistic children as disabled.

2. *Developmentally Disabled or Developmentally Delayed* (DD): The same general meaning as *Learning Disabled*. However there are usually test scores involved by which the person is categorized as a certain number of years behind the expected norm for academic performance, life skills, or social development. As a former test technician, I am sure that many extremely intelligent children are miscategorized by tests that are culturally skewed toward certain kinds of information.

3. *Attention Deficit Disorder* (ADD): Since lack of attention is one of the main causes for learning problems, it has become a label in itself. Most ADD children are also labeled as either *hyperactive* or *lethargic*. The problem is that there are so many causes for lack of attention, it doesn't explain anything merely to label a person ADD. Unfortunately ADD can be thought of as irreversible, since it is often perceived as a medical term that is physically based.

4. *Attention Deficit-Hyperkinetic or Hyperactive Child* (AD-HD): This term is applied to a wide range of children who can't pay attention as they wiggle, hum, fidget, and talk incessantly. They might furtively look everywhere at once, as they are distracted by the slightest sound or movement. They are often compelled to jump up and move around whenever possible. Focus and concentration seem impossible, and they have trouble attending to a task. Disagreements by the experts as to AD-HD's causes and recommended remedies made me decide that it is best to just deal with the behavior on an individual basis. Strong medications and/or special diets might be prescribed, but differences of opinion concerning such remedies can be completely contradictory, depending on the expert.

5. *Lethargic Child:* This term is assigned to the type of child who also has enormous difficulty paying attention, but for different reasons. She sits immobile, uncommunicative, and seemingly lost in a world of her own. You may feel as though you are having a one-way conversation with such a child because she doesn't acknowledge what is going on around her or what you have just been discussing. Her energy level seems so low at times that she appears not to be in her body and can look traumatized or shocked if she's talked to. There are a number of different causes for such behavior. The child could be autistic, in a phase of depression, affected by drugs, or just consumed with fear over a very real existing situation. Again, I feel it is counterproductive to approach such a child by responding to the label she's been given and prefer to find new ways to alter her behavior.

6. *Dyslexia:* The technical definition of the term *Dyslexia* actually means *dysfunction in reading.* Dysfunction in writing is called *Dysgraphia,* and dysfunction in math is known as *Dyscalcula.*

When most psychologists or school personnel assign the label dyslexia to a child, they may lump all three of these problems together with a list of particular symptoms they see as signs of the condition. The symptoms they cite include a certain kind of disorientation that can result in intermittently seeing letters and numbers or images reversed or upside down, an inconsistency in being able to tell left from right, a tendency to act spontaneously without appreciation of the consequences,

difficulty in remembering the sequence in which steps are taken for a particular result, the inability to tell time or notice the passage of time, messiness, and a disorganized way of keeping equipment and possessions.

Some educators or psychologists see dyslexia as a gift. They focus on the positive "symptoms" that can also be present in a student with this learning problem. Dyslexic individuals tend to have an above-average ability for observation, a very sensitive reading of human behavior, intuition about the feelings of others, artistic or creative problem-solving ability, and a knack for coming up with ingenious inventions.

Generalized characteristics, symptoms, causes, and labels can lead to a great deal of confusion. Every child is different. Every human being has different strengths and weaknesses in terms of the type of intelligence they demonstrate and the way they learn. The same is true of the person who is having learning problems. Intelligence is distributed normally across the learning disabled population in the same way it is in the "normal" population. There is no reason to assume that a person is "retarded" or will be slow in any area other than the one he is having difficulty with. Unless there is physical injury or impairment, a person can use his intelligence in one area to compensate and create growth in the area of difficulty.

Unfortunately, if a child is obviously intelligent in one area and cannot function in others, it confuses the average parent or teacher. Too often the adult comes to the conclusion that the child is sloppy or lazy and could change if she would "only try." They get annoyed, humiliate the child with accusations about her behavior, and the behavior gets worse.

If a child has difficulty learning to read, it may be helpful to be aware of some of the symptoms that suggest the possibility of dyslexia. In this way annoyance and judgment can be avoided. The symptoms include reversing words ("top" for "pot"), confusing the letters *d, b, p,* or *m, n, w,* etc., losing one's place, unintentionally rereading the line, having difficulty learning to blend words together and reading very slowly in a word-by-word fashion, and having difficulty understanding what is read.

There are remedies for dyslexia, but "trying harder" is not one of them. If any type of learning problem is present, it probably indicates that different teaching methods are required to take advantage of the child's best learning style.

When treatment is specifically designed to target a particular problem, successful changes can be brought about.

The visual perceptual training inherent in the Monart program is one of the most effective ways to help a person with visual/spatial problems.

7. *At Risk Student* (ARS): This term can apply to a student who has any learning problem. In addition, it is sometimes used in relationship to students who are living in economically depressed areas and whose learning is being affected by unstable home environments, and/or drugs, molestation, violence, and language barriers.

Individualizing and Appreciating Behavior

No matter what term you give a child, the bottom line is how you are going to handle his or her specific needs and behavior. I feel the most powerful tools are nonjudgment, matter-of-fact honesty, and an open-minded expectation level. The minute you get into judgment, annoyance, accusations, or name calling, you have lost the game. The problem learner needs respect and appreciation. He resents sympathy or babying just as much as people who have special physical needs. If you can maintain a friendly matter-of-fact attitude, give the person the benefit of the doubt, and build in certain kinds of success, you will be amazed at the results. My experience has been that if children are treated in a particular way, and trained to organize themselves, the negative symptoms that are to be expected may not even surface.

There are endless case histories that show how expectation level affects the end result. I have worked with children who were released from institutions with an apology for misdiagnosed brain damage. They had taken on all the behavior and symptoms that the staff in the hospital expected them to exhibit. I also watched them completely transform as they were expected to return to "normal."

One of the most memorable cases of misdiagnosis was a boy I worked with from the ERAS Center. He was born with

some brain damage, but the impairment was overdiagnosed. The doctor convinced the mother to institutionalize the child because he was sure there was no chance for development. The child lived up to that expectation for fourteen years, until his mother decided to release him and take him to ERAS. When I first met him, he had only been there a short time. He was unable to read or write, talked like a three-year-old child, and had the behavior patterns of a six-year-old. He was unable to hold a pen or to control it well enough to draw. He had the gross-motor coordination of a two-year-old and simply scribbled and made swatches of color. With the staff's positive expectation level, a coordinated retraining plan, and the Monart drawing program's very structured and safe environment, I watched a teenage boy slowly leave behind his pronounced immature behavior and show tremendous growth. Within six months he was able to make the drawing of himself that you see in Fig. 6.5. I left the program soon afterward but saw him when I visited a couple of years later. He was reading, writing, drawing, and talking with the enthusiasm of a teenager.

FIG. 6.5 *Overdiagnosed with severe brain damage, this boy was hospitalized for fourteen years. He had no language and scribbled like a three-year-old when he was released to ERAS. It only took six months of structured guidance for him to accomplish this self-portrait. Within a year he was learning to read and communicate.*

Solving the Problems

Once you relinquish labels and create a positive expectation level, you can establish simple ways of tackling general performance, skill, and behavior patterns. It will help if you develop a few general principles. The endless detail of how you will handle each situation will fall into place if you keep focusing on these principles. Here are some general guidelines concerning what to look for and what kind of practical steps you can take to make the desired changes. In each case, I will give you an example and some step-by-step recommendations of helpful things to do.

DISORIENTATION OR MISREPRESENTATION OF IMAGES

Behavior: Making letters or numbers upside down or backward. Drawing an object in the opposite direction or upside down.

FIG. 6.6 *For almost three months, this five-year-old boy seemed disoriented and unable to duplicate simple elements of shape.*

FIG. 6.7 *With daily repetition, this same boy gradually became focused and was able to accomplish duplication consistently. His teacher reported that he was finally able to learn the alphabet and begin to read at the same time.*

Example: Before I was knowledgeable about learning problems, I noticed that a few students would draw images upside down or backward. If I was demonstrating how to draw an object like a fish swimming to the right, a few children would draw it swimming to the left. This caused no problem for some, while it threw others into a state of disorientation. They would become disturbed and unable to finish. The interesting thing was that it only happened on occasion to certain students.

Figure 6.6 is an example of a five-year-old boy who pretty consistently copied images differently from the sample models. He never showed any sign of this bothering him, nor did he seem to know the difference. Since this was the first time I had observed this phenomenon, I didn't know what to do. I simply waited to see what would happen and let the child enjoy the safety of nonjudgment or correction. It turned out that the daily activity of doing warm-up exercises and guided lessons was enough to reorient him entirely. Within three months he was no longer confusing images and was consistently completing accurate exercises like the one in Fig. 6.7. His teacher reported that after the drawing lessons he was finally able to

master the alphabet and numbers and began to read. Later when I learned about dyslexia, I realized he had avoided a potential reading problem by participating in the daily activity of organized, guided drawing lessons.

Recommendations: Get away from the tendency to think of a child's response as "right" or "wrong." Using the word **"notice"** is the key. If children copy different images than the ones on warm-up exercises, there is no reason to have them do them over or imply they are wrong. You can simply ask them to "notice the differences." If they continue to have problems or are disturbed, you can have them draw right on top of the sample images with a different color of pen. As they trace the images they will gain some confidence in direction and structure and then return to copying with more accuracy.

It is not necessary to always "catch" a student's visual disorientation. Just as he will sometimes have no problem, you can sometimes miss the problem. Too much emphasis on correction can be counterproductive. If a child doesn't care about drawing an object upside down or reversing it in a picture, don't ask him to change it. Abstract artists draw any way they want. But if you are trying to change the child's overall spatial orientation, you can make it clear there is no need to change his drawing, and then casually have him "notice" directional differences.

Another example: The series of drawings in Fig. 6.8 through 6.10 were done by an eight-year-old girl who was severely disoriented. When I first tried to get her to place the features of the face within a circle, she was incapable of duplicating any of the instructions. She had very low verbal skills as well, and it was impossible to tell what was really going on for her. With constant exposure, repetition of warm-up sheets, and positive feedback, she slowly began to duplicate what she saw. It took patience and eight months to get to the stage where she put all the pieces together in the lion face. The fact that she had also learned to communicate with me enough to express herself was more than worth the patience. One day her mother was going to be late picking her up from school and I agreed to let her sit in on my after-school classes with "regular" kids. I never saw such an example of *mainstreaming.*

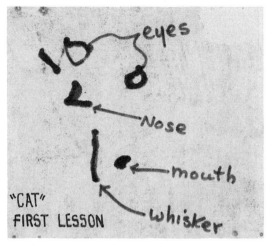

FIG. 6.8 *This eight-year-old's verbal skills were not developed enough for me to understand her disorientation. She could not grasp how to draw simple eyes, nose, and mouth into an image of a face.*

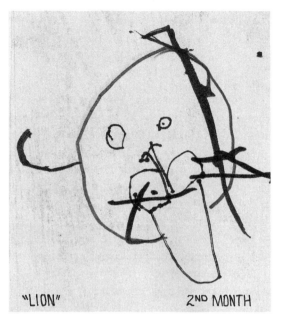

FIG. 6.9 *With daily exercises in recognition of the elements of shape, and positive feedback, she slowly began to duplicate the features of a lion's face.*

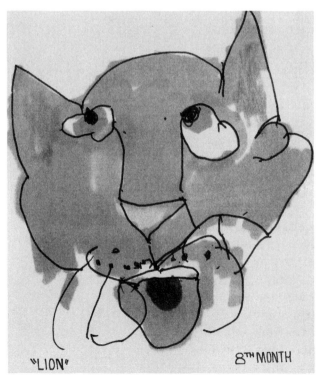

FIG. 6.10 *It took eight months of patience and repetition for her to put all the pieces together in this face of a lion. At the same time, she began to expand her communication skills and reading readiness.*

She was aware that the private drawing students were different from her classmates at the special school. She studied their every move. She followed every instruction completely, had no difficulties at all, and performed at a level I had never seen possible for her. The so-called normal kids never noticed anything different about her. She was so proud of herself that she beamed. She continued to perform at this higher level and communicated more and more each week.

HYPERACTIVITY

Behavior: Any form of fidgeting or restlessness.

Example: I began working with a seven-year-old child in my private drawing school who had been designated by the public schools as AD-HD (Attention Deficit-Hyperactive). He and his mother had both been counseled regarding his symptoms and behavior, and they were both able to talk openly with me. He ended up being more challenging than most students, but he also was capable of being a very skilled drawer. The first couple of classes he was like an angel, evidently in awe of being in such a quiet, focused environment and completely thrilled with his results. But his angelic behavior couldn't last. As he got used to the class, his learned habits of fidgeting and bolting around the room kept him from achieving the same kind of results he had that first day. And his behavior bothered the rest of the class. He soon felt the judgment of the other students and became defensive and even more restless. Parents began to complain and asked if he could be removed. It took extreme patience and understanding to deal with him and the other parents. I talked privately with him and helped him see how capable he was in his artistic ability. I also shared my understanding about his hyperactive behavior. I told him that the other students were upset because they were distracted by his behavior. I assured him that they could like him if he could understand their needs and make some changes. We made deals where he had a way of letting me know when he felt restless and was allowed to quietly get up and walk around and stretch. The biggest change related to getting him to notice the difference in his drawing skills on

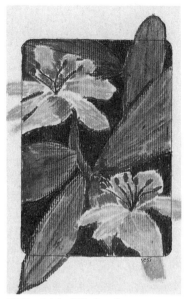

FIG. 6.11 *His restlessness and excessive noisiness made it impossible for this student to function in a classroom without rejection by his peers. His success in art was the key to calming him and allowing a change in his behavior.*

days when he had trouble focusing. He was so motivated to achieve the kind of finished and skillful drawing that you see in Fig. 6.11, that he went through the pain of reconditioning his behavior patterns.

Recommendations: Find something that the child does well and that he can be proud of. Show him how focus and concentration relate to the results. As he becomes restless, be understanding and build in acceptable outlets for the energy. Make deals by which he can be rewarded for letting you know ahead of time when his energy is on the brink of exploding. A code word can help prevent other students being aware of his difficulty. For example, there is a girl I have in my class whom I call Panda as a nickname when she starts getting wild. This alerts her before she really gets noisy, and she can rechannel the energy.

The drawing process itself can be a calming effect to hyperactive children. It is one of the best activities to promote focused concentration. Since the average person loses track of time while she is drawing intently, it creates a longer and longer attention span.

RESISTANCE TO PARTICIPATION AND/OR INTROVERTED BEHAVIOR

Behavior: Only wants to draw the same familiar images or not at all. Can't think of anything he'd like to draw. Is very negative about any suggested topic.

Example: I was assigned to a fifteen-year-old boy from ERAS who used very little language, sat slumped in the chair looking down at the ground, and would not respond at all to questions or comments. I would show him some projects that we could work on and wasn't even sure if he noticed or heard me. I would give him warm-up exercises and he would ignore them, turn the paper over, and draw the same drawing over and over. His drawings were very complex schema of what looked like electrical wiring and circuits. I would show him a specific project, give him drawing paper, and he would continue to repeat his own images. Figure 6.12 is one of the first

FIG. 6.13 *The staff at ERAS said the boy saw himself as a machine. They felt it was a tremendous breakthrough when he finally added a mechanical-type being to his drawings.*

FIG. 6.12 *This student refused to participate in any project, at first, and endlessly drew the same images of circuits and wiring. He refused to talk or acknowledge questions, as well.*

FIG. 6.14 *After many weeks, he drew this Santa Claus along with the other students. After that, he would draw the class projects at times and his own mechanical drawings at other times. More important, he began to communicate with us and show interest in the subjects we were studying.*

drawings he did like this. For weeks he refused to do any of the planned projects and would only duplicate these drawings.

The staff at ERAS explained to me that he thought of himself as a machine and was very caught up in his own inner world. I gave him very positive feedback and appreciation for these fabulous drawings and assured him how capable he could be if he attempted to draw other images as well. As he accepted that I wouldn't try to make him conform, he began to trust me and talk to me a bit. One day he finally broke away from the circuitry drawing and drew the mechanical being in Fig. 6.13. The director of the school felt it was a self-portrait and a real breakthrough, an attempt to share himself with me.

I began to make deals with him. If he would spend 10 minutes on the warm-up sheet and the weekly project, he could draw what he wanted for the remainder of the time. Each week he lost track of time a little more and was up to 15 or 20 minutes before he returned to his mechanical drawings. Within six months, he sometimes chose to draw the weekly project, as depicted in the realistic drawing of the Santa Claus in Fig. 6.14, and sometimes he chose to draw his mechanical drawings. The important part of the process was that he started relating to me. He talked about the weekly project, which led to his ability to share his thoughts and feelings. For example, the week of the Santa drawing, he talked about the upcoming holidays and what Santa meant to him. It gave him some safe subjects to talk about and an opportunity to build his communication skills. Along with the work that the other staff members were doing with him, the drawing projects gave him a vehicle through which to relate to others, and he gradually became less obsessed with his internal world. He not only learned special skills, but he also increased his interest in other academic subjects.

Recommendations: Sometimes a child doesn't want to risk failure and instead acts as if she is not interested. Remember to tell the stories about how artists don't like everything they do. Make it safe for children to explore. One suggestion is to give students templates and rulers to make designs with first. Pick subject matter to draw that the child is interested in. Use the drawing time to ask him questions about what he's drawing

and what he likes. Help him build his communication skills. Don't demand that he draw the projects you offer, but begin to make deals and compromises. Give a lot of positive feedback and rewards for involvement of any kind. If a child in a classroom setting refuses to participate, set very definite limits and give him something else to do that will not bother those who are participating. Preferably, have other choices available that are related to the class subject. The child will join in when he feels safe and observes the fun everyone else is having.

Sometimes children who are loudly verbal and extroverted resist participation. They can even be hostile or try to push your buttons to get negative attention. This needs to be handled in a different manner from the introvert. For example, I once worked at a school where the majority of the students were gang kids. The first week I arrived, only two out of the sixty students wanted to draw. They tried to intimidate me and made very derogatory remarks about art and "sissy" stuff. I let them know I didn't need them to draw but established the silent atmosphere anyway. I was easygoing and unaffected by their lack of participation, making it very clear they couldn't bother me or anyone who wanted to draw. They had the option of doing designs with templates or reading art magazines. They quietly hung out with the magazines and seemed to enjoy the silence. The two students who drew did fabulous work. One of them began to bring in car magazines and did a great drawing of a 1950 Chevy. That changed everything. The next week several brought in pictures of motorcycles, kung fu books, dragons, and jungle animals. By midterm all sixty were drawing. They learned it was safe to try, that they were going to get help, and that they didn't have to like everything they did. At the end of the year they proudly came to an art show that included two matted pieces created by each of them.

INABILITY TO OBSERVE OR REMEMBER THE SEQUENCE OF INSTRUCTIONS

Behavior: Continually feels confused, doesn't seem to observe your instructions on the board, needs to have instructions repeated, and keeps asking what step to take next.

Example: I had in my class a seven-year-old boy whose behavior was an extreme example of these particular traits. When I would stand in front of the class and demonstrate the steps, he would sit frozen and staring into space. But if I went to him and repeated the instructions step-by-step on a piece of scratch paper next to him, he had no trouble understanding. I could not figure out why he could not see the exact same thing on the board. He had no vision problem that would explain it. The only thing I knew to do was continue to repeat the steps individually for him. If I gave two or three instructions at once for the rest of the group, I would have to go to his seat and on a separate piece of paper give them to him one at a time. He was having problems remembering sequence, and distance made his observation break down. The one-to-one attention helped him focus better and build sequencing habits. It took about three months, and the problem finally disappeared. The teachers at school reported that the drawing method had helped him so much with sequencing it carried over into his other subjects.

Recommendations: Watch out for your frustration and negative body language. It's easy to get annoyed with this type of child. Keep in mind that negative comments and exasperation never help you or the child. Be willing to repeat instructions or demonstrations without judgment. Use as few words as possible, since sequencing of ideas is harder as sentences get longer.

Help children to develop sequenced thinking habits. For instance, ask them about the activities they enjoy, like sports or dancing. Outline with them the equipment needed or steps involved to participate in this favorite activity. Practice remembering the steps together in order to build concentration and to remember patterns or sequence. For example, if a child loves to ski you can plan the steps involved in taking a ski trip. Make a list of equipment needed and items to be packed, plan the route of travel and where he or she will stay, and make an outline of the things to consider in order to get to a chair lift and up the slope.

Tutors and vision therapists can be found at private learning centers. There are some vision therapists who have children do work on trampolines and remember patterns of information

while jumping. It is called Pepper trampoline work and is very effective. Many of these therapists are optometrists who are also doing the William Bates eye exercises to correct visual problems. I strongly recommend this work for children who are experiencing learning problems. I did the Pepper trampoline work when I was having difficulty learning to use a computer. After a few sessions I felt as though I had a new mind and was able to hold patterns and sequence in an entirely different way.

As you work with any type of learning problem, remember that every child is different. Giving children respect and patience is the most valuable thing you can do. If one thing doesn't work, try another. You will be amazed at the enormous amount of change that can take place when you expect that it can.

Using Drawing to Teach Other Subjects

When I was in school I was more motivated and had better academic success when I could incorporate drawing into my class assignments. In science I drew the objects we were studying and remembered all the details for tests. In English I created color-coded diagrams of sentence structure and composition ideas. In social studies my elaborate reports were illustrated with maps of the countries, peoples, and habitat of the various cultures we were studying. I took notes in college with charts and pictograms and used a system that is now called *mind-mapping* to remember the content of lectures. Although I had many symptoms of dyslexia, I overcompensated for these problems and did very well in school. I now understand why. Drawing, visual perception, and the ability to solve problems with visual logic saved me from being a poor learner.

According to research in the field of language acquisition, *you can learn information eight times faster and retain it eight times longer if you draw what you are learning about.* However, very few language teachers use drawing as a tool. They say it is because they feel inadequate in their own drawing skills. When they manage to break through their own drawing block, they are thrilled with the results they can achieve with

students. Drawing creates the language immersion experience they have been striving for.

Elementary teachers have been telling me for years that their students are scoring as much as 20% higher in reading, writing, and math, with only one semester of exposure to Monart. School districts are reporting the same encouraging statistics and are making sure their teachers use my programs in all areas of their curriculum. The illustrations in Fig. 7.1 through 7.4 are examples of drawings that were done in conjunction with a basic classroom lesson.

In 1982 I joined Lucia Capacchione, author of several books on creative journal writing, in a project called Playworks. We worked in the public schools and used the arts to teach basic subjects. Every school we worked in saw enormous academic growth in their students after our program. But due to budget problems in the '80s, the schools were making huge cuts in art, music, and physical education programs. By the late '80s teachers were reporting that cutting arts programs had been a mistake. They knew the arts could affect academic success but didn't understand quite why.

Now in the mid-'90s there is a complete reversal. I finally find myself in an era when using the arts to teach basic academic subjects is gaining wider acceptance. Two things are highly responsible for this shift. The *Multiple Intelligence* (MI) theories of Howard Gardner have rapidly spread throughout the country, and people like Dee Dickenson, of New Horizons for Learning, are showing teachers how *Integrated Learning* methods can achieve the results they desire.

Multiple Intelligence Theory (MI)

Howard Gardner, codirector of Project Zero at the Harvard Graduate School of Education, and adjunct professor of neurology at the Boston University School of Medicine, has convinced a large number of educators that intelligence has been defined in too limited a way and thus incorrectly measured. He asserts that there are seven (eight as of 1995) major types of intelligence that need to be addressed in any learning environment. With this new information in mind, the *Verbal/Lin-*

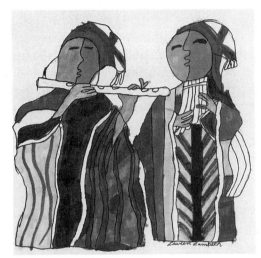

Lauren Lambeth—age 9

FIG. 7.1 *Literature-based reading and social studies.*

Melissa Lago—age 12

FIG. 7.2 *Math and geometry. Escher-type tessellation.*

Third-grade student—age 8

FIG. 7.3 *Science lesson.*

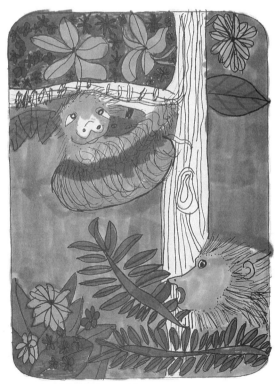

Kira Stoddard—age 12

FIG. 7.4 *Ecology reading unit.*

guistic mode of teaching is no longer deemed appropriate as the primary or only way to expose students to information. Teachers are now aware that some children who had been labeled *Learning Handicapped* were actually very intelligent children who learned in different modalities.

If you are having difficulty "getting through" to a child, it is important to know how to shift to a different mode of teaching. The eight kinds of intelligence toward which you can gear a child's learning are:

1. *Logical/mathematical:* The ability to quantify, make hypotheses, use sequential logic, calculate, and solve complex mathematical problems. This kind of learner learns most effectively when she can manipulate digits or work with abstract numbers to solve problems.

2. *Verbal/linguistic:* Sequentially thinking in words and using language to express the meaning of things, in a speed that is similar to the amount of time it takes to formulate sentences. This student can learn a lot of detailed information by hearing or reading about it.

3. *Visual/spatial:* The ability to think in three-dimensional pictures and holistic concepts at a very rapid rate. This student can perceive, retain the whole idea, and then re-create, transform, produce, or decode. She can envision her ideas in a way that allows her to formulate a step-by-step plan to arrive at the results. She needs to draw, chart, map, or visualize information to understand it.

4. *Body/kinesthetic:* The ability to learn through the feeling, movement, and touch involved in an experience. This student can do better if he can take things apart, feel them, or operate them in order to understand things. He needs to be guided in doing things himself, rather than being shown how to do something by demonstration.

5. *Musical:* A sensitivity to sound, tone, melody, pitch, and rhythm. Hearing the sound or feeling the beat can help this type of learner. For example, math can be understood through studying rhythm, while motivation for learning history could be acquired through studying the music of the culture or era.

6. *Interpersonal:* The ability to interact with others and understand them. This type of learner works well in groups, where she can pick up information from the experiences of and communication with others.

7. *Intrapersonal:* The ability to understand the self in relationship to the world at large. Experience is the best teacher for this type of learner, since his emotional and physical reactions to an experience are crucial to his understanding and memory of it.

8. *Naturalist:* The individual who is able readily to recognize flora and fauna, to make other consequential distinctions in the natural world, and to use this ability productively (in hunting, farming, or biological sciences).

Successful teaching involves recognizing the different types of intelligence and knowing how to reach a child with an approach that fits. You avoid a lot of frustration for everyone if you can gear your teaching mode to the child's particular strengths. Of course these eight intelligences exist in varying degrees in each of us, and therefore *integrated learning* is the most effective way to go.

Integrated Learning

At home or at school, a child can be exposed to many intelligences. A parent who is aware of this can relate to his or her children in a variety of ways and promote multiple intelligence skills. The teacher can develop an *integrated curriculum* that will reach all students. When dealing with problem learners, you can focus on the mode they respond to best. Monart is one of the most effective ways to incorporate the visual process. Since it is also fun, it appeals to every child.

If you are using Monart at home or in a classroom, you might as well use it to teach other subjects as well. It doesn't take any more effort to gear drawing projects toward a particular academic area. If you are a classroom teacher you can simply use drawing *across the curriculum,* in conjunction with what lesson units you have already planned.

The Monart method can help a student who is developing learning problems in a verbally oriented culture. Just as important, it can help the verbal or kinesthetic student to become

even more functional as he accesses visual thinking skills. If you use the drawing method as it is explained in this book, a lot of integrated learning will happen naturally. But if you also plan your projects to tie in with basic academic subjects, you will increase the child's learning and motivation.

I have chosen reading, writing, math, science, social studies, history, geography, multicultural studies, environmental studies, primary language, and secondary language as the main subjects of focus for the following lessons. I will give you one lesson for each category, and you will then understand how to create your own integrated learning projects.

READING AND WRITING

Educators have reported to me that their children's reading and writing ability can improve as much as 20 to 30% when they draw the subjects and characters from the book they're reading. Marlene and Robert McCracken, leaders in *literature-based reading programs,* tell all their workshop participants to use Monart in conjunction with their methods. They feel that learning the elements of shape helps with alphabet recognition and reading readiness. They explain that as the child draws subjects from the assigned book, her motivation to reread the book increases. Drawing also helps children master word recognition by motivating them to match words with the things they have drawn into their pictures. As they enjoy the process of drawing, they take in more of the text, and their comprehension increases as well.

Sample Lesson: There are several wonderful reading books with a tiger as the main character. One for younger children is *Who Is the Beast?* by Keith Baker. *Tiger,* by Judy Allen, is a nice one for older children. *The Great Kapok Tree,* by Lynne Cherry, is full of resource materials for jungle life and background ideas.

1. *Warm-up sheet:* Create a warm-up sheet that fits the particular subject you've chosen, adding some background ideas as well. Figures 7.5 and 7.6 show how to gear practice exercises to different age levels.

FIG. 7.5 *Children four to seven years old need simple lines and a few background ideas for a warm-up.*

FIG. 7.6 *Children over eight or nine can handle the more sophisticated images of a tiger, and need many options for background ideas.*

FIG. 7.7 *Give general shape as demonstration, using a sequence that starts with something central and builds out. Allow freedom for each student to interpret as he or she wishes.*

FIG. 7.8 *When drawing hair, the general shape can be blocked out with dotted lines first.*

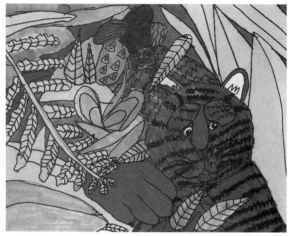

Alexandra Cryes—age 7

FIG. 7.9 *After reading a book and drawing the characters, you can have a child write a new story about his or her drawing.*

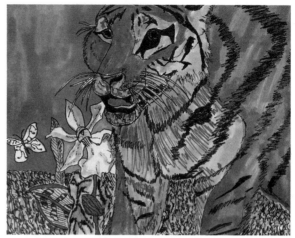

Angelo Africa—age 14

FIG. 7.10 *Once students draw the characters from a book, their motivation to read books on similar subjects will increase.*

2. *Demonstration:* Have a large contour line drawing of the main subject in view, like the ones in Fig. 7.7 and 7.8, so the student can see how the pieces fit together. You can indicate the sequence in which you intend to teach those parts by numbering them, as I did in the examples. For those who need it, do a step-by-step demonstration of the main subject as described in Lesson 1. For those who are able to draw on their own, provide them with copies of illustrations from the book and encourage them to make changes in any way they wish.

3. *Completion and backgrounds:* Have lots of background ideas available for finishing up. The finished drawings for this project, in Fig. 7.9 and 7.10, would not have been as exciting had the students not been stimulated and inspired by the resource materials that were provided.

4. *Follow-up reading and writing projects:* After the drawings are finished, don't forget to go back and read the book again, or find additional books on the same subject to read

Christyn Edmundson—age 9

FIG. 7.11 *This drawing of a model A car was inspired by a lesson designed from a photo and a book on Henry Ford.*

Eric Goto—age 9

FIG. 7.12 *Notice the completely different character that Eric's car has from Christyn's, even though they were based on the same instructions.*

further. With children who are beginning to write, you can have them write a few sentences about how they constructed their drawing and the tools they used. Forming simple sentences comes easily, since it relates to an activity they just experienced. For older children who are learning to write creative compositions, you can have them write a whole new story based on the drawing that was inspired by the original book.

Some books for older children have no illustrations. In this case the child can do research and find related materials to create illustrations that go with the content of the book. For instance, the model A cars in Fig. 7.11 and Fig. 7.12 may have come from reading a book on Henry Ford and then doing research to study the type of cars that he invented. This might then interest the child in further research of transportation vehicles, which could lead to a series of drawings and a very comprehensive overview of the history of transportation. A child's reading, research, and writing skills can improve very rapidly when his motivation to draw is incorporated into the lesson.

MATH

Early on in the development of my drawing program, it became obvious to everyone that I had also hit on a way to teach visual mathematics. A person cannot do the *Matching Warm-Ups,* which are discussed in Lesson 1, Figure 1.5, without using addition and subtraction principles. The *Abstract Design Warm-Ups,* from Lesson 1, Fig. 1.7 through Fig. 1.10, use addition, subtraction, multiplication, and division. You can make these projects even more oriented to math by simply changing the emphasis a little. For example, here is a way to change the instructions just a little so that an abstract design warm-up becomes a math lesson.

General Suggestions:

1. *Environment:* Create an atmosphere of playing math games and doing art projects at the same time. Explain to the children that you will be asking questions and you want everyone to answer as a group, making it clear there is no need to feel worried about right or wrong answers. Set up some kind of bell or gong as a signal for when to answer questions. If you don't do this, the fast kids will always answer very rapidly and never give the others time to think or calculate. I simply use my voice and say "ding" when I am ready for their answers. You will have to work at it to delay their answering, as there is a great tendency in our culture to be the first person to answer. Even when I show groups of teachers how to do these math games, they can't believe how long it takes them to stop blurting out the answer the minute I ask a question!

2. *Reading instructions:* Remember, most people have a great deal of difficulty understanding visual instructions in a verbal mode. Repeat them as many times as needed, without getting annoyed.

3. *Materials:* Use a fairly small paper, 7 × 9 up to 9 × 12, which will shorten the finish-up time. Use drawing paper instead of scratch paper, since these projects can end up being lovely designs. Markers are the fastest and most colorful medium to use.

Here is a simple addition problem. You can change it to fit the proficiency level of your child or group. Figures 7.13 and 7.14 are two very different results from these same instructions.

Addition Project—Sample Lesson: Slowly read the following instructions. If you want more complex addition concepts, you can use the same format of this lesson and change the details.

- Choose any color you want. Draw a straight line that goes from one edge of the paper to another, in any direction that you wish.

- Choose another color and make another straight line from edge to edge in any direction that you want. The two straight lines may or may not cross over each other depending on your choice of design.

Carrie St. Louis—age 5

FIG. 7.13 *Very young children can learn addition through design.*

Nicole Mullen—age 9

FIG. 7.14 *Creatively different designs will result from the same addition problem.*

- Repeat this one more time with any color you wish.
 (Q: Remember, don't answer until you hear the ding! How many straight lines do you have now? A: 3)

- Take a broad-tipped pen and make a dot in an empty space.

- Choose a different color and make a group of 5 dots in a different empty space.
 (Q: How many dots do you have? A: 6)

- Before you follow the next instruction, think for a minute. I'm going to ask you to make one curve. One curve cannot wiggle around like a snake or a wavy line. That would be a series of curves. One curve keeps bending in the same direction. Now choose a pen that you want to use and listen to the whole instruction before you start.

- Put your pen on one of the dots in the group of 5, make a curve that goes through the one dot that is alone, and then let the curve go off the edge of the paper somewhere.

- Next, take another color and start on a different dot in the group of 5, go around the dot that is alone, and let it go off the edge of the paper somewhere.
 (Q: Don't answer until you hear the ding. How many curves do you have? A: 2)
 (Q: If you add your curves and your dots together, what is the total? A:8)
 (Q: If you add your curves, dots, and straight lines together, what is the sum total? A: 11)

- Now take any pen you want and make three angle lines that start on the edge of the paper and end on an edge of the paper. They could go on and off the same or different edges. Remember, angles can be very closed like a V or open like an L.
 (Q: If you add your angles and your dots together, what is the sum? A: 9)

- Add anything else that you want and color in your designs. You can use flat or solid colors in some of your shapes, or you can create textures. Leaving some of the shapes white is also an option.

If you want to integrate art history into this lesson, you can also show some examples of abstract designs by famous artists for inspiration. From around 1910 to 1950 there were many modern artists, such as Mondrian, Leger, Henri, Arp, Rothko, Klee, Kandinsky, and Malevich whose work would lend itself to this lesson. Talk about the different artists' styles as well as the countries they were from and the period of time in which they lived.

Addition, Subtraction, and Percent Problem—Sample Lesson: When doing subtraction or percent you need some kind of grid to keep track of the used or unused spaces. Here is a problem that was done on a 100-space grid, like the one in Fig. 7.15. The beautiful design in Fig. 7.16 is the type of result that will occur from the following instructions.

• Whenever I give the instructions to fill in a grid space, remember you could make a design that ends up being any type of overall shape. For example, it could be round, square, triangular, star shaped, etc.

FIG. 7.15 *100-space grid.*

Becky Locker—age 10

FIG. 7.16 *Result of subtraction and percent problem in this lesson.*

- First, make any design you want in one of the grids, and then repeat that same design in nine more grid spaces.
 (Q: Remember not to answer until you hear the ding. What percent of the grid spaces are left unused? A: 90%)

- Now make a different design in a grid space, and repeat that design 5 more times.
 (Q: How many grid spaces have you used? A: 16)
 (Q. How many grid spaces are left? A: 84)

- Next, make a design by combining three adjacent grid spaces. Use your imagination. You might use 3 in a row or 3 that make an L shape.
 (Q: What percent of the grids do you have left now? A: 81%)

- Repeat that design 3 more times.

- Color any 20 grid spaces with the same solid color, in any design pattern that you want.
 (Q: What is the sum total of the grid spaces that have been used? A: 48)
 (Q: How many more grid spaces would you have to use to fill in a majority of the spaces? A: 3)

- Use those three spaces by creating a new and different design for each one of them.

- Pick one of the three designs you just made and repeat it 11 more times.
 (Q: What percent of your design is in this new pattern you just created? A: 12%)
 (Q: How many grid spaces have you used now? A: 62)
 (Q: How many grid spaces would you have to use to have 10% of your grid spaces left as white empty spaces? A: 38)

- Use those 38 spaces in a way that makes an interesting design out of the 10 white spaces that will be left. Add color or designs any way you wish, leaving the last 10 white spaces as part of your finished design.

This kind of visual game can be geared to different ages and aptitudes by changing the grid or the instructions to match the children's proficiency level.

Krisztianna's tessellation pattern

FIG. 7.17 *Notice how the tessellation pattern was rotated and changed for variety of design in the center circle. The two heart-shaped curves right in the middle of the pattern are the fish's tail and the crab's mouth.*

Krisztianna Ecsedy—age 12

pattern

repetitions

Author's example

FIG. 7.18 *Notice how the original pattern is broken up into several different images. The repetitions may stay the same, or veer off into new images.*

GEOMETRY

Since geometry already incorporates drawing, I didn't have to invent ways to teach it visually. There are many excellent resource books available in this area. My favorite is *Discovering Geometry, an Inductive Approach* by Michael Serra.

Sample Lesson: The current rave is *Escher Tessellations,* which are excellent for teaching geometric concepts. Michael Serra's book gives very clear instructions. They are a bit overwhelming for kids under eight, but if you work off squares instead of hexagons they can handle it. Tessellating can become very time-consuming and it may take from two to six hours to completely finish, depending on the complexity. If you want artistically detailed and beautiful results, you could easily use four sessions of at least an hour each.

The biggest challenge is helping the child break up the repeating pattern into creative designs. One suggestion is to avoid making one object out of the original tessellated shape. Helping children find ways to break up the original shape into several ideas or objects is the key to creative and exciting design. The tessellations done by the students in Fig. 7.17 and 7.18 are examples of this. Notice how the basic pattern shape became several overlapping and repetitive ideas.

SCIENCE

Science lends itself to drawing more than any other subject. No matter what you're studying there are endless ways to illustrate scientific information. You can draw diagrammatic, technical subjects like the human brain in 7.19 or things from nature like the turtle in Fig. 7.20.

Sample Lesson—Plants: Draw a cutaway view of a plant, and label the various parts, like the example in Fig. 7.21. If at all possible, have a sample of the plant itself for study. As you study the different sections of the plant and how they function, have the children redraw each part and take notes about it.

Vanessa Sorgman—age 11

FIG. 7.19 *Study of the human brain.*

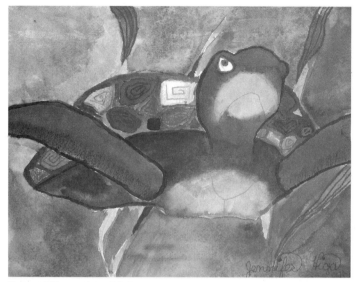

Jenny Higa—age 10

FIG. 7.20 *Science lesson about sea turtles.*

HISTORY, GEOGRAPHY, AND MULTICULTURAL STUDIES

Children love to draw maps of different countries and continents and learn about the people and cultural differences in those places. There are a wealth of books available now that lend themselves to this activity. Since I have been teaching art in conjunction with social studies and geography, I have learned a tremendous amount about the world and its peoples myself. Here is a project from the book *Ka-ha-si and the Loon, an Eskimo Legend* by Terri Cohlene. One of the first times I did this lesson I was told by a teacher that the real name for the people of this part of the world was Inuits, and that they did not appreciate the English word Eskimo being used to refer to them. Out of respect for the Inuit people, I have changed the title to *an Inuit Legend.*

Sample Lesson—The Inuits: *Ka-ha-si and the Loon,* like many multicultural books, is geared for academic study as well as having an inspirational message. After the legend is

Julie Michael—age 11

FIG. 7.21 *Result of the sample science lesson.*

told, there is a section in the book with a map of the Inuit territories and photographs of the people as they live in current times.

1. *Draw a map:* Before studying a place, it is important to get a clear understanding of where it is in relationship to where the student lives. Each time you draw a new place, draw it first as part of the world map, and talk about distances, weather, terrain, and mode of travel from the student's home to the place you are studying. A child who draws maps of a particular location will have a much closer connection to and deeper memory of the place than if he had just looked at pictures of it.

2. *General discussion:* Before choosing drawings on the topic, find out what the child already knows about the city, region, country, or continent. Then offer some general information, covering such things as the type of culture and people, the vegetation and animal life, the style of buildings and homes, and the kinds of transportation in use. I feel that it is very important to impart an atmosphere of respect as you introduce information about other cultures. If you can find a way to create appreciation for differences and focus on the positives, it will go a long way to helping us all honor each other in the world. In our troubled times this is more important than any memorization of facts about history or geography.

3. *Warm-up sheet:* Choose an illustration or photograph from the story and create a warm-up sheet that will match the drawing of the main subject. The warm-up example in Fig. 7.22 gives some practice information about Ka-ha-si, the loon, and some background ideas.

4. *Demonstration:* For younger children or beginning drawers you can do a step-by-step demonstration of the main subject and guide them through background information. With older children you can give them many different choices by photocopying different illustrations from the book to take to their desk and work from. The end result can be as exciting as the drawing in Fig. 7.23 of a walrus race. There is nothing in the story or the illustrations in the book about riding walruses. This student was inspired by the story and the pictures

Aaron Bates—age 11

FIG. 7.22 *Warm-up sheet based on multicultural reading unit.*

FIG. 7.23 *Inspired by the characters in the book, this student made up an original illustration about a walrus race.*

and then proceeded to make up his own original drawing about a walrus race. Figures 7.24 through 7.26 are other examples of similar multicultural projects.

ESL—LANGUAGE ACQUISITION

Regardless of the particular language you want to teach, many students will be more successful with the incorporation of drawing. In fact, it may be your only way to communicate with many non-English-speaking students. First, develop lessons that teach repetitive recognition of nouns that you can draw. Then you can introduce grammar and sentence structure, conjugating the verb *to be* by pointing to parts of the drawing. Working on plural, singular, and third person comes naturally through visual recognition of the parts being drawn. You can develop conversational skills around the repetitive activity of the drawing experience or about the particular lesson.

Any project that you design for the purpose of learning language can always be combined with another subject. I will combine an ESL (English as a second language) lesson with an

Aaron Bates—age 11

Tyler Neumann—age 14

FIG. 7.24 *Geography, social studies, multicultural awareness, and improvement in reading can be integrated into one lesson. Students can draw maps of the countries they study, as well as the peoples and artifacts of a culture, as they do research and read about the world.*

Meredith Wroblewski—age 10

Katie Hullfish—age 10

Sola Shin—age 8

FIG. 7.25 *The Native American*
The wide variety of books available about the
Native American lend themselves to whole
language study units.

FIG. 7.26 *The kabuki*
Appreciation of music from other cultures and
study of movement can add kinesthetic learning to
lessons based on dance forms.

Eliana Sinizer—age 8

environmental studies project for the last category of lesson samples.

Environmental Studies—ESL

Developing an awareness of our environmental problems is crucial to our very existence now. Today's students are very interested in this subject, since they are beginning to realize the urgency of how it will affect their lives. Using the concept of integrated studies, you can combine environmental lessons with other study units. For example, you can incorporate it into reading, writing, science, geography, or multicultural studies. In the following lesson I will combine a rain forest unit with geography, alphabet recognition, reading readiness, and an ESL lesson.

Sample Lesson—Red-Eyed Tree Frog: This lesson has been developed by using two books. The first book, *A Walk in the Rainforest,* by Kristin Pratt, is a bilingual alphabet book that is in English and Spanish. Each alphabet letter is illustrated with an endangered species, with a short paragraph about it in both languages. It has a map of the world in the beginning of the book, with the rain forests marked for recognition. The second book, *The First Thousand Words in Spanish,* by Heather Amery, an Usborne book, is one in a series of books, in many languages, with the exact same illustrations. The particular page that I have used is for learning the nouns that go with body parts. This unit of study would be broken up into several parts and combined with other material on the subject. The lessons could be integrated over a one- or two-week period, depending on the amount of material you wish to cover.

1. *Draw the map:* Have the students draw the map of the world and designate the location of the rain forest territories. Have a general discussion about what is happening to the rain forest, and the issues involved. Relate these issues directly to lifestyles and what we can do to help the situation.

2. *Incorporate music:* Try to locate a cassette tape containing authentic sounds from the rain forests, and have the chil-

dren listen to it while they are drawing. These are available in nature-oriented stores, like The Nature Company, as well as most large music stores. Whenever you can match the music to what you are learning about, you are increasing the students' exposure to the subject.

3. *Read the rain forest book:* With younger children you can focus on learning the alphabet and drawing the alphabet letters in conjunction with drawing the endangered species they stand for. With older children focus on how much fun it is to read the same words in both Spanish and English and to compare the sentence structure. Choose the red-eyed tree frog for a special project, and collect other resource materials for an in-depth study. You might combine a science lesson at this time by comparing it with other types of frogs from other habitats and then drawing them all. You could also assign other reading materials about frogs as a way of strengthening the research/reading process.

4. *Add ESL component:* Explain that while you learn about the rain forest and study the tree frog you are also going to learn how to say body parts in both languages. Hand out a warm-up sheet like the one in Fig. 7.27, from *The First Thousand Words in Spanish.* Have the children copy the cartoon character people, the body parts, and the words that depict them. It helps if you have them color in only the body part that matches the word, in order to link the word with its meaning.

5. *Tree frog ESL warm-up:* Have the child practice drawing the parts of the tree frog and the words that match. Figure 7.28 is an example of the kind of warm-up sheet you can design.

6. *Tree frog drawing:* You can do a step-by-step demonstration or have a number of pictures for inspiration, depending on the skill level and age of the student. Don't forget to provide lots of background resource materials. Figure 7.29 is an example of a finished drawing from this project.

7. *Follow-up and reinforcement of ESL:* We all know the power of repetition. Immediately design another project that

FIG. 7.27 *When you draw what you are learning about you learn it eight times faster and retain it eight times longer.*

FIG. 7.28 *Language immersion comes automatically as you draw the subjects and words being learned.*

Omar Arevado—Age 11

FIG. 7.29 *Results of bilingual language lesson.*

incorporates the same nouns. If you draw five different animals and reintroduce the same body part names, you can expect to hold conversations with children in which they will feel comfortable using the body part words and incorporating them in basic sentences.

INTEGRATION OF MULTIPLE SUBJECTS

You can integrate as many subjects as you want into one project. I heard about one of the most exciting examples of this in the course of writing this chapter. I was in another city, giving a teacher training seminar, when one of the teachers showed up an hour early, so I invited her to breakfast. As we sat down she immediately began expounding on how Monart was improving her students' reading ability. She gave an example of an Early Explorers unit she had developed, and within a couple of minutes spelled out how she had incorporated a variety of subjects. I found myself stopping her in midstream and asking if she would mind writing down her ideas so I could include her project in this chapter. How fortunate that she had mistakenly come to the seminar an hour early! By the time the class started, she handed me an outline of her project. This is the kind of creative project design that thrills me, and I give it to you from Jane Ploetz, who is a fourth-grade teacher in the Vista Unified School District in southern California.

Project Example—Life on a Galleon (Early Explorers Unit): For several days Jane kept weaving every subject around the original drawing of a galleon ship. Here are some of the ways she integrated her lesson and some additional ideas she included for you. Figures 7.30 and 7.31 are two examples of the galleon ship drawings. Each student wrote a story to go with their drawing.

1. *History, geography, and multicultural studies:* Covered general information about the Spanish explorers who sailed in Spanish galleon ships to the Orient for spices, silks, and other goods in the late 1500s to early 1600s. Added local history about how San Diego, California, was discovered as a way sta-

tion for provisions and went on to become the major seaport adjacent to where the children live.

2. *Reading, vocabulary, and spelling:* Used resource materials that the children read in order to study the time period and the galleon ships. Learned all the parts of the ship and had the children label them on the drawing, studying the correct spelling.

3. *Writing project:* Used all the learned vocabulary words to write individual stories in which each child chose a particular job on the ship from the list they had studied. Put all the stories together in a bound laminated book entitled *Life of a Sailor.*

4. *Science:* Studied the working structure of a ship and its relationship to how the human body is built. For example, studied the keel as the backbone of the ship and how the keel and ribs of the ship were the skeleton or the frame. Talked about how big and how old trees had to be to build masts, and what kind of trees would be appropriate. Could study the physics of sail design and rudder stability.

5. *Environmental studies:* Talked about how the cutting of large old trees to build massive ships affected the growth of the forests. Could consider how the building of seaports and cities affect wildlife and nature.

6. *Math:* Studied the dimensions of the ship, and how many trees had to be used to build it. Learned how to determine the circumference of a mast by having several children stand back to back and measuring them. Studied perimeter and area by marking off the size of the ship, 90' × 40', with chalk, on the play yard. Had the children arrange themselves in the space and imagine 100 people in this space for a period of six months. Gave groups of children chalk and string and had them make other shapes with the same measurements and try them out for size. Calculated which shapes were roomier in relationship to which ones would travel faster. Could figure out how much the list of provisions for a six-month journey might cost.

Meredith Mackey—age 10

FIG. 7.30 Life on a Galleon *was the title of this fourth-grade integrated writing project.*

Kasey MacFarlane—age 10

FIG. 7.31 *The teacher covered over a dozen topics of study before the unit was completed.*

7. *Physical education:* Had races across the size and around the perimeter of the areas and figured out distances and speeds. Could construct some ratlines like the ones to the crow's nest for climbing exercises.

8. *Music:* Sang old sailing songs together while in the chalk-drawn ship on the playground. Studied the kinds of musical instruments that were popular at the time and how they were used for entertainment on the ship.

9. *Lifestyle and health issues:* Talked about daily life by studying each level of the ship and what its purpose was. For example, how the prisoners, cargo, and food were in the hold, and how the cold, damp conditions affected that combination. Talked about the food preservation methods available and the kinds of diseases that resulted. Studied the invention of gunpowder and history of wars in relationship to the cannons and portholes and how the seamen slept in hammocks right over the cannons. Imagined all the possible jobs on the ship and made lists of them. Discussed the slave trade and what kind of conditions it caused.

If you decide to do a project like this, a book that will help you is *Ships and How to Draw Them,* by the Grosset Art Instruction Series. I actually have a large-scale model of a galleon in my studio and do a similar lesson with students. This is one lesson that comes out very dramatic in pen and ink. Figure 7.32 is an example of this approach. If you can find a three-dimensional model of the ship you are drawing, it adds a great deal to the lesson. It allows students to draw the ship from different views, and they can also handle it and see it in a more realistic form.

Needless to say, this kind of project can result in an unforgettable experience for children. By being immersed in such a creative, hands-on, multifaceted experience, the learner can relate cultural, historical, scientific, and mathematical information to his own experiences. Analysis and problem solving become fun. And it all begins by drawing a ship—or anything else you choose!

Once you get the hang of it, you won't want to teach any other way. It is not only more fun for your children or your students, it's more inspirational for you.

Brandon Hyman—age 6
Fine-line ink, contour drawing.

FIG. 7.32 *The self-esteem that results from accomplishing a drawing like this goes a long way. It transfers itself to other subjects a child is learning about, and can provide the motivation and passion to learn.*

Infinite Possibilities

Some of my students have been with me since I started Monart in 1979. This has forced me to come up with new projects every week for years. With all its inconveniences, I am eternally grateful for having had such a challenge. It has made me see the potential for beauty or inspiration in nearly everything my eyes fall upon. Even when I go to have my car repaired, I find myself imagining how the spare parts could be used in a still life, or how the oil on the floor could create design patterns.

You have been exposed to a tremendous amount of material in this book, and it wouldn't be unusual if you were feeling a little unsure about it all. My desire has been to give you enough experience so you'll be aware of your options and know how you can be successful with this method of teaching. How far you want to take this program is now up to you.

I hope the words "I can't draw" or "I can't use drawing to teach" are no longer in your vocabulary. Having overcome this false barrier, you now have the pleasant task of creating your own drawing projects. Refer back to sections of the book that particularly excited you. Add the lesson planning information from *Drawing for Older Children* to your repertoire. Experiment with different styles of drawing, various types of media, interesting ways of integrating material into the teaching of other subjects. I guarantee you will never run out of stimulating new ideas.

There are endless artistic experiences to explore. Once you eliminate unnecessary concern over the finished product, you'll feel free to develop your own form of expression. As you let go of old concepts and fears, you will enjoy learning along with your children or your students. As you open your eyes and heart to the infinite creativity of our universe, you will be inspired to become part of that dynamic process.

Bibliography

EDUCATION AND
MULTIPLE INTELLIGENCE THEORY

Armstrong, Thomas. *Awakening Your Child's Natural Genius.* Los Angeles: J. P. Tarcher, 1991.

Briggs, John. *Fire in the Crucible.* Los Angeles: J. P. Tarcher, 1988.

Campbell, Bruce. *Multiple Intelligences Handbook.* Stanwood, Wash.: Campbell and Associates, 1994.

Campbell, Don. *100 Ways to Improve Teaching Using Your Voice and Music.* Tucson, Ariz.: Zephyr Press, 1992.

Campbell, Linda, Bruce Campbell, and Dee Dickenson. *Teaching and Learning Through Multiple Intelligences.* Needham, Mass.: Allyn & Bacon, 1996.

Capacchione, Lucia. *The Power of Your Other Hand.* North Hollywood, Calif.: Newcastle Publishing, 1988.

Collins, Georgia, and Renee Sandell. *Gender Issues in Art Education: Content, Context, Strategies.* Reston, Va.: National Art Education Association, 1995.

Dickenson, Dee. *Creating the Future: Perspectives on Educational Change.* Buks, England: Accelerated Learning Systems, 1991.

Forman, George. *Constructive Play: Applying Piaget in the Preschool.* Menlo Park, Calif.: Addison-Wesley Publishing, 1984.

Gardner, Howard. *Frames of Mind.* New York: Basic Books, 1983.

———. *Multiple Intelligences.* New York: Basic Books, 1993.

Kealoha, Anna. *Trust the Children, an Activity Guide for Homeschooling and Alternative Learning.* Berkeley: Celestial Arts, 1995.

Lazear, David. *Seven Ways of Teaching.* Palatine, Ill.: Skylight Publishing, 1991.

Lowenfeld, Victor, and Brittain Lambert. *Creative and Mental Growth.* New York: Macmillan Co., 1947.

McCracken, Marlene, and Robert McCracken. *Reading, Writing, and Language* (series). Winnipeg, Canada: Peguis Press, 1979.

Margulies, Nancy. *Mapping Inner Space, Learning and Teaching Mind Mapping.* Tucson, Ariz.: Zephyr Press, 1991.

Mason, Kathy. *Going Beyond Words.* Tucson, Ariz.: Zephyr Press, 1991.

Stevens, Suzanne. *Classroom Success for the Learning Disabled.* Winston-Salem, N.C.: John Blair Publisher, 1984.

DRAWING

Bates, William. *Better Eyesight Without Glasses.* New York: Holt, 1940.

Brookes, Mona. *Drawing for Older Children and Teens.* Los Angeles: J. P. Tarcher, 1991.

Dodson, Bert. *Keys to Drawing.* Chicago: North Light Books, 1985.

Edwards, Betty. *Drawing on the Right Side of the Brain.* Los Angeles: J. P. Tarcher, 1989.

Eenst, James A. *Drawing the Line.* New York: Reinhold, 1962.

Guptill, Arthur. *Drawing with Pen and Ink.* New York: Van Nostrand Reinhold Company, 1961.

Kistler, Mark. *The Draw Squad.* New York: Simon & Schuster, 1988.

Nicolaides, Kimon. *The Natural Way to Draw.* Boston: Houghton Mifflin, 1941.

Smith, Ray. *How to Draw and Paint What You See.* New York: Alfred A. Knopf, 1989.

Woods, Michael. *Life Drawing.* New York: Dover Publications, 1987.

Books that lend themselves to pencil drawings

Adams, Norman, and Joe Singer. *Drawing Animals.* New York: Watson-Guptill, 1989.

Dover Pictorial Archive Series. New York: Dover Publications, 1984.

Franks, Gene. *Pencil Drawing.* Tustin, Calif.: Walter Foster, 1988.

George, Jean Craighead. *One Day in the Tropical Rain Forest.* New York: HarperCollins, 1990.

Harter, Jim. *Transportation—A Pictorial Archive.* New York: Dover Publications, 1984.

WRITING

Capacchione, Lucia. *The Creative Journal for Children.* Boston: Shambhala, 1989.

Heller, Ruth. *A Cache of Jewels, and Other Collective Nouns.* New York: Putnam & Grosset Group, 1987.

———. *Kites Sail High: A Book About Verbs.* New York: Putnam & Grosset Group, 1988.

———. *Many Luscious Lollipops: A Book About Adjectives.* New York: Putnam & Grosset Group, 1989.

———. *Merry-Go-Round: A Book About Nouns.* New York: Putnam & Grosset Group, 1990.

———. *Up, Up and Away: A Book About Adverbs.* New York: Putnam & Grosset Group, 1991.

Rico, Gabriele. *Writing the Natural Way.* Los Angeles: J. P. Tarcher, 1983.

INTEGRATED LEARNING: USING DRAWING WITH:
1. LITERATURE-BASED READING PROGRAMS

Aardema, Verna. *Why Mosquitoes Buzz in People's Ears.* New York: Dial Books, 1975.

Baker, Keith. *Who Is the Beast.* New York: Harcourt Brace Jovanovich Publishers, 1990.

Berenstain, Stan, Jan Berenstain. *First Time Books* (series). New York: Random House, 1982.

Cullinan, Bernice. *Children's Literature in the Reading Program.* Newark, Del.: International Reading Assoc., 1987.

Hissey, Jane. *Old Bear.* New York: Sandcastle Books, 1986.

Hudson, Cheryl, and Bernette Ford. *Bright Eyes, Brown Skin.* Orange, N.J.: Just Us Books, 1990.

Hudson, Wade. *I'm Gonna Be!* Orange, N.J.: Just Us Books, 1992.

Igus, Toyomi. *When I Was Little.* Orange, N.J.: Just Us Books, 1992.

Lewis, Shari, and Lan O'Kun. *One-Minute Teddy Bear Stories.* New York: Bantam Doubleday Dell Publishing Group, 1993.

Loomans, Diane. *The Lovables in the Kingdom of Self-Esteem.* Tiburon, Calif.: J. J. Kramer, Inc., 1991.

Pfister, Marcus. *The Rainbow Fish.* New York: North-South Books, 1992.

Raffi. *Raffi Songs to Read* (series). New York: Random House, 1980.

Royston, Angela. *Diggers and Dump Trucks.* London: Dorling Kindersley, 1991.

Step into Reading (series). New York: Random House, 1986.

2. MATH

Braddon, Kathryn. *Math Through Children's Literature.* Englewood, Colo.: Teacher Ideas Press, 1993.

Pappas, Theoni. *More Joys of Math*. San Carlos, Calif.: Wide World Publishing Co., 1995.

Sheppard, Jeff. *The Right Number of Elephants*. New York: Harper-Collins, 1990.

Tafuri, Nancy. *Who's Counting?* New York: Mulberry Paperback Books, 1986.

Tudor, Tasha. *1 is One*. New York: Checkerboard Press, 1956.

3. GEOMETRY AND TESSELLATIONS

Ernst, Bruno. *The Magic Mirror of M. C. Escher*. New York: Ballantine Books, 1976.

Serra, Michael. *Discovering Geometry: An Inductive Approach*. Berkeley, Calif.: Key Curriculum Press, 1989.

4. SCIENCE

Cummings, Meri. *Project Treasure Hunt Activity Manual*. Miami Shores, Fla.: Florida Department of Education, 1991.

Heller, Ruth. *The Reason for a Flower*. New York: Grosset & Dunlap, 1983.

Parker, Steve. *How Things Work*. New York: Random House, 1990.

Pembleton, Seliesa. *Magnifiers and Microscopes: Science and Technology for Children*. Washington, D. C.: Smithsonian Institution, 1989.

Ruef, Kerry. *The Private Eye*. Tucson, Ariz.: Zephyr Press, 1992.

Stockley, Corinne. *Dictionary of Biology*. London: Usborne, 1986.

5. SCIENCE SERIES

Usborne First Nature Books. Tulsa, Okla.: EDC Publishing, 1990.

Eyewitness Visual Dictionaries. New York: Dorling Kindersley Books, 1991.

Milliken's Experiences in Science. St. Louis: Milliken Publishing, 1986.

Step-by-Step Science Series. Greensboro, N.C.: Carson-Dellosa Publishing Co., 1994.

6. SOCIAL STUDIES, GEOGRAPHY, AND MULTICULTURAL STUDIES

A. Geography and Map Making

Graham, Alma. *Discovering Maps, A Young Person's World Atlas*. Maplewood, N.J.: Hammond Incorporated, 1991.

Lilly, Kenneth. *The Animal Atlas*. New York: Alfred A. Knopf, 1992.

Tyler, Jenny. *The Usborne Book of World Geography*. London: Usborne, 1993.

Wright, David, and Jill Wright. *Children's Atlas*. New York: Facts on File, 1991.

B. Books That Cover Many Countries and Cultures

Count Your Way Through (series). Minneapolis: Carolrhoda Books, Inc., 1990.

De Spain, Pleasant. *Thirty-Three Multicultural Tales to Tell*. Little Rock, Ark.: August House Publishing, Inc., 1993.

Inside Story (series). New York: Peter Bedrick Books, 1991.

Journey Through (series). Mahwah, N.J.: Troll Associates, 1991.

Kindersley, Barnabas, and Anabel Kindersley. *Children Just Like Me* (UNICEF). New York: Dorling Kindersley, 1995.

New True Book (series). Chicago: Childrens Press, 1990.

See Through History (series). New York: Penguin Group, 1992.

C. African

Aardema, Verna. *Bringing the Rain to Kapiti Plain*. New York: Dial Books, 1981.

Musgrove, Margaret. *Ashanti to Zulu*. New York: Dial Books, 1976.

Ford, Bernette. *The Hunter Who Was King and Other African Tales*. New York: Harper Books, 1994.

Onyefulu, Ifeoma. *A is for Africa*. New York: Cobblehill Books, 1993.

D. American Indian

Bierburst, John. *The Ring in the Prairie: A Shawnee Legend*. New York: Dial Press, 1976.

Bruchac, Joseph. *Native American Animal Stories*. Golden, Colo.: Fulcrum Publishing, 1992.

DePaola, Tomie. *The Legend of the Bluebonnet*. New York: G. P. Putnam's Sons, 1983.

Goble, Paul. *Star Boy*. New York: Macmillan, 1991.

Gorsline, Marie, and Douglas Gorsline. *North American Indians*. New York: Random House, 1977.

E. Asian

Chiemruom, Sothrea. *Dara's Cambodian New Year*. New York: Simon & Schuster, 1992.

Climo, Shirley. *The Korean Cinderella*. New York: HarperCollins, 1993.

Reddix, Valerie. *Dragon Kite of the August Moon*. New York: Lothrop, Lee & Shepard Books, 1991.

F. European

Treays, Rebecca. *The Usborne Book of Europe*. Tulsa, Okla.: EDC Publishing House, 1993.

G. India and Tibet

Gerstein, Mordicai. *The Mountains of Tibet*. New York: Harper-Collins, 1987.

Goalen, Paul. *India: From Mughal Empire to British Raj*. New York: Cambridge University Press, 1992.

Reynolds, Jan. *Himalaya, Vanishing Cultures*. Orlando, Fla.: Harcourt Brace Jovanovich Publishing, 1991.

H. Inuit (Eskimo) and First Nations Peoples

Cohlene, Terri. *Ka-ha-si and the Loon*. Mahwah, N.J.: Watermill Press, 1990.

Joose, Barbara. *Mama Do You Love Me?* San Francisco: Chronicle Books, 1991.

Levitt, Paul. *The Stolen Appaloosa*. Longmont, Colo.: Bookmakers Guild, 1988.

San Souci, Robert. *Song of Sedna*. New York: Bantam Doubleday Dell Publishing Group, 1981.

Siberell, Anne. *Whale in the Sky*. New York: Puffin-Penguin Books, 1982.

I. Mexico and South America

Cobb, Vicki. *This Place Is High: The Andes Mountains*. New York: Walker & Company, 1989.

Jacobsen, Karen. *Mexico*. Chicago: Childrens Press, 1982.

Lewington, Anna. *The Amazonian Indians: What Do We Know About* (series). New York: Peter Bedrick Books, 1993.

Palacios, Argentina. *The Llama's Secret: A Peruvian Legend*. Mahwah, N.J.: Troll Associates, 1993.

Rice, James. *La Nochebuena South of the Border*. Gretna, La.: Pelican Publishing Co., 1993.

Wood, Tim. *The Aztecs*. New York: Penguin Books, 1992.

J. Middle East

Climo, Shirley. *The Egyptian Cinderella*. New York: HarperCollins, 1989.

Cohen, Daniel. *Ancient Egypt*. New York: Doubleday, 1990.

Heide, Florence, and Judith Heide Gilliland. *The Day of Ahmed's Secret*. New York: Lothrop, Lee & Shepard Books, 1990.

———. *Sami and the Time of the Troubles*. New York: Houghton Mifflin, 1992.

Mantin, Peter, and Ruth Mantin. *The Islamic World*. New York: Cambridge University Press, 1993.

Morley, Jacqueline. *An Egyptian Pyramid*. New York: Peter Bedrick Books, 1991.

K. Multi-Ethnic Americans

Girard, Linda. *We Adopted You, Benjamin Koo*. Morton Grove, Ill.: Albert Whitman & Co., 1989.

In America (series). Minneapolis, Minn.: Lerner Publications, 1988.

Kuklin, Susan. *How My Family Lives in America*. New York: Bradbury Press, 1992.

Peoples of North America (series). New York: Chelsea House Publishing, 1988.

L. U.S. History

Commager, Henry. *The American Destiny*. New York: Danbury Press, 1975.

Estrin, Jock. *American History Made Simple*. New York: Bantam Doubleday Dell Publishing Group, 1991.

Johnson, Paul. *The California Missions*. Menlo Park, Calif.: Sunset Publishing, 1979.

7. ENVIRONMENTAL STUDY UNITS

Benchley, Peter. *Ocean Planet*. New York: Harry Abrams, 1995.

Carwardine, Mark. *Animal Opposites* (series). Sussex, England: Wayland Publishers, 1988.

Cherry, Lynne. *The Great Kapok Tree*. New York: Harcourt Brace & Co., 1990.

Earth Island Institute. *Dolphin Sponsorship Kit*. Southport, Conn.: Friends of the Environment, 1993.

George, Jean. *One Day in the Tropical Rain Forest*. New York: HarperCollins, 1990.

Minnich, Michelle. *Vanishing Species*. San Rafael, Calif.: Cedco Publishing, 1993.

Pope, Joyce. *Kenneth Lilly's Animals*. New York: Lothrop, Lee & Shepard Books, 1988.

Silver, Donald. *Why Save the Rain Forest?* New York: Simon & Schuster, 1993.

Simon, Noel. *Nature in Danger*. New York: Oxford University Press, 1995.

Taylor, Barbara. *Rain Forest*. New York: Dorling Kindersley Books, 1992.

8. English as a Second Language

Amery, Heather, and Reyes Mila. *The First Thousand Words In* (series of many languages). London: Usborne, 1989.

Emberley, Rebecca. *My House, Mi Casa.* Boston: Little, Brown and Co., 1990.

Garza, Carmen. *Family Pictures.* San Francisco, Calif.: Children's Book Press, 1990.

Goodman, Marlene. *Let's Learn: Spanish Picture Dictionary.* Lincolnwood, Ill.: NTC Publishing Group, 1991.

Griego, Margot. *Tortillitas Para Mama and Other Nursery Rhymes.* New York: Henry Holt and Co., 1981.

Pratt, Kristin. *A Walk in the Rainforest* (A Bilingual ABC Book). Nevada City, Calif.: Dawn Publications, 1993.

Zapater, Beatriz. *Fiesta!* New York: Simon & Schuster, 1992.

Zeff, Claudia. *The Animal Picture Word Book.* London: Usborne, 1981.

Index

About the Author

Always the school artist, Mona Brookes's talent and passion have become her lifework. After receiving a scholarship to Chouinard Art Institute, she completed her degree at Pepperdine University, where she majored in art and psychology. In 1979, Mona took a position developing a drawing program for Tocaloma Preschool in California. It was this job that led her to develop the Monart Drawing Method, which would eventually become the basis for a revolutionary new way of teaching drawing.

After the first Monart School was established in 1982, the number of schools grew quickly throughout the country; there are now twenty-four, including schools in Victoria, Australia, and Berlin, Germany. Major art exhibitions by Monart students have been sponsored by the Los Angeles and Washington, D.C., children's museums, the Kennedy Center Education Department, and the Smithsonian Education Department.

Today, Mona continues to teach her students and to personally train the interns who are working toward their licenses to conduct Monart classes. She is a keynote speaker at educational conferences, gives workshops at school districts nationwide, and has been featured on NBC's *Today Show,* ABC's *Home Show,* the Disney Channel, as well as numerous regional television shows. Dozens of publications have featured her work, including *The Washington Post,* the *Los Angeles Times, USA Today, New Horizons for Learning, Montessori Life, New Age Journal, Principal,* and the *Detroit Free Press.*